FROM THE LIBRARY OF E
512/664-5261

Whatever the Wind Delivers

Whatever the Wind Delivers

Celebrating West Texas and the Near Southwest

Photographs of the Southwest Collection Selected by
Janet M. Neugebauer

New and Selected Poems by
Walt McDonald

Foreword by
Laura Bush

Texas Tech University Press

© Copyright 1999 Texas Tech University Press

All rights reserved. No portion of this book may be reproduced in any form or by any means, including electronic storage and retrieval systems, except by explicit, prior written permission of the publisher except for brief passages excerpted for review and critical purposes.

This book was set in Adobe Garamond. The paper used in this book meets the minimum requirements of ANSI/NISO Z39.48-1992 (R1997).♾

Design by Tamara Kruciak

Printed in United States of America

Library of Congress Cataloging-in-Publication Data
 McDonald, Walter.
 Whatever the wind delivers : celebrating west Texas and the near Southwest : photographs of the Southwest Collection / selected by Janet M. Neugebauer ; new and selected poems by Walt McDonald.
 p. cm.
 ISBN 0-89672-427-1 (alk. paper)
 1. Texas, West Poetry. 2. Southwestern States Pictorial works. 3. Texas, West Pictorial works. 4. Southwestern States Poetry. I. Neugebauer, Janet M., 1935- . II. Texas Tech University. Southwest Collection. III. Title.
 PS3563.A2914W44 1999
 811'.54—dc21 99-16608
 CIP

00 01 02 03 04 05 06 07 / 9 8 7 6 5 4 3 2

Texas Tech University Press
Box 41037
Lubbock, Texas 79409-1037 USA

800-832-4042

ttup@ttu.edu

http://www.ttup.ttu.edu

For the pioneers, who took whatever the wind delivered, and made West Texas their home; for all of those who came after and built on that foundation; and for all the ones we love, and all we've loved and lost awhile.

Contents

Foreword by Laura Bush······xi
Preface······xiv
Acknowledgments······xvi
An Archivist's Perspective······xix

If We Build Here

When a violent sandstorm leveled their tents in March, all three families went back to where they had come from. Paris Cox and his family stayed.
—**W.C. Holden, in** *A History of Lubbock*

The Price They Paid for Range······2
Settling on Open Plains······4
In Fields of Buffalo······6
Cabin······8
Nights on the Porch Swing······10
Under Vast Tornado Skies······12
Grandfather and the Prairie Fire······14
Dazzling between Fast Lanes······16
After the Monsoon······18
When the Children Have Gone······20
Whatever the Wind Delivers······22

A Thousand Miles of Stars

I was born in Alabama back when Herbert Hoover was still president of the United States, but two years ago, I unilaterally declared myself a native Texan.
—**James Ward Lee**, *Texas, My Texas*

Estacado	26
The Hammer	28
When It Seemed Easy	30
Spending the Night near Matador	32
Nights around the Hi-D-Ho	34
Sword in the Cottonwood	36
Rattler	38
Hardscrabble Nights	40
Sunday Morning Roundup	42
Uncle Ernest and the Endless Range	44
The Dust of Tommy's Toyota	46
Turning Thin Shimmer into Wells	48
Home on the Range	50
The First Hard Thunder of Another Dawn	52

All the Old Songs

This high, dry region is hot in summer, cold in winter and the wind nearly always blows.
—**Jim Bones**, *Texas, Images of the Landscape*

The Waltz We Were Born For	56
Fathers and Sons	58
Before Flying Off to War	60
For Friends Missing in Action	62
Sipping Iced Tea in Silence	64
The Last Bale before Christmas	66
Learning to Live with Sandstorms	68
Where Seldom Is Heard	70
The Summer Our Grandsons Turned Twelve	72
High Plains Drifter	74
The Last Saloon in Lubbock	76

With Horsehairs Dipped in Oils	78
Granddaddy's Knuckles	80
Rain Dance	82
Saying the Blessing	84
It's Still the Same Old Story	86

The Silver Coronado Missed

He reckoned they might look a hundred years and never find that place, but he was glad that Mary Dove believed the promises.
—Jane Gilmore Rushing, *Mary Dove*

Historical Markers	90
Steeples and Deep Wells	92
Fifth Grade	94
Seconds of Free Fall and Chaos	96
Hosanna in the Family	98
Starting a Pasture	100
Turning Fifty	102
Plowing with a Six-Mule Team	104
Heart Attack	106
Caught in a Squall near Matador	108
Turn Around, Turn Around	112
One Thing Leads to Another	114
The Middle Years	116

Neighbors Miles Away

We reached Estacado just after dark, and drove to Dr. Hunt's. We suddenly stopped in front of his house, as a buggy wheel locked around a fence post. It is needless to say that here was a joyful meeting. I don't mean with the fence post but with our relatives.
—George M. Hunt, *Early Days Upon the Plains of Texas*

The Last Good Saddles	120
Dogs in the World They Own	122
Neighbors Miles Away	124
Goats Imported from Austin	126

South Plains Fences	128
Loading the Summer Cattle	130
At the Stone Café	132
Goat Herding on Hardscrabble	134
In a Dry Season	136
Aunt Myrtle's Albums	138
A Hatch of Flies	140
A Wide Continuous Sandbar	142
Grandfather's Matched Palominos	144
After the Madness of Saigon	146
Living in Old Adobe	148

All Occasions

All occasions invite his mercies, and all times are his seasons.
— John Donne, *LXXX Sermons*, 3, preached on Christmas Day 1625

Hosannas Dangling on String	152
Nearing the End of the Century	154
In Hot Hardscrabble Skies	156
For Dawes, on Takeoff	158
The White-Haired Trial Judge Deliberates	160
Hardwood Rocking Chairs	162
First Solo	164
What's Up?	166
First View of the Enemy	168
Never in My Life	170
Consider the Lilies	174
The Food Pickers of Saigon	176
Leaving Sixty	178
Faith Is a Radical Master	180
Photo Credits	182

Foreword

The title of this book, *Whatever the Wind Delivers,* gives away the contents of the pages that follow. Through this book, one of the sharpest archivists and one of the best poets in America pay homage to the mystery and appeal of the vast and unpredictable region of West Texas and the near Southwest.

Despite its paradoxical nature, or perhaps because of it, the region commands the respect of its inhabitants. If one thing could be said of those whose lives and livelihoods revolve around the place, it is that they don't simply live on or off the land; they live with it—and thrive.

Whatever the Wind Delivers could be a scrapbook from my father's side of the family. My grandparents, Mark and Lula Lane Welch, moved to Lubbock in 1918, and that's where they stayed. They lived through the "dust bowl" days, and these images might have been familiar to them. My father, Harold Welch, was six when they arrived. He grew up in Lubbock and went to school at Texas Technological College.

When my parents were married and my father returned from the war, they moved to Midland, where I was born and spent my childhood. I remember riding to Lubbock nearly every other weekend to visit my grandmother. Years later when I was married and living in Midland, George and I campaigned throughout this same region when he was running for Congress. The drive between Midland and Lubbock was beautiful to me as a child and even more beautiful to me as an adult because of the memories it evoked.

I have been fascinated with West Texas since those early trips to Lubbock.

To survive, every day is a negotiation, an agreement, an acceptance of terms that the soil and the sky outline without the slightest bit of consideration. And yet, even at its worst—at its dustiest, hottest, and driest—the region is rich with anticipation and hope for a merciful change. And it does change.

Just when a man resigns his fields to a dry season, precious rain bursts from a cloud, calming the dust about his boots, washing the red dirt off the windows of his pickup and summoning birds to bathe and drink.

This is the paradox of West Texas and the mighty Southwest. It is at once dull and unpredictable; subtle and grand.

Whatever the Wind Delivers is also a Texas scrapbook. It contains photographs and notes from our collective past; from our predecessors.

Generations of poets and photographers have devoted their time and talent to immortalizing our precious Western region. The results have been volumes and collections of information, such as what you'll find at Texas Tech University's Southwest Collection. Most West Texans would agree that anything short of volumes and collections would fail to do the place justice.

Perhaps no one has come as close to capturing the essence of this limitless subject matter in the pages of a book as have Walter McDonald and Janet M. Neugebauer in their two collaborations—the first, *All That Matters: The Texas Plains in Photographs and Poems,* and now with this book.

Walt and Janet have appropriately dedicated this book to such "pioneers, who took whatever the wind delivered, and made West Texas their home; for all those who came after; and for all the ones we love, and all we've loved and lost awhile."

The collaborators took a different approach the second time around. In their first book, *All That Matters,* Janet, an associate archivist with a sharp eye and a keen understanding of the Southwest Collection, punctuated Walt's poetry with photographs that she culled from the extensive collection.

This time, it is the arrangement of the pictures that shapes the book. Walt used his new and selected poems to expand upon the theme that emerged from the photographs. The result is a monument to the story of the settlement of that region.

The eighty-three poems are a generous sampling of the Lubbock native's body of works. Walt's poetry accompanies Janet's selection of pictures to create a three-dimensional view of the Southwest, which

influences and moves its inhabitants through "those hauntingly wide horizons, the splendor of it all."

You can see it in the creased and sweaty brow of a hard-working cowboy who stops to tip his hat in a cool stream. And you can feel it in the meter of Walt's words in "The Price They Paid for Range." The elements of sight and sound are well matched, yet they are strong enough to stand individually and tell us their own tales. Both paired and singularly, they are a testament to a region and a people who even today teach us about our past and give us hope for the future.

Let this book take you to West Texas and the near Southwest. Let it show you a place that, for generations, has stirred the imagination of its inhabitants and visitors. If ever there was a region that merited the respect of great writers and photographers, it would be this one.

Janet and Walt have accomplished what they set out to do—they celebrate West Texas and the near Southwest. I share their love of the land and its people. These are our people, and this is our home.

<div style="text-align: right">

Laura Bush
August 31, 1999

</div>

Preface

Whatever the Wind Delivers celebrates the opening up and settlement of the plains—not limited to the early days on the plains, but focused on the scope and quality of life both then and in the century since ranching and farming came to the region. The scope of photos and poems is the Southwest Collection's regional focus, West Texas and the near Southwest—the area of Texas west of the Brazos River on to the Llano Estacado in New Mexico. The photos tell the story of settlement, and the poems connect to the continuing currency of those captured moments in history. We hoped that together they would yield a surprising resonance of joy.

We matched poems with photos not in any way to illustrate actual persons, but as continuing celebrations of living in West Texas and the near Southwest. Archival photographs tell a story of settlement, and Janet's selections are diversely appropriate. She has the best cache there is, for such a book, treasures of the Southwest Collection's bounty of more than 500,000 photographs, located at Texas Tech University. Janet found photographs that capture how, in the process of settling, the people of West Texas satisfied those needs basic to all humankind: food, clothing, shelter, government, recreation, and religion.

Then, with Janet's advice, Walt chose eighty-three of his poems to connect with those images. The poems don't merely describe the photographs. We didn't try to match poems with the historical setting and time of the photographs, but we wanted ones that connected with the spirit of the photos. Sometimes, the poems may goad stories that might be behind the photos, or voice similar values

and encounters with the landscape, or celebrate the people who boldly made and make this region home.

Combined, a poem and photo may yield more than either one could give, alone. Sometimes, we paired them for the resonance of similar textures or settings in both time and space—for instance, matching a photo of an early dance for ranchers with a poem about people a century later. Such a juxtaposition can work like a simile: by yoking together those people separated by decades, we hoped to show more harmony than contrasts between generations, between bold pioneers and their blessed inheritors—at risk, but singing on the same wide plains, under the same tornado skies, the same vast, thousand miles of stars.

<div style="text-align: right;">
Janet M. Neugebauer

Walt McDonald
</div>

Acknowledgments

I'm grateful to the following publications in which earlier versions of these poems first appeared, some with different titles:

American Poetry Review: "Starting a Pasture"
American Scholar: "Seconds of Free-Fall and Chaos," "Turning Fifty"
Antigonish Review (Canada): "Whatever the Wind Delivers"
Ariel (Canada): "The Waltz We Were Born For"
Arkansas Review: "When It Seemed Easy"
Artful Dodge: "Aunt Myrtle's Albums"
Beloit Poetry Journal: "Spending the Night near Matador"
Birmingham Poetry Review: "Plowing with a Six-Mule Team"
Blue Mesa Review: "Nights Around the Hi-D-Ho"
Bottomfish: "The Last Bale before Christmas"
Carolina Quarterly: "Nights on the Porch Swing"
CEA Critic: "The White-Haired Trial Judge Deliberates"
Cimarron Review: "The Middle Years"
Cincinnati Poetry Review: "The Last Good Saddles"
Clackamas Literary Review: "Sipping Iced Tea in Silence"
Clockwatch Review: "Saying the Blessing"
College English: "Before Flying Off to War," "Loading the Summer Cattle"
Colorado Review: "Caught in a Squall near Matador"
Comstock Review: "In Hot Hardscrabble Skies"
Connecticut Poetry Review: "Neighbors Miles Away"
Crosscurrents: "Settling on Open Plains"

Crossroads: A Journal of Southern Culture: "Uncle Ernest and the Endless Range"
Descant (Canada)*:* "In a Dry Season"
Fiddlehead (Canada): "South Plains Fences," "Steeples and Deep Wells"
First Things: "It's Still the Same Old Story"
Gettysburg Review: "A Hatch of Flies"
Grand Street: "Dogs in the World They Own"
Hampden-Sydney Poetry Review: "Rattler"
Hiram Poetry Review: "First Solo"
Image: "Historical Markers"
Inklings: "Hosanna in the Family"
JAMA: The Journal of the American Medical Association: "After the Madness of Saigon," "Heart Attack"
Liberty Hill Poetry Review: "A Wide Continuous Sandbar"
Literary Review: "Hardscrabble Nights"
Mānoa: "The Last Saloon in Lubbock," "The Price They Paid for Range"
Meridian: "Consider the Lilies"
Missouri Review: "With Horsehairs Dipped in Oils"
National Forum: "After the Monsoon"
New Letters: "For Friends Missing in Action"
New Texas 95: "High Plains Drifter"
New Texas 98: "When the Children Have Gone"
Nightsun: "Under Vast Tornado Skies"
North Dakota Quarterly: "Learning to Live with Sandstorms"
Owen Wister Review: "Sword in the Cottonwood"
Palo Alto Review: "Fifth Grade"
Parting Gifts: "What's Up?"
Poem: "Living in Old Adobe," "Turning Thin Shimmer into Wells"
Poetry: "For Dawes, on Takeoff"
Poetry Durham (U.K.): "Goats Imported from Austin"
Poetry Wales (U.K.): "Fathers and Sons"
Presbyterian Record (Canada): "Leaving Sixty"
Riverwind: "Grandfather and the Prairie Fire"
Rocky Mountain Review: "Never in My Life"
Sam Houston Literary Review (now *The Texas Review):* "The Hammer"
San Jose Studies: "Rain Dance"
Sewanee Review: "In Fields of Buffalo"

Slant: "Where Seldom Is Heard"
South Dakota Review: "Estacado," "Grandfather's Matched Palominos"
Sou'wester: "Hardwood Rocking Chairs"
Sulphur River: "Granddaddy's Knuckles"
Sweet Nothings: "At the Stone Café"
Tar River Poetry: "Nearing the End of the Century"
Tex!: "Dazzling between Fast Lanes," "Hosannas Dangling on String," "One Thing Leads to Another"
Three Rivers Poetry Journal: "Sunday Morning Roundup"
TriQuarterly: "The Food Pickers of Saigon"
Verve: "First View of the Enemy"
Windhover: "Faith Is a Radical Master"

I'm especially grateful to the editors and presses that published earlier books with several of the poems included in *Whatever the Wind Delivers*: *After the Noise of Saigon* (University of Massachusetts Press, 1988); *Burning the Fence* (Texas Tech University Press, 1981); *Caliban in Blue* (Texas Tech University Press, 1976); *Counting Survivors* (University of Pittsburgh Press, 1995); *The Flying Dutchman* (Ohio State University Press, 1987); *Night Landings* (Harper & Row, 1989); *Where Skies Are Not Cloudy* (University of North Texas Press, 1993); *Witching on Hardscrabble* (Spoon River Poetry Press, 1985).

A special thanks to Vicky Jones, Reference Archivist, Southwest Collection, for her patience during the photograph selection process, and to Tim Rickman, Medical Photographer, Texas Tech University Health Sciences Center, who reproduced the photographs.

Every poem in this book is fiction, freely invented, and its content comes from Walt's imagination. Any similarities between these poems and the real lives of any persons living or dead are unintended and coincidental.

An Archivist's Perspective

If a picture is worth a thousand words, then perhaps a photograph and a poem together will generate a million ideas and feelings for the reader. That is the hope of Walt McDonald and Janet Neugebauer in *Whatever the Wind Delivers,* their second cooperative venture. In the first, *All That Matters,* photographs were selected to accompany already written poems. The process was reversed in this project. Neugebauer selected more than three hundred photographs that reflect settlement in West Texas, and McDonald matched more than one hundred of his poems, many as yet unpublished, to them. Eighty-three pairs were selected for this volume. As the project progressed, it was exciting to see how the basic needs and feelings of all humankind truly transcend time and space.

For decades scholars, artists, and interested citizens have used photographs from the Southwest Collection at Texas Tech University for documentation or inspiration, but the concept of using the photographs and poems for mutual enhancement is unique to McDonald and Neugebauer. Gladly, they credit Judith Keeling, Editor of the Texas Tech University Press, for suggesting the concept of that first book and bringing them together a decade ago.

The photograph files of the Southwest Collection contain more than five hundred thousand images. The earliest photographs were received in the 1930s as part of manuscript collections, such as the Matador Land and Cattle Company Records, that were kept in a special room of the Texas Tech Library until the Southwest Collection was established in 1955. The material was then transferred to other quarters. A professional archivist was hired to oversee the Collection, and a program was initiated to begin collecting

photographs county by county. Many that were not available for in-house storage were copied. This aggressive approach has produced a large body of photographs, which in turn has become a stimulus for encouraging more donations. Themes began to surface: ranching, pioneering, land promotion, railroads, agriculture, community development, education, and water usage—themes that reflect the settlement of West Texas and the near Southwest.

Collecting historical information democratically has always been a goal of the Southwest Collection. For example, its holdings contain information about farmers, cowboys, miners, women, African Americans, Mexican Americans, and soldiers. This information documents the ongoing relation that people of the Southwest have to each other and to the environment in which they live.

By 1998 the Southwest Collection had grown to include more than twenty-one million items. These items include original manuscript material such as letters, diaries, and business records, as well as books on the American West and Southwest, photographs, oral histories, newspapers, microfilm, film, and video. Scholars and interested citizens come from throughout the state, nation, and world to use the material housed in the Southwest Collection. Its staff handles more than seven thousand inquiries annually, and anticipates increased usage as more of the holdings are put on the World Wide Web. For more information about the photographic holdings, please visit the Southwest Collection's web site at http://www.lib.ttu.edu/swc.

William E. Tydeman
Associate Dean of Libraries
For Southwest Collection/Special Collections Library

When a violent sandstorm leveled their tents in March, all three families went back to where they had come from. Paris Cox and his family stayed.

W. C. Holden, *A History of Lubbock*

The Price They Paid for Range

Bone-white caliche undercuts our dust.
Most trees dry up, stunted on starving roots.
To save imported stumps, we ditch the fields
with peat imported from swamps,
tamp bonemeal into dirt for roses.
Cactus rode here as burrs with soldiers,
their Spanish ponies stumbling
under the sun, dumping knobs of seeds

from weed fields miles away.
Wind taught our fathers how to survive
so far from forests: build low and far apart
and ration water. Let stallions and cattle
be enough, rough bunks and windmills
the way to pray, cow chips for fire, cactus
and rattlers the price they paid for range
and a thousand miles of stars.

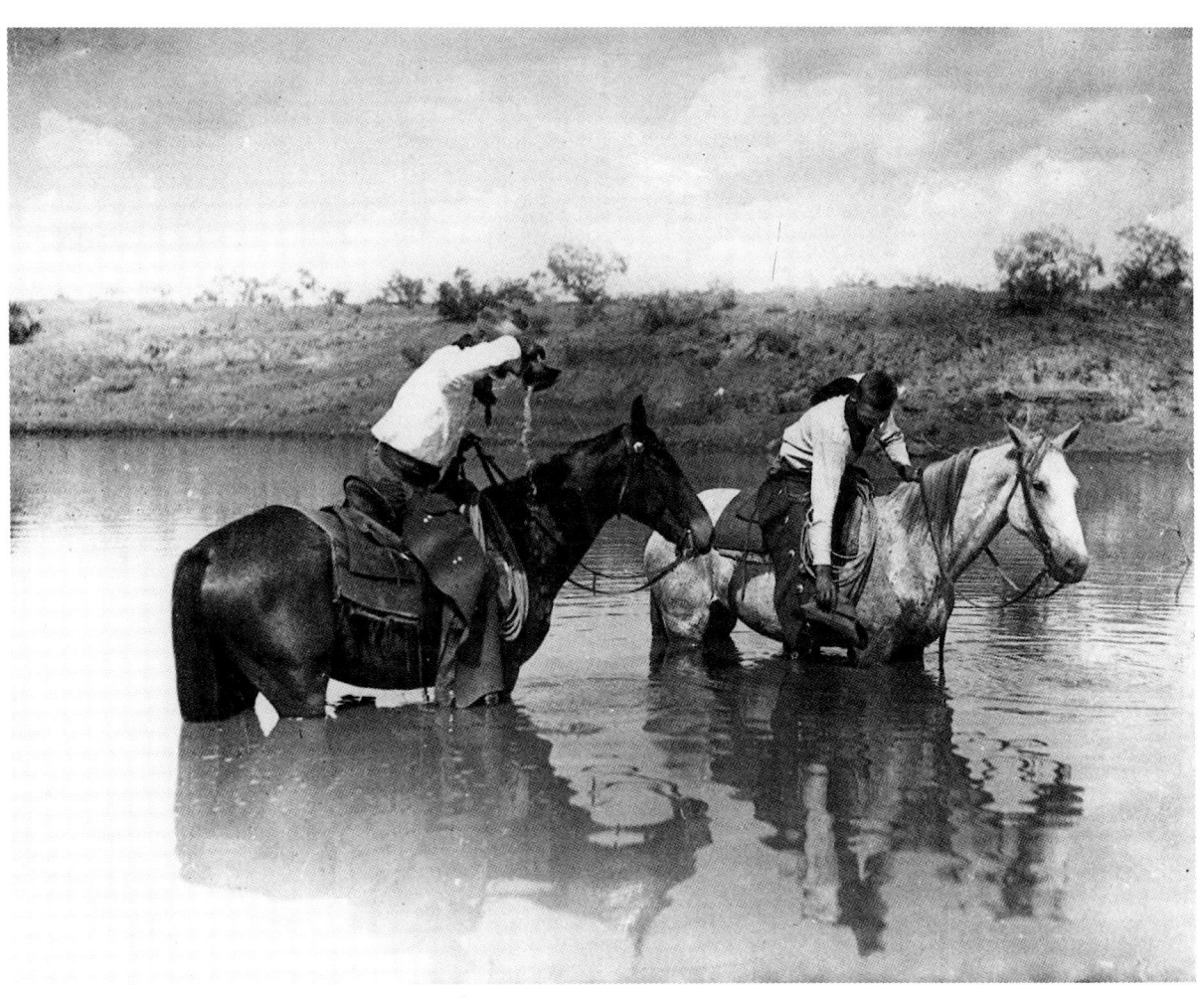

Settling on Open Plains

They were never alone
here without hills
to protect them,

no caves, not even a stream
to hide their scent in.
The quality of mercy

was two hands touching.
They came to expect wind
like a lost child

pounding the shutters.
They opened the door
on stars falling

on flat fields,
wolves sniffing their cow,
coyotes howling all night.

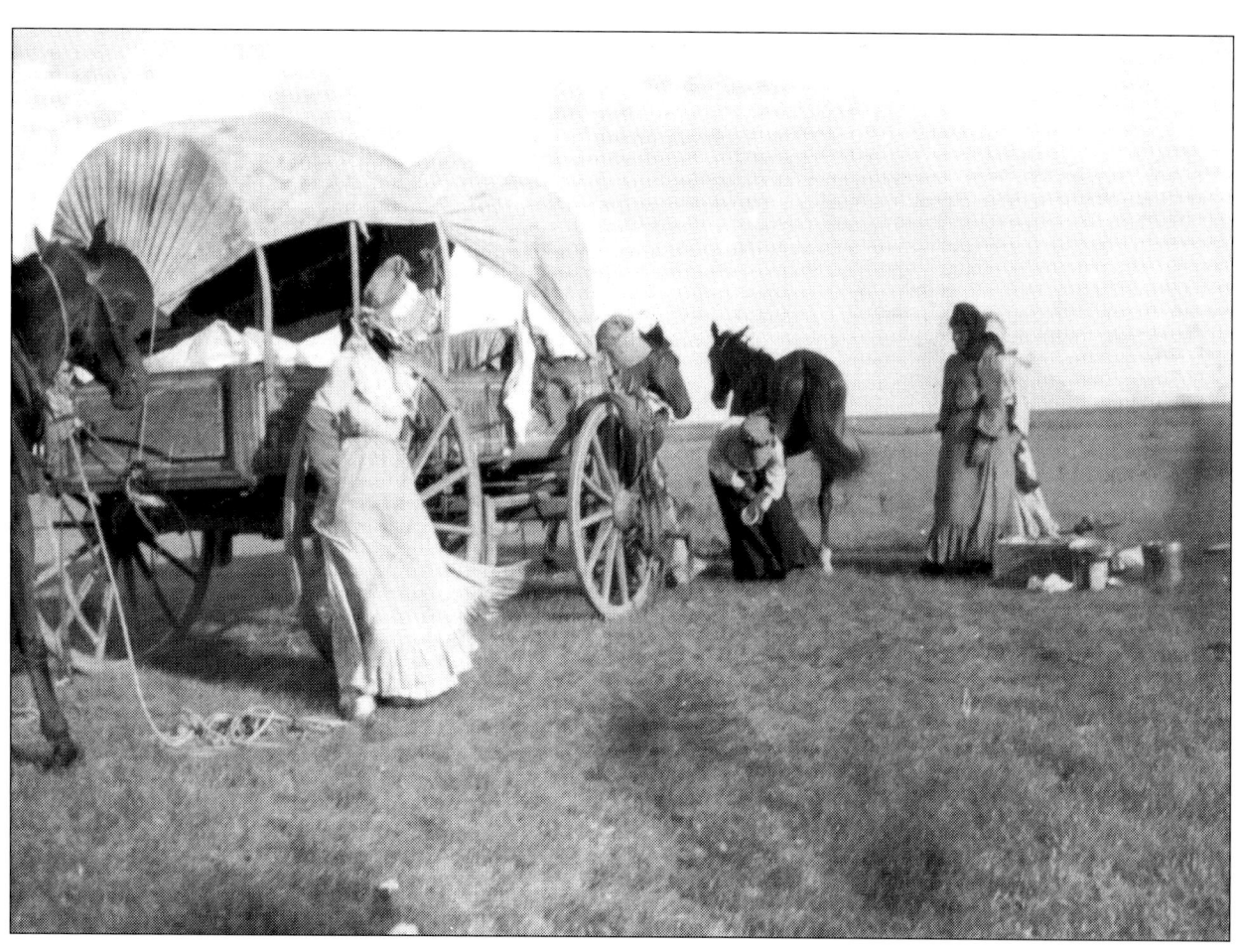

In Fields of Buffalo

Granddaddy waited while men with spades
dug a maze of trenches to test the treasure maps.
Skulls wedged up like onions on his farm.
Diggers from Austin brought along charts
of slaughter on the plains. By 1880,

buffalo hunters had aimed long rifles
where he plowed. Thousands dropped like manna
for horseflies, hides worth their weight
in silver in St. Louis. . . . I remember the truck,
the loading ramp, crates of bones dollied aboard.

I hadn't known buffalo roamed there,
never dreamed his dirt was home to anyone
before Granddaddy's father. Cotton
was all I'd seen on his rows, those skies
my only horizon. At night I listened hard

and heard far in the distance the howl of coyotes,
the thunder of summer storms. Lying still,
I felt an earthquake rumble, a herd
stampeded by rifles, miles of humpbacks
galloping, about to disappear.

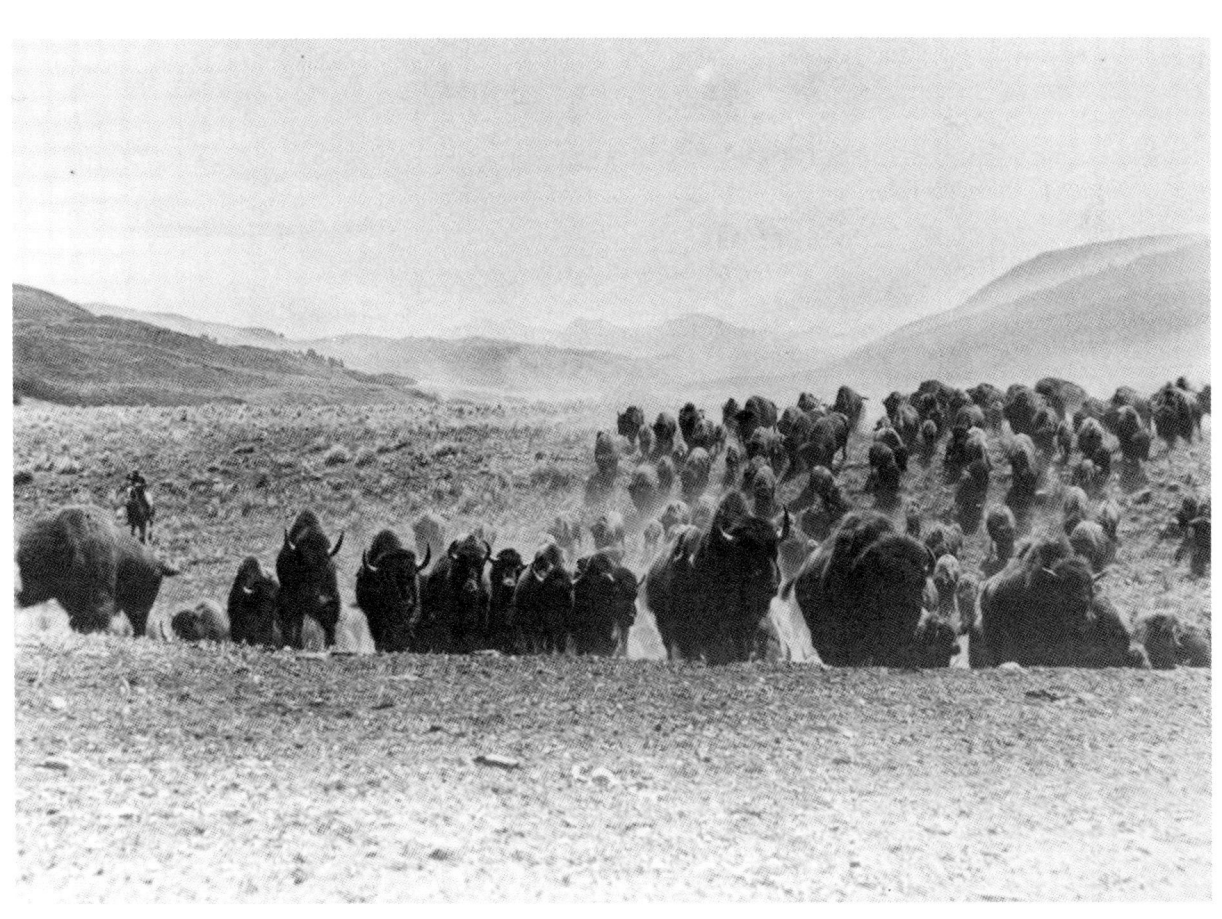

Cabin

If we build here,
all sorts of things are possible:
dawn earlier, fog curled at our feet,
the spring far enough downhill
for exercise, buckets of water
balanced for the cool climb home.

Here's where from down below
we've seen deer silhouetted,
here we'll be level with hawks
perched high in the oaks—
look, one's watching us, swaying,
its dark eyes blinking.

Up here, the breeze will be
always strong, the chimney will draw,
the roof swirled free of snow,
and in spring we'll dust,
shake blankets fresh outside,
and beat the rugs.

Nights on the Porch Swing

I see from my wife's dark eyes
we're not alone. Our stock tank
shimmers in moonlight. Whatever warns her

makes her squeeze my neck—a whiff of fear,
a riffle of feathers. Owls own the earth,
round eyes thrust downward. I've seen her

rescue five baby ducks a day, a night-light on
for ducks waddling spoiled in the washroom.
On the swing, I talk of hunger,

the natural curve of talons. *Hush*,
she warns me. Her body knows the rhythms
of the moon, expects owls most nights

and ignores them. Tonight, her fingers
strum the short hairs of my neck.
We hear a scream squeezed out by talons.

I shove the porch swing higher with my boots,
but her moccasins stop us,
dragging the swing off balance. *Hush*,

she says, her nails in my flesh.
She tugs my beard and squeezes,
her fingers stroking, stroking my neck.

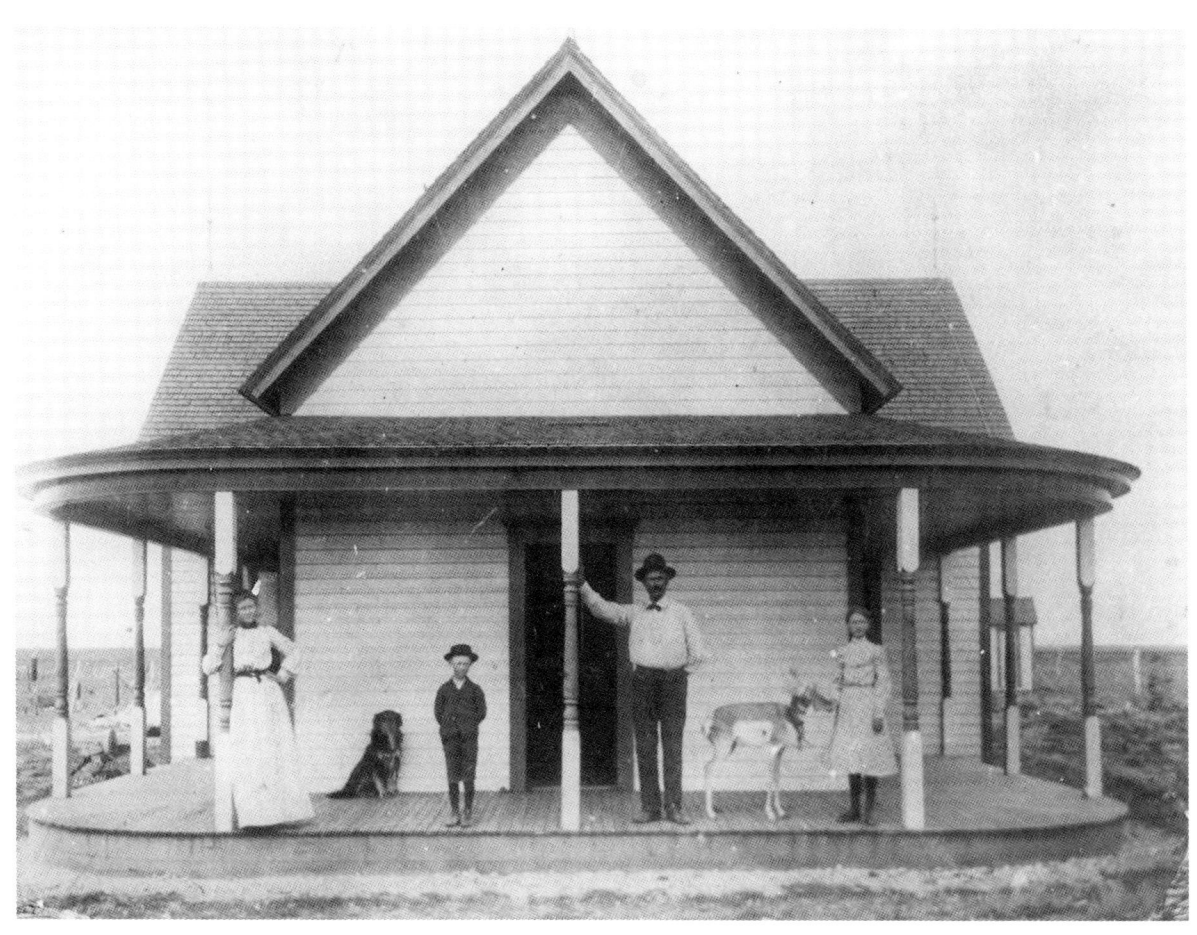

Under Vast Tornado Skies

We pan the dust like gold,
hoping for ribs and flints, finding a fang,
the jawbone of a bear. For months, then,
nothing but buzzards gliding,

as if other diggers seeded the site
to trick us. In time, small bones turn up,
buried by sand a thousand years.
We've proved plains people lived and where,

facts good as gold, dust stored in vaults
of regional museums. Leave it to us
to understand with atomic tables
and sextants. We rescue strangers

from the dead, people we might
have loved, dusting for secrets
of how they lived on the plains
and why. If they dreamed of gods

and hid from enemies at night
without fires, time fast as the wind
was enough to fear under the same blue dome,
the same tornado skies.

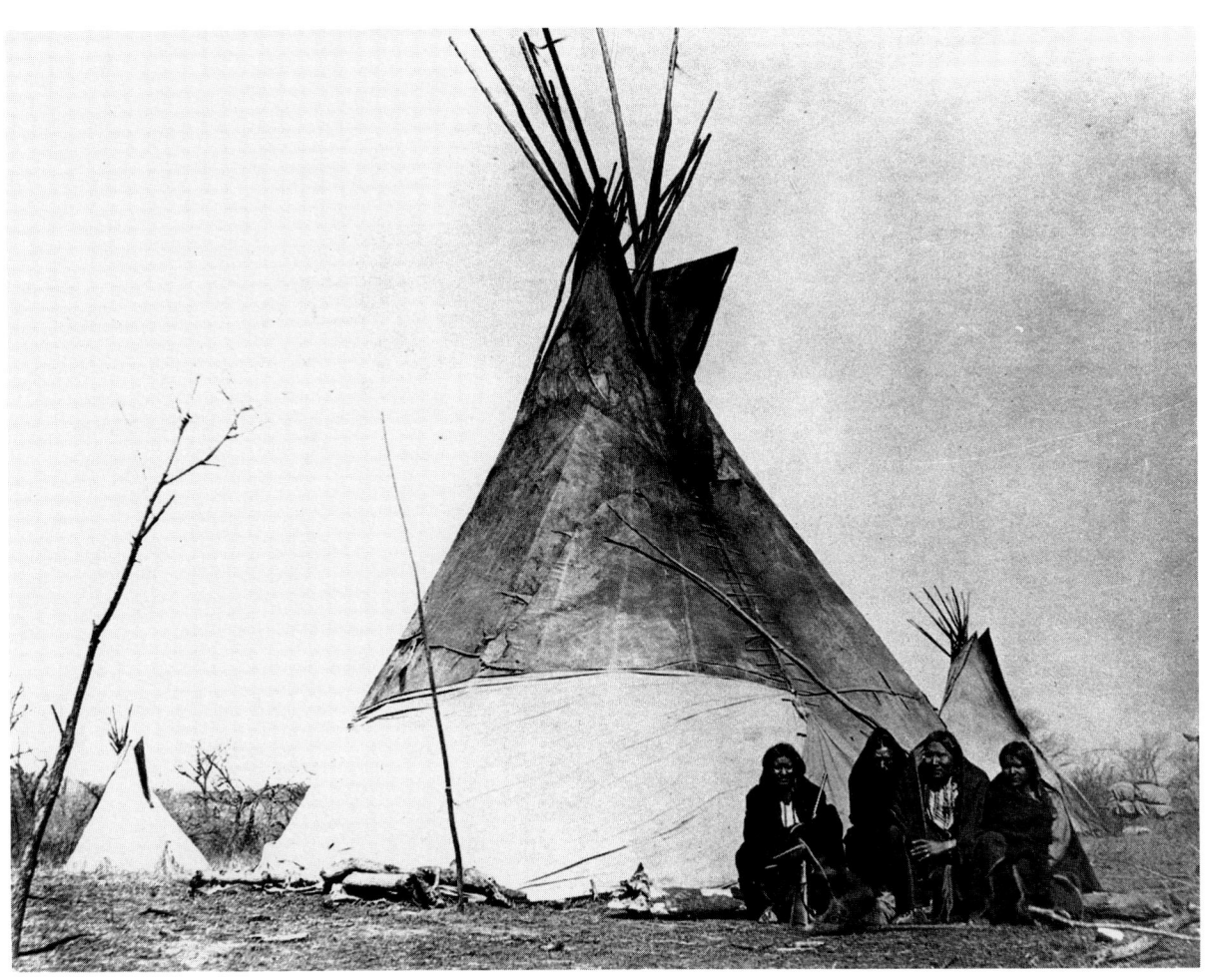

Grandfather and the Prairie Fire

I saw him ride up soaked and hatless
to the porch, fat gelding drenched and steaming
while the lightning flashed. My mother followed him
inside and found the towels, scouring his hair
like scolding an unruly child. I remember his eyes,

cold blue above his dripping beard. Always he winked
and flipped a spray of rain at me. Big shoulders
bulged under the sopping shirt. Dinner was always
chickens he sent to heaven. I grew up thinking
angels wore chicken wings, and hope was the pulley bone.

Grandfather's world was cattle and cactus, nothing
above him all day long but sun. He never married
or wore a raincoat after Mamaw died. When it rained,
he stayed outside with the herd, as if that would save them
when rare thunder rolled. Grandfather bought a bull

in Montana he'd never seen. He liked the name,
Storm Maker. After long drought, Mamaw died
of cancer, when I was nine, the year heat lightning
set the fire downrange that burned five ranches down.
Grandfather's neighbors lost their herds, their barns
and keepsakes, no beds, not even photographs.

Grandfather lost his beard and eyebrows,
fighting the flames, face and arms mottled
for years until he died. What saved his house
was luck, a shift of wind, his horses
lunging against barbed wires out of the fire.

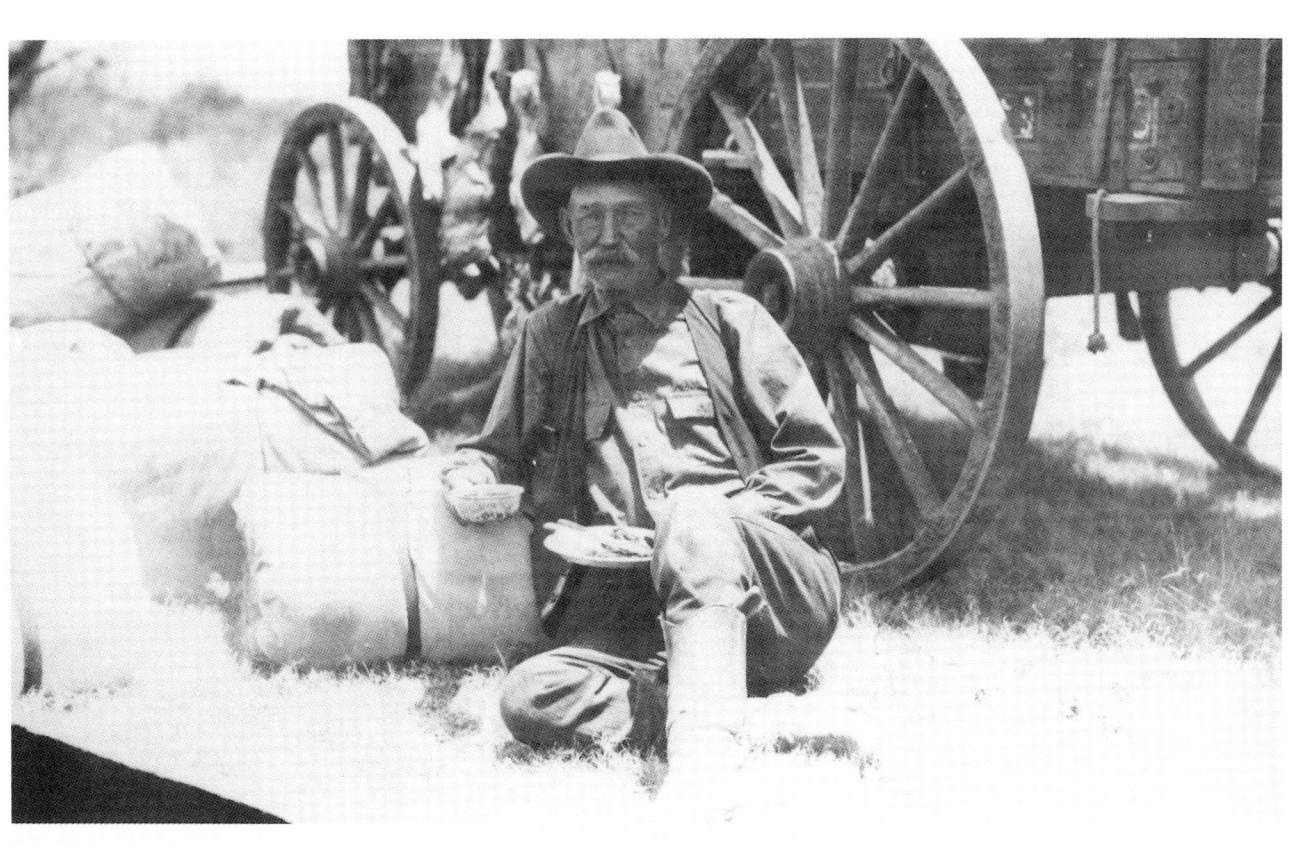

Dazzling between Fast Lanes

Bull-necked oxen couldn't budge that plow.
Somebody Jones of Dallas polished the bronze,
the curved steel shining like glass,
dazzling traffic around the county square.
O Pioneers! Jones named it after Cather.

The plow's set deep, as if they tilled one row
and stopped to pose. Squatters in bronze
seem sunburned although a bonnet shields
the woman's nose. The boy stares far off
at a hawk, or the first real cloud since Alabama.

My great-greats came with oxen
to the plains, bought eight hundred acres from a ranch
that failed. I've seen their skinny mules
in pictures grainy as the sand they plowed.
I've seen their tight-lipped faces, all beard

and dark clothes buttoned at the neck,
eyes hollow as Matthew Brady's corpses'
in the Civil War. I doubt this handsome father
could plow straight rows, or if he could,
they'd be bronze and perfect, like the reins

draped in his hand. He stares at the statue wife,
probably some model in Neiman Marcus jeans.
Mounted between fast lanes, the steel
blinds drivers racing to beat the lights,
bricks loud with traffic even after dark.

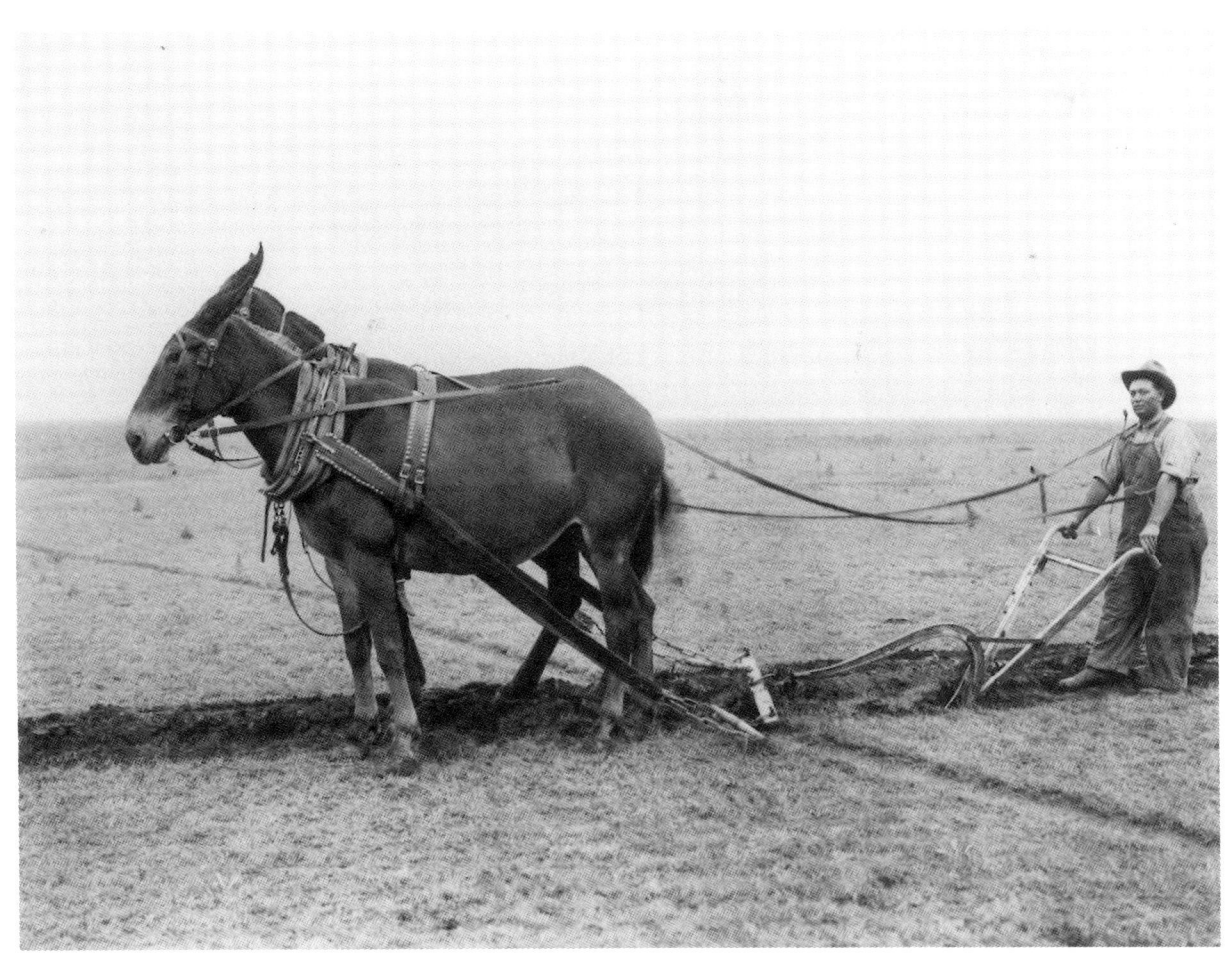

After the Monsoon

Our stock tanks offer the only water for miles,
ponds we're never stingy with. I'd sell all we own
for a cloudburst, trade sleep for a day of rain.
At dawn, we rock on the back porch, counting stars.

Doves dive out of purple skies to drink. If we talk,
we drive them off, skittish as colts Grandfather herded
sixty years ago. We count the doves and wonder
how many breed in a pasture. Dust clings to our eyes,

grains of grit in our teeth. If this hot land is all mirage,
at least we're home. I came back after Vietnam to burn,
heat waves shimmering for years. Grandfather's herd is gone,
even his windmill that pumped sweet water to pastures.

The wolves are gone, the buffalo, the last game warden bored
with nothing to patrol. We're here far from war,
on a porch swing. The day's first siren calls the dogs.
Ears back, they mourn the void no dog calls father.

Parents we thought immortal trembled for years in rockers,
brittle as frost. We taught them to listen for our footsteps
on visits, lie back and sleep without weeping, trusting
lullaby good-byes. Today, we'll seed the puffy clouds

with faith and plow real fields for grain. The way to move
through nightmare is to sit up, pretending it's dawn.
Rocking, mugs of hot coffee in our fists, we watch the sky
light up like a lantern, slowly at first, then burning.

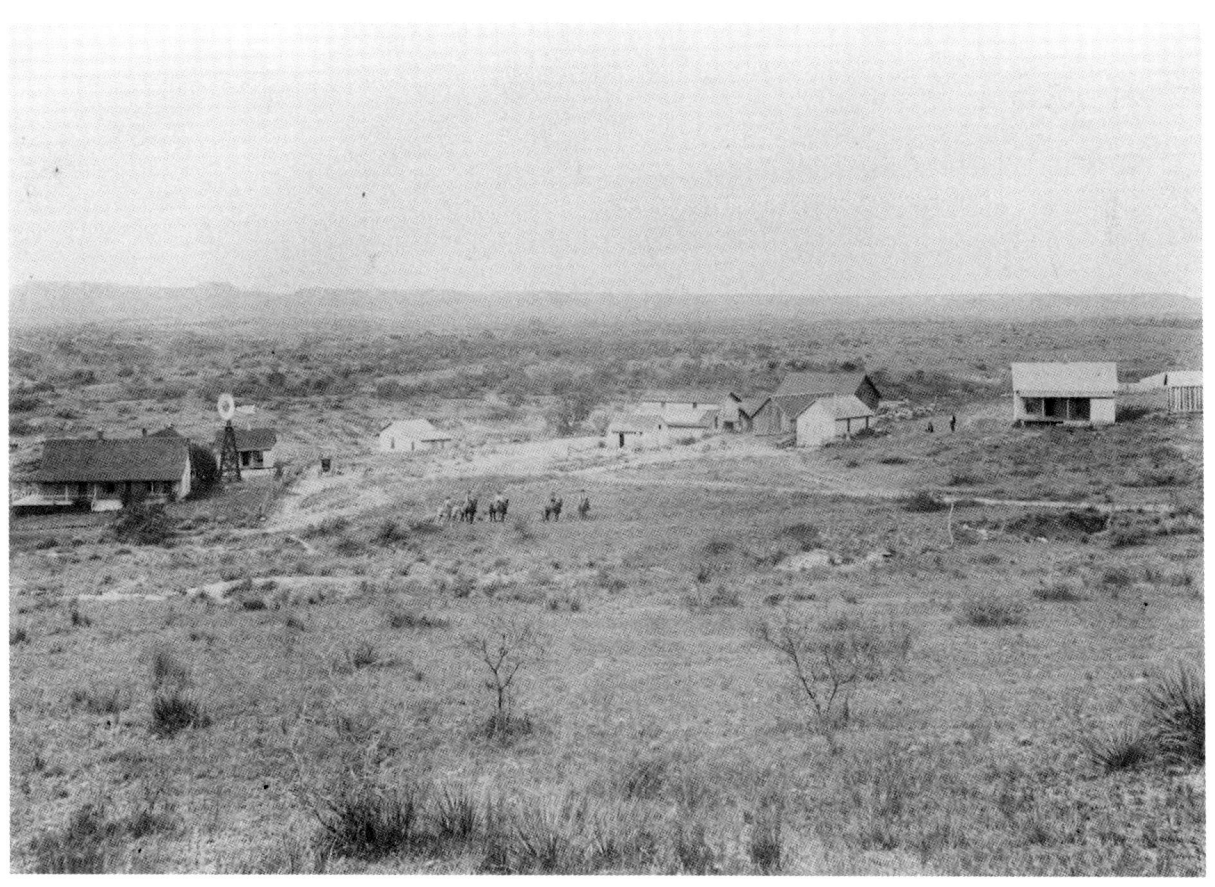

When the Children Have Gone

Points on a map, wobbly daylong escape
out of town. My wife drove fast
but not wild enough for traffic
that jockeyed to pass, not enough lanes
for cars stacked up at eighty.
Trucks shifted uphill and rumbled past

on the downgrade, jeweled mud flaps
flopping, spitting out rocks
and tire treads. All rest stops
were packed along the interstate.
We drove without snacks or ice chest,
the grass half-mowed, the last stamps

stuck to letters we forgot to mail.
We tried counting pelts
flattened like signals for help,
armadillos, rabbits, rattlers,
like somebody's frantic letters
scattered for miles along the trail.

We imagined raising cattle on the plains
before trains and highways, before ice.
We pictured Great-grandfather's house
miles from neighbors—the only shade, bear grass
and cactus. We remembered Grandmother's fans
she brought from Georgia, the set of her face

as she rocked on the porch and sewed.
We thought of hot Julys, the bawl
of distant calves, no cars, no phones,
no whining tires of trucks rumbling by,
not even miles away. Where did they drive
when their last child left home?

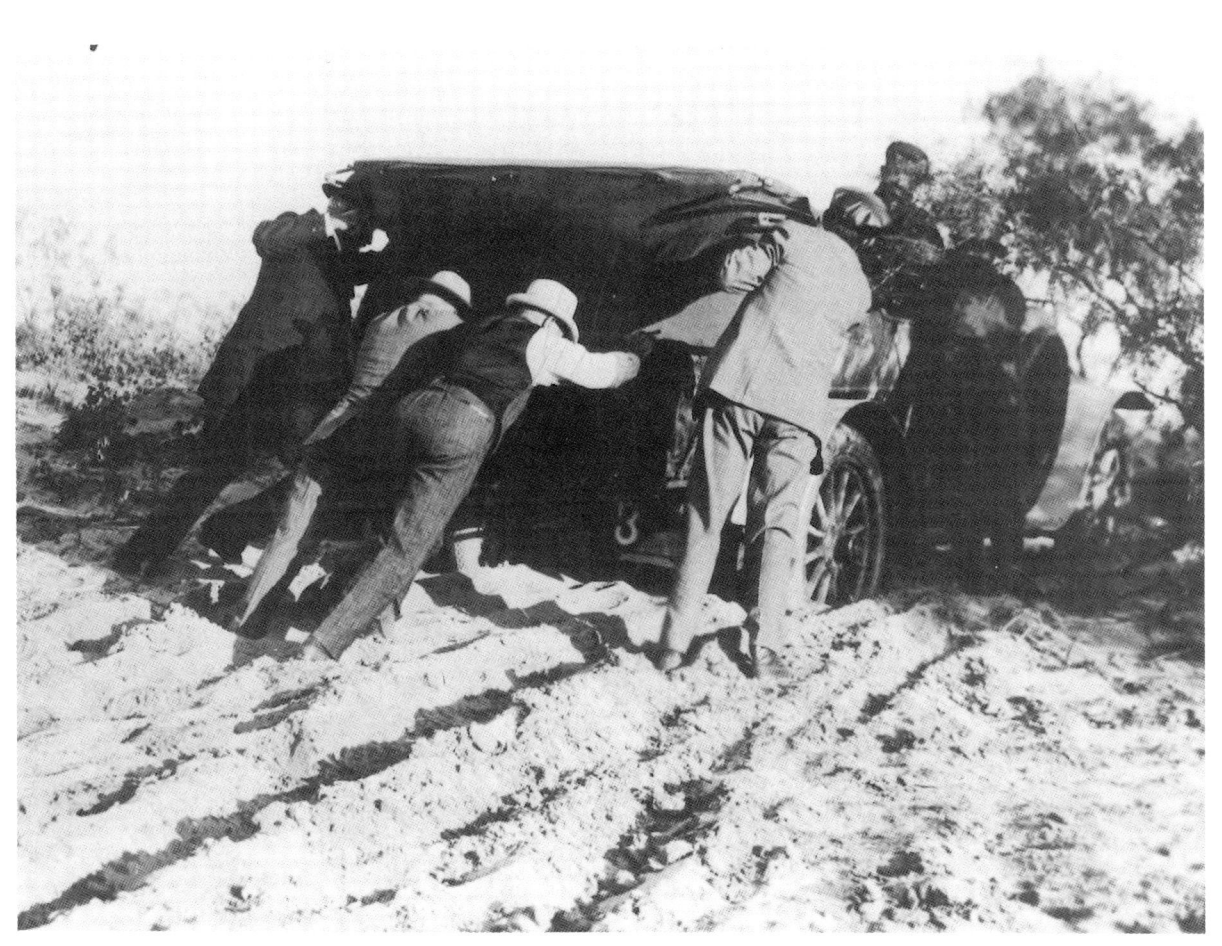

Whatever the Wind Delivers

This is the rage for order on the plains,
barbed wire cinched tight from post to post.
Acres of land each year go back to sand

and disappear. Nothing not tied down
stays home. Canadian geese fly over us
each fall, each spring, and never stay.

Our steers two times a year trudge up
board ramps to slatted walls of trucks
from the slaughterhouse. Even our children

rise up like owls and fly away. Nights,
you turn for me to hold you. We pretend
we go away by writing French love notes

in dust on the headboard. At dawn,
you smooth oiled cloths over all we wrote
the night before. By dusk, the film is back,

the earth we live on, the dust our fingers
string new fences on, holding each other
one more night with loving words.

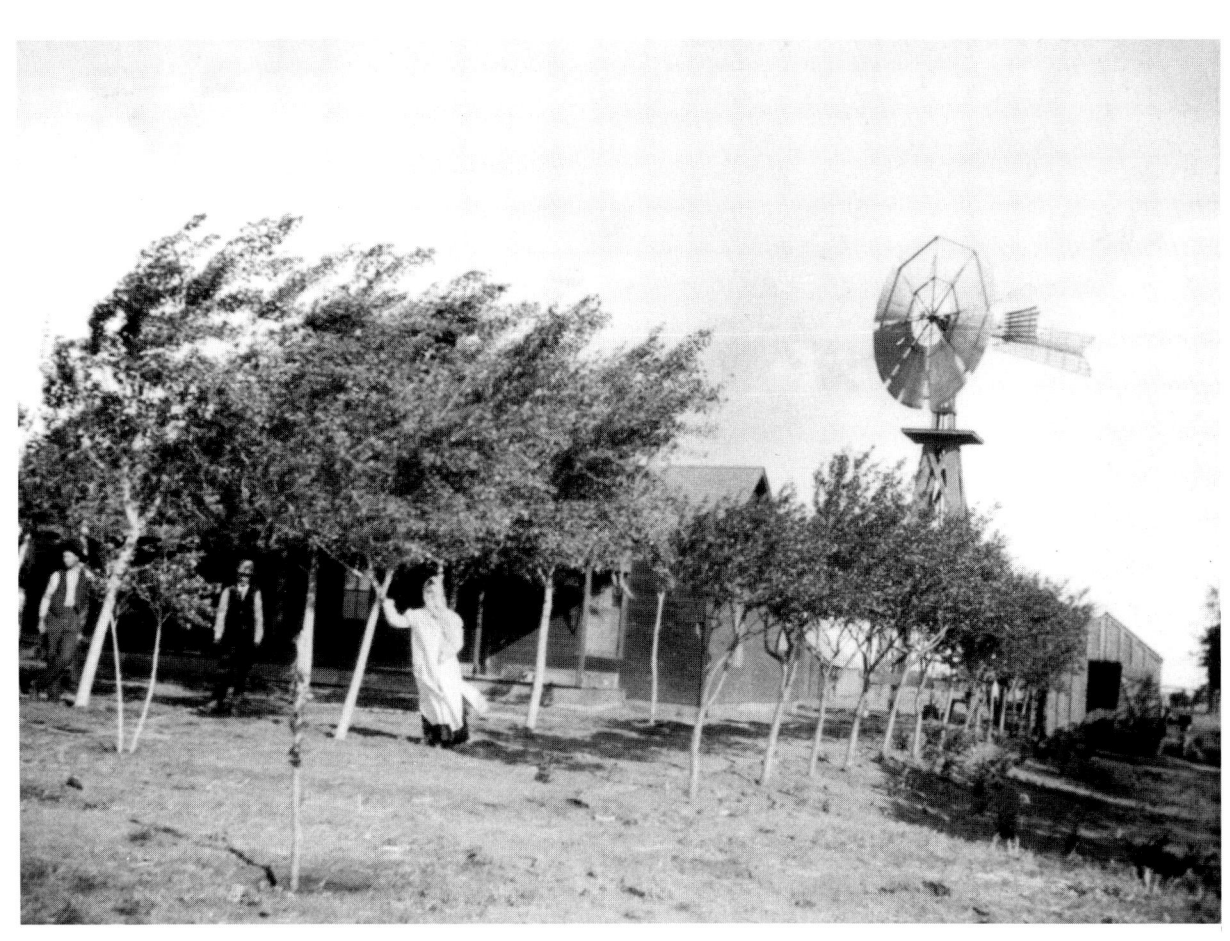

A Thousand Miles of Stars

I was born in Alabama back when Herbert Hoover was still president of the United States, but two years ago, I unilaterally declared myself a native Texan.

James Ward Lee, *Texas, My Texas*

Estacado

Great-grandmother in 1880
raised eight children on plains
she called heaven's tableland.
A Quaker teacher from Iowa
with two dead babies
and two that lived, she talked softly

to her husband, a godly farmer,
and called the Friends' village
in West Texas their promised land.
They loaded up and left
with nothing but a letter
to lead them. This wide prairie

with waving buffalo grass
reminded them of bread without yeast,
the unleavened body of the Lord.
The only milk here flowed in the cow
roped to their wagon,
their only honey, words in a book.

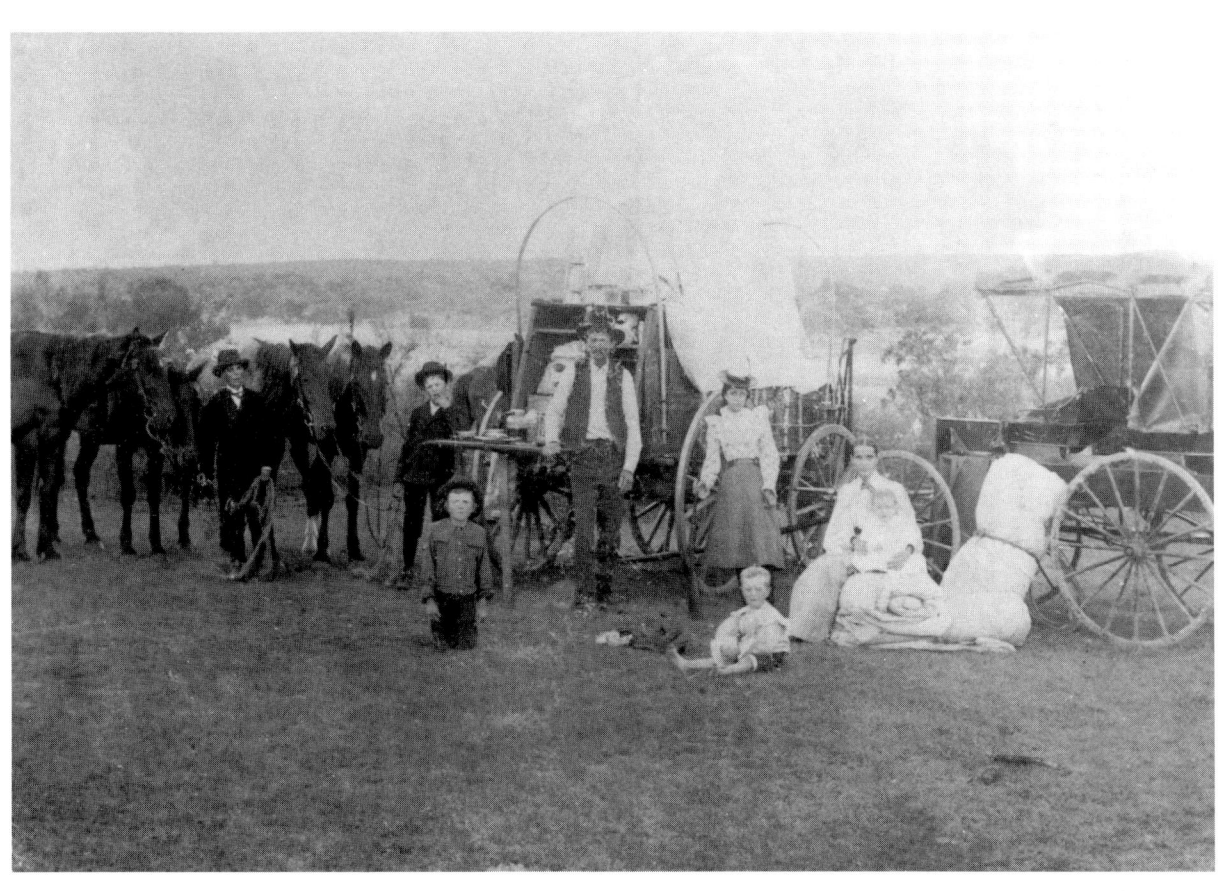

The Hammer

The night Grandfather died,
his heart stopped sixteen times,
struck fire, stopped,
and struck again, like a hammer
fusing the bond.

Afterwards, blowing our steaming coffee,
rubbing our hands like flint against the cups,
we marveled at such mettle.

For decades, he was a blacksmith.
His arm, my father said, would only flex
right angled to his biceps,
warped by the hammer and the forge.

I knew him humped, a little man
lurching as he walked,
a slow voice deep with ash
and pale eyes banking sparks.
I knew a tremor in his hands—
his fingers shook, curled all the way
around my arm, easy,
like testing a two-pound hammer
for its strength.

Sixteen, the doctor said,
each like the clang of steel on steel,
the stiff slow bellow blowing sparks,
stoking time, feeding the flame
until the nails were in,
until the hammer stopped,
until the shod horse of death stood by,
waiting for the road.

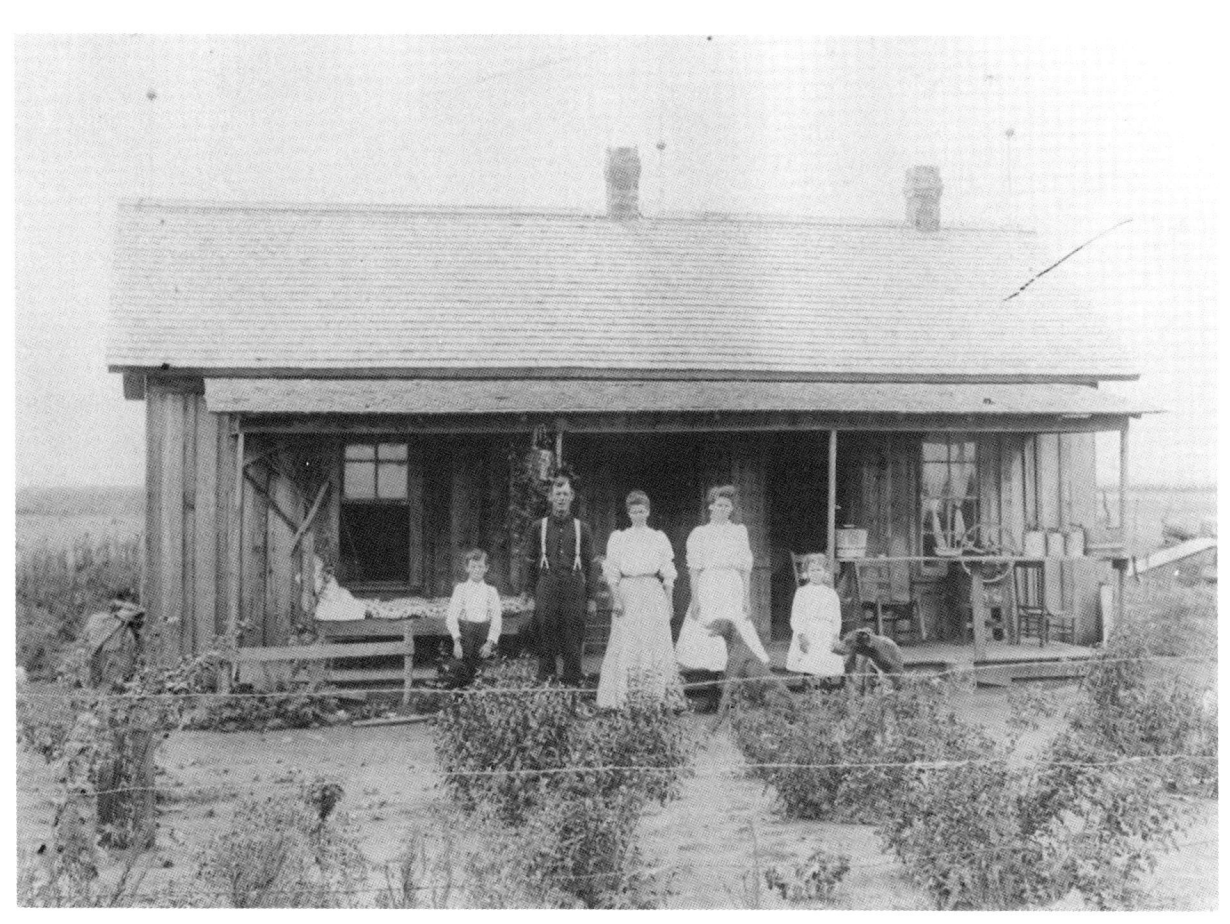

When It Seemed Easy

A thousand weeds a penny, wages I made
chopping fields when I was ten. Daddy swore
I was lucky, ten hours' pay when he was eight
an extra biscuit after sweating and sore
on his poppa's rocky farm in Arkansas,
often a belt to his back, a cotton sack
on the dirt floor for a bed. *Right*, I thought,
and miles uphill both ways to school and back

barefoot in blizzards and twenty feet of snow.
I watched loud freight trains roaring out of town,
trucks on the road, cars with places to go
and kids my age riding with the windows down.
I raised my hand and let rain slap my face,
cool after my daddy's nicotine fists
last night, kerosene lamp sputtering haze
in the Texas depression. Heat burned the mist

to rash and sunburn. Rocks dulled the hoe,
pigweed thick as my wrist, chop and chop again.
Sometimes, with tall weeds falling in the row,
I called *Timber!* and leaped back, laughing. Then
sometimes, a slither froze me, rattlesnake
locking eyes with me, and inching away,
waiting somewhere in shadows. Long summer days
I chopped and chopped until my shoulders ached

and bulged, swearing I could hack down a tree
with such swings. Puffing, I stared at level fields,
miles of nothing but cotton leaves to see
in rows always alike, while boys like me
after school played ball and yelled themselves hoarse
or sat inside the Cactus, sipping Cokes,
watching Roy Rogers ride a golden horse
called Trigger wherever there was to go.

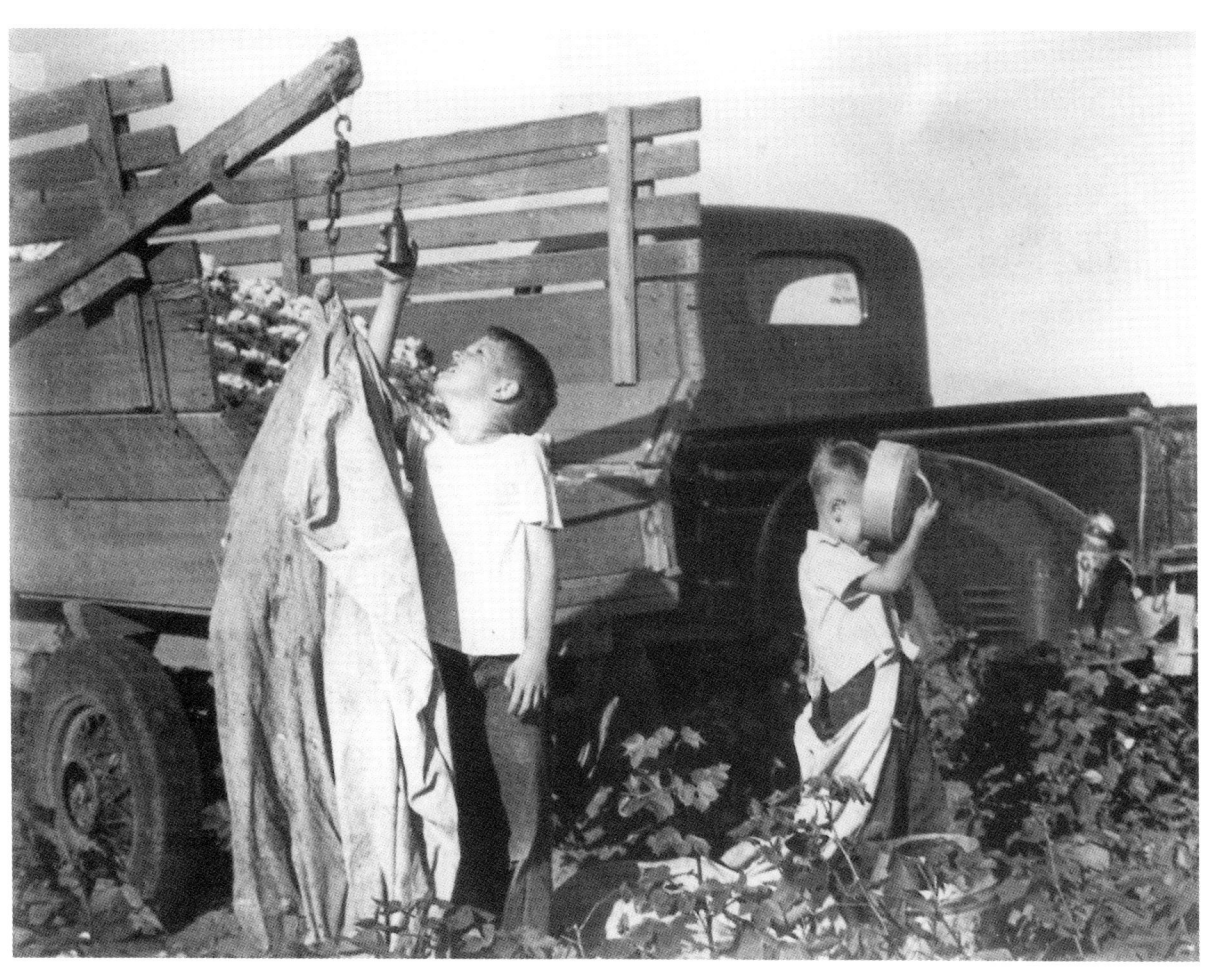

Spending the Night near Matador

Deep in the game preserve,
night coming on, I sit in the car
cursing a battery that crawled out here
to die. Did it hope to find dignity
dying far from its kind, miles

from the nearest town, no way to call
for help? The wind has gone away.
I haven't heard a shot since noon.
Thousands of mesquite trees
stand around pretending to be

green flamingos, their trunks
supporting ugly, skinny twigs
I expect to dream about tonight.
Dove breasts I cleaned at the stock tank
are bunched on ice in plastic

like a bag of hearts.
I would cook them,
but I have no skillet,
no fire but the car lighter,
and the battery is dead—

I would eat them raw
if it were dark enough
and I weren't mad
and didn't need the breasts
to buy off wolves tonight.

I've done nothing
but hunt in season. I consider
flashing my hunting license
to the nearest tree.
My sixteen-gauge is empty,

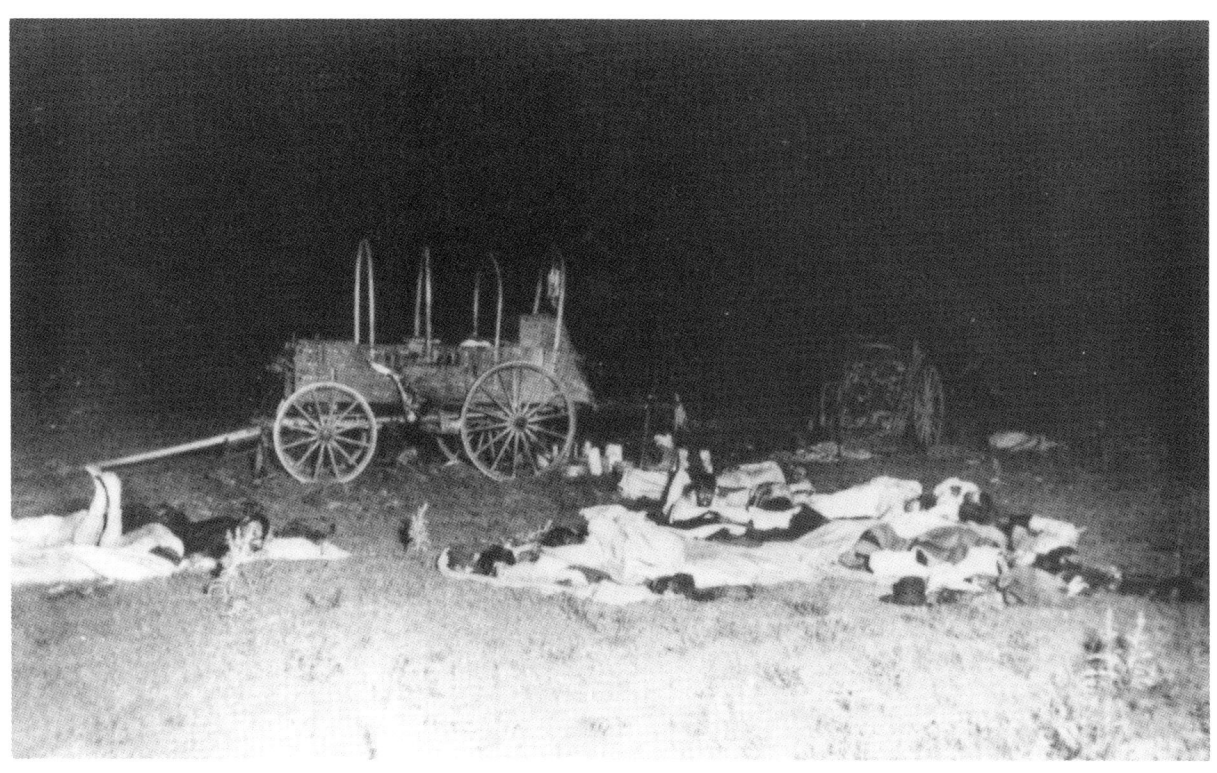

but there's no need to load it,
not under a moon this full.
I would try the battery
again, but I never disturb the dead
this time of night.

Nights around the Hi-D-Ho

Rats came and stayed, fattened by pigs
that ran off cliffs and arroyos, maddened by drought
or buzzards circling, feathers flexed like knives.
What makes wild pigs go mad is thunder, a sniff of bowels

burst by the sun—coyote or calf that wandered off
and fell. Too little rain for months, alfalfa stunted,
bulls sold at auction, the market for hogs like gold.
Feed them and leap back, snouts that crunch any rinds

and bones stuck in their soup, squealing and grunting,
butting each other for the deepest slurp,
the richest grease. We took turns shooting rats
with rifles, picking them off by flashlight

deep in the dumps of canyons, boys so far from town
we chased each other at night around the Hi-D-Ho,
back when Buddy Holly was a boy we knew in school
with wide-rimmed glasses and his own guitar,

school bus loaded by four, roaring off,
smoking, dumping us one by one by a mailbox,
leaving us miles from town under the widest sky,
years before children and the death of friends.

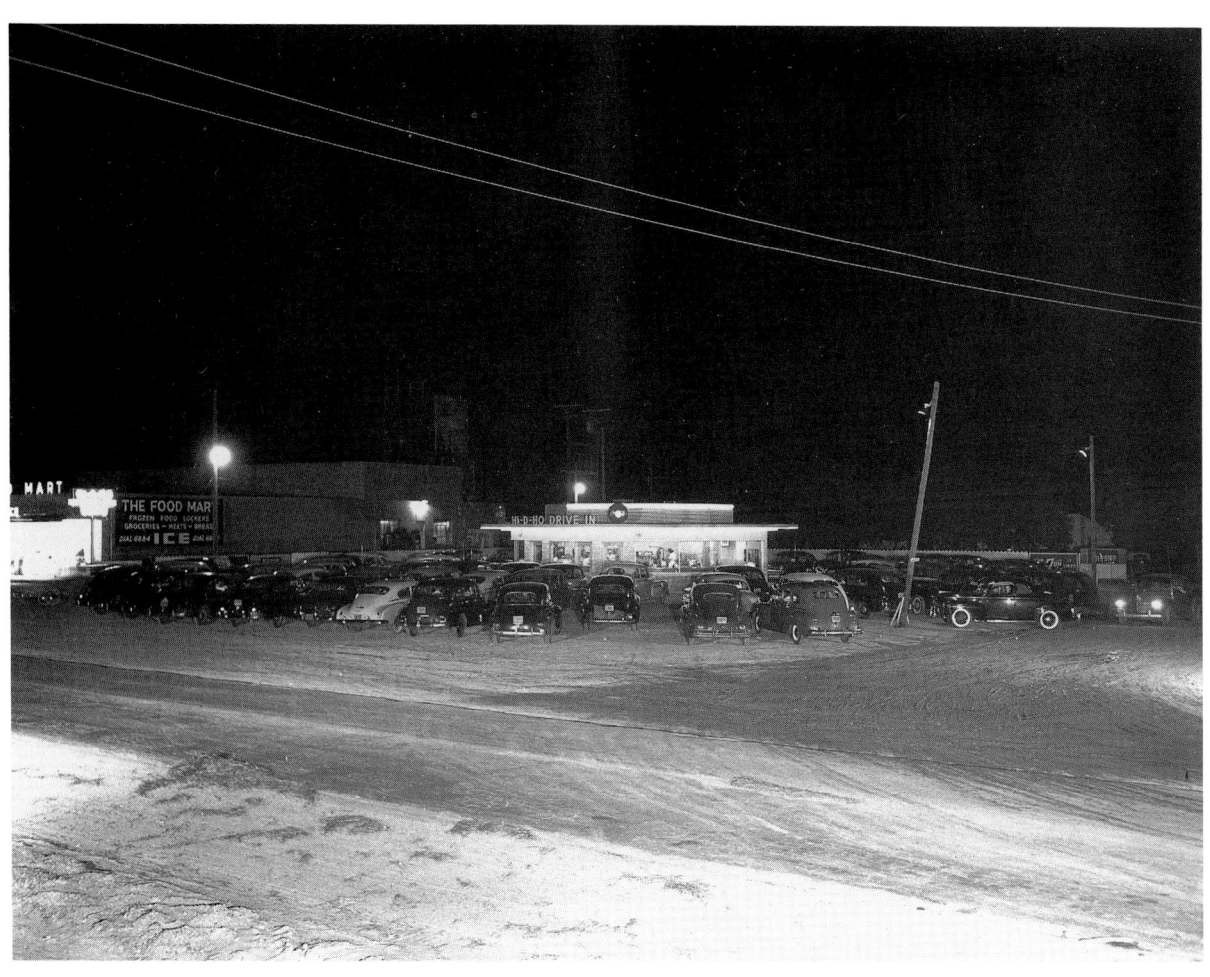

Sword in the Cottonwood

Uncle Oscar lashed another rattler to his saddle,
St. Patrick of the badlands, saving his calves
to fatten for the slaughterhouse. Oscar taught me
to rope and ride in that valley, a sargasso sea of grass.
He almost lost the ranch after World War Two,

gambling and brawling. Great-grandfather
had settled that canyon after the Civil War,
rammed a cavalry sword into cottonwood bark
and settled down, mastered the fence and plow.
A dozen graves fanned out around that tree,

family I never met. I never saw the steel,
the haft broken off, blade nowhere to be seen,
although I saw it drawn in a warped Daguerreotype,
a bearded stern-eyed captain with a sword.
Uncle Oscar swore it was there, the sword was there.

I rubbed my thumb along that trunk, the warped,
dark bulge of bark. But Oscar died childless,
his ranch and cattle sold to settle gambling debts.
I watched the land chopped into city blocks,
trees bulldozed and burned. Years later

when I drove back to the ranch, I found paved streets
instead of rattlers, a shopping mall
where coyotes had always prowled, where I had swayed
up high as a boy on wobbly cottonwood limbs
and watched the moon and fields I dreamed I owned.

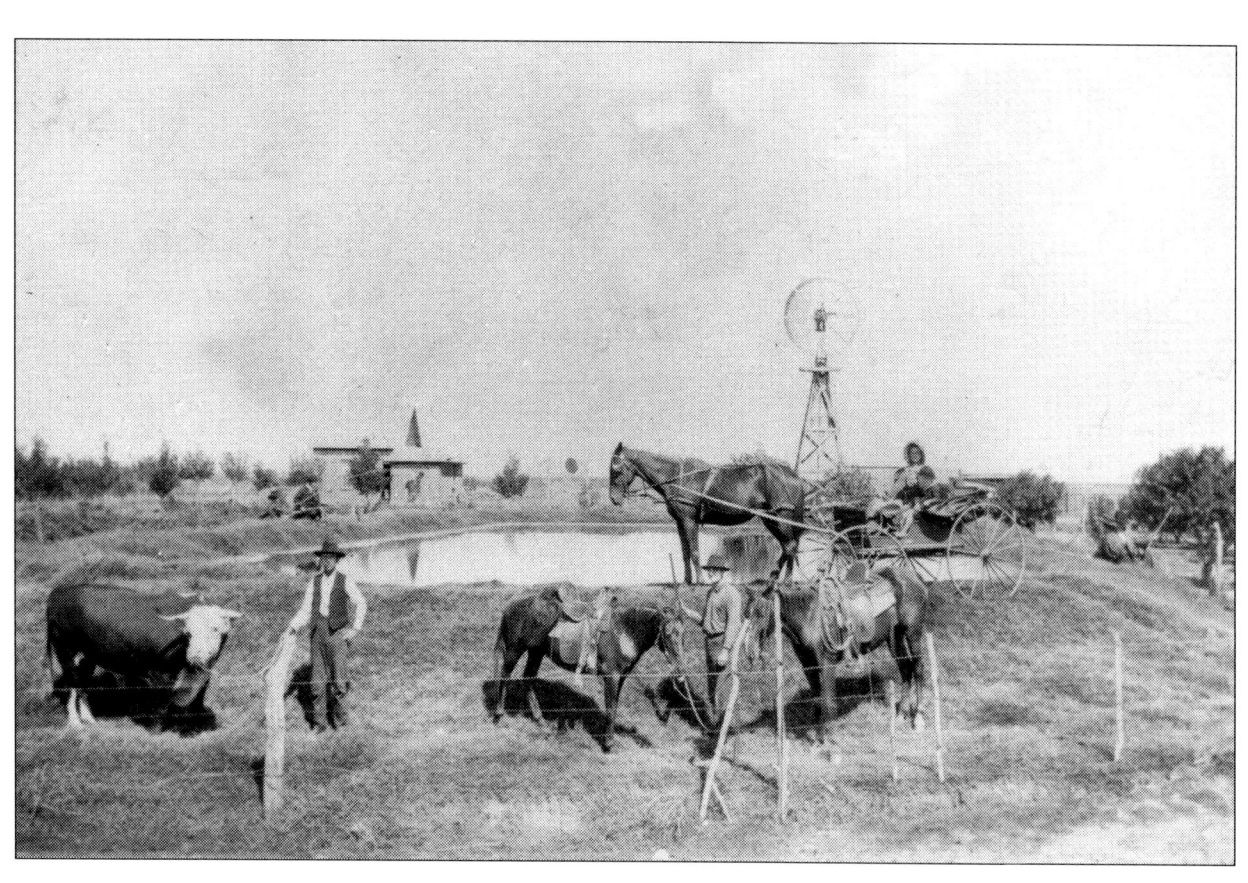

Rattler

Coiled, it's crazy and hostile, without a lawyer,
tail rattling like dice in a plastic cup. *Mine*,
its tongue flicks out, guarding nothing but rocks
and cactus, its eyes squeezed tight

nursing a grudge, alone and wandering forty years
in the desert, the loss of gardens not its fault,
nobody had to gamble the family farm on its advice,
its diamonds squeezed in the fist of its muscle

bulged and stingy like a gut, nothing but a mouth
with fangs and a knotty large intestine,
devouring all it can swallow, all it can kill.
I told my grandsons never bend down by a woodpile,

never go barefoot in cactus, but their Frisbee
angled off from the yard, wobbled and rolled
in the weeds. I saw them and hobbled, calling,
almost too late to save them, snatched one in each arm

and leaped back, panting. We watched the old pretender
coil and sway like a magic rope and squirm away,
head weaving from side to side, as if nodding
from cactus to cactus, *Mine, mine*.

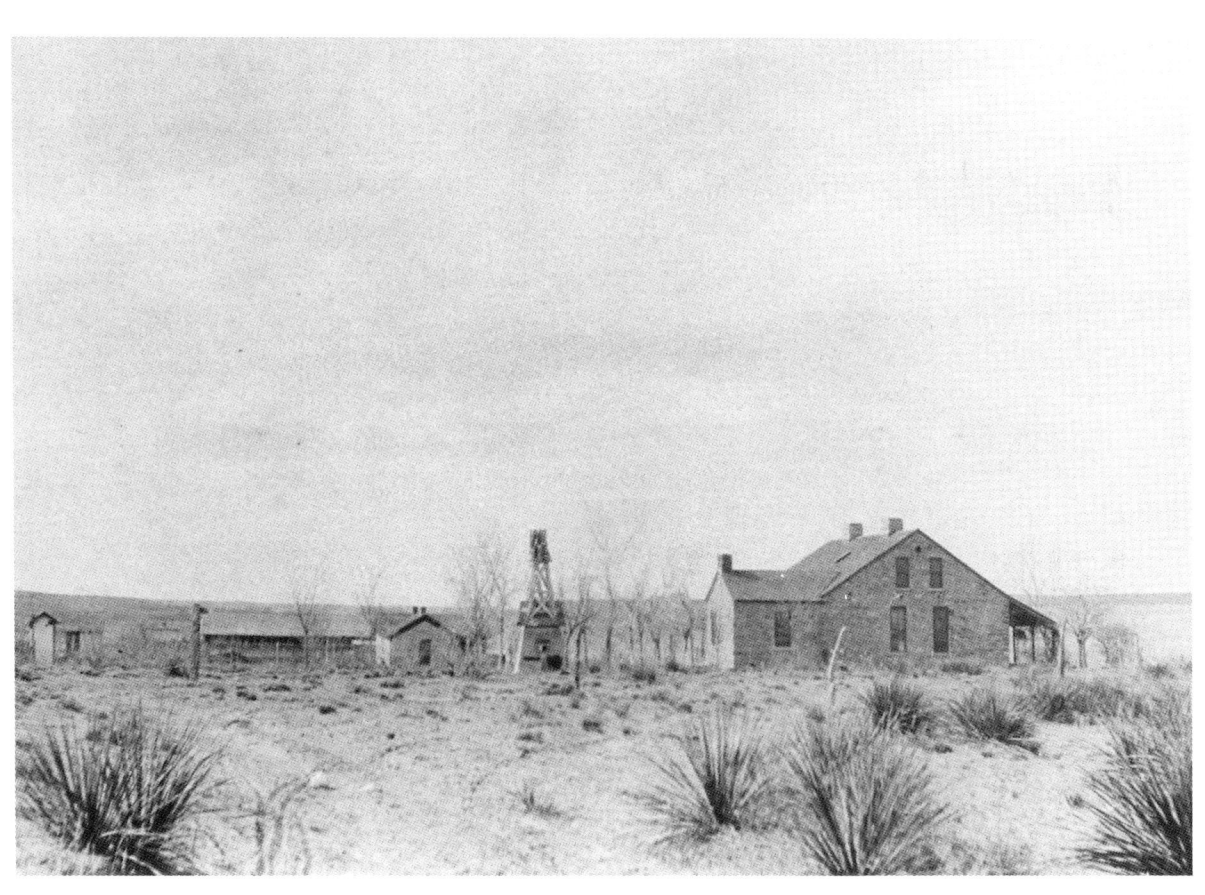

Hardscrabble Nights

A road rolls past our house for miles
and doesn't curve. Surveyors aimed it,
black as a Bible and seldom used. Home on the range
is a refuge, cool rooms to harbor weapons
oiled and locked. Clouds float by to wide horizons,
heading always away. Stalks and sheaves dry up

and still they come, parades of elephants and whales,
fat clouds that billow up and fade, a circus act.
Nothing claims these fields that doesn't kill,
coyotes and bobcats mainly out of sight,
panting under hawks gliding a last patrol. At dusk,
skunks waddle up, and coyotes lope after rabbits

crouched between cactus, fur giving them away
in a breeze vinegar-sweet with mesquite,
wind straight and useful as a road. Nights,
we toss under fans stirring our blood
like sauce. We dab and grapple on the bed
like in a rain dance, sweaty even in the dark.

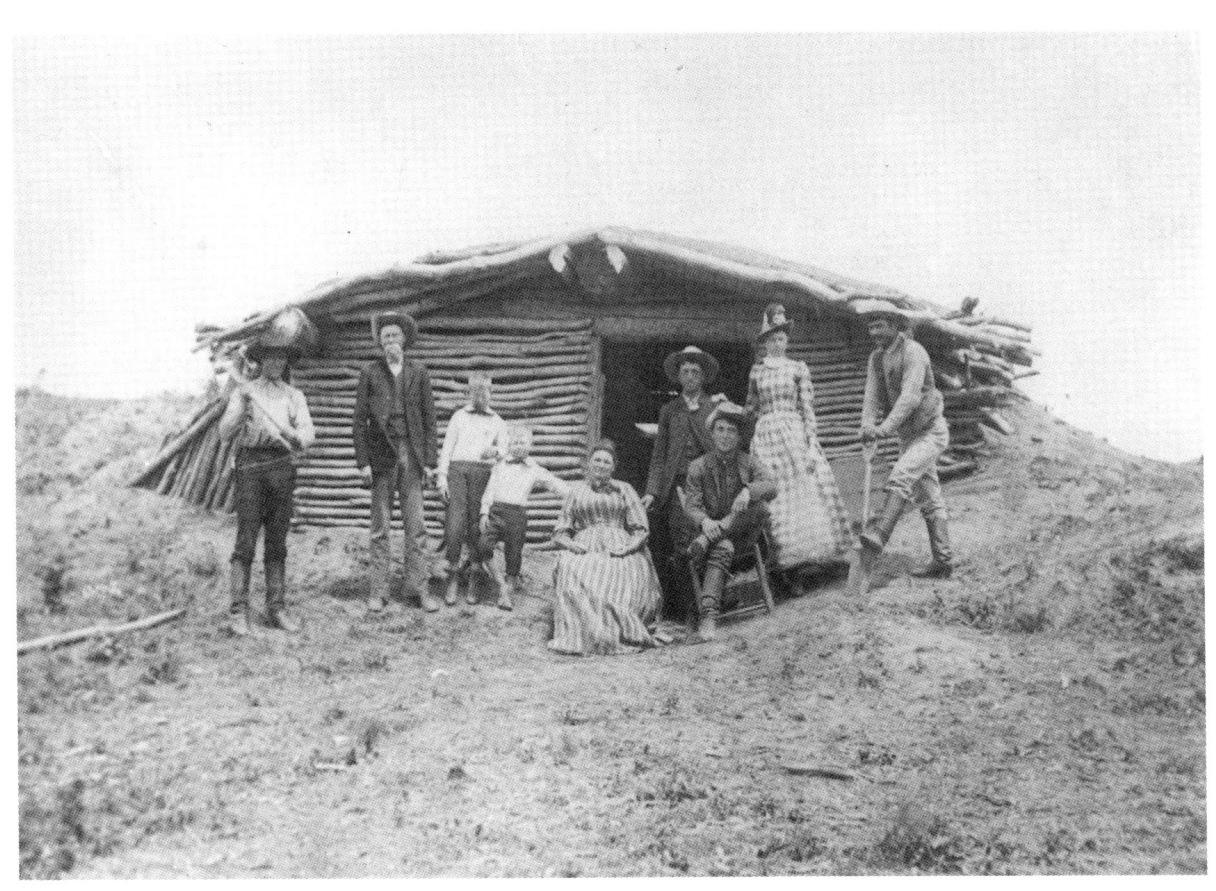

Sunday Morning Roundup

I guide my sorrel down a steep arroyo,
humming each crumbling step of shale, oil rich,
if I could afford to drill it.
I tell my mama's conscience

work is a virtue of godly men on Sunday
when starving cougars believe spring calves
are born to feed them. Better here
than in some high-roofed church with robed choirs

shouting Latin. I've sung this hymn a thousand times
and mean it, washed by the blood of the Lamb,
though I can't stand mutton. Red meat for me,
cattle and goats the only hooves I'd have

on prairies fit for scorpions. I let the gelding
climb back to the plains, following the dog,
nothing in that valley of shadows
but bones, not one spiraling buzzard in sight

and it's almost noon, time to stumble on a big cat
sleeping it off, feeling smug as a rich man
counting his barns. The dog stops and stiffens,
wants to bay but doesn't, breaks running

toward a weed-grown playa lake. Tapping the reins,
I gallop toward shadow, a flash of weeds,
and tug my Stetson tight against the wind,
lean down and slide the rifle out.

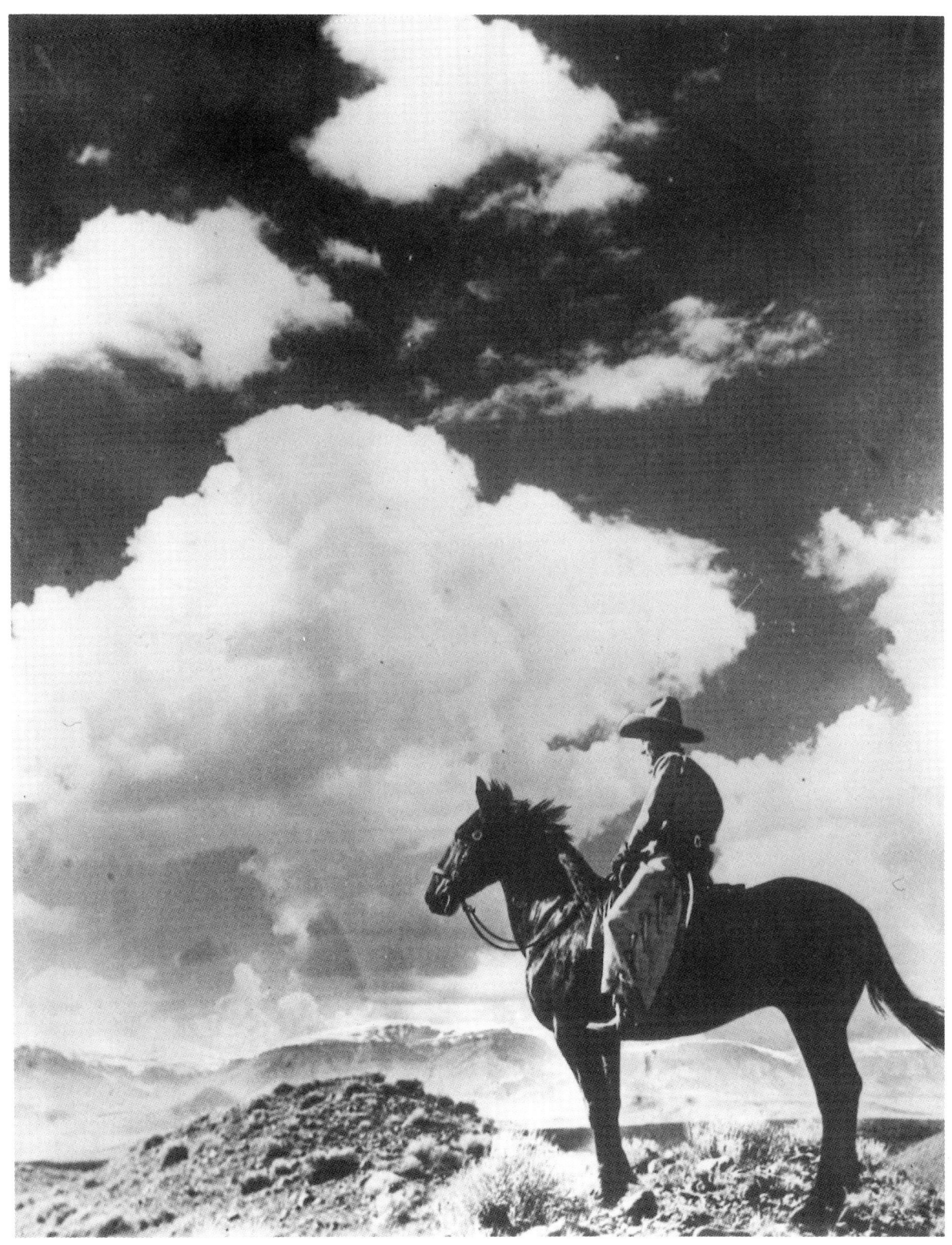

Uncle Ernest and the Endless Range

That boy with a red bandanna thought a horse
was all he needed, enough rope to hang from a saddle horn,
enough arroyos and strays to earn his keep

under a thousand miles of stars. A bedroll was the home
Uncle Ernest wanted at fifteen, black coffee steaming.
So much muscle and bone, his face bleached white without a hat

in this grainy photo, wide grin and crinkled eyes, a rowdy cowboy
twirling a rope. So many years reduced to this, a snapshot
stiff as leather chaps. Not much to show of a boy

caught bow-legged and swaggering, as if nothing could stop him
from riding wherever he wanted to go, not cactus or mesas
hazy behind him, not black wings wheeling in the sky.

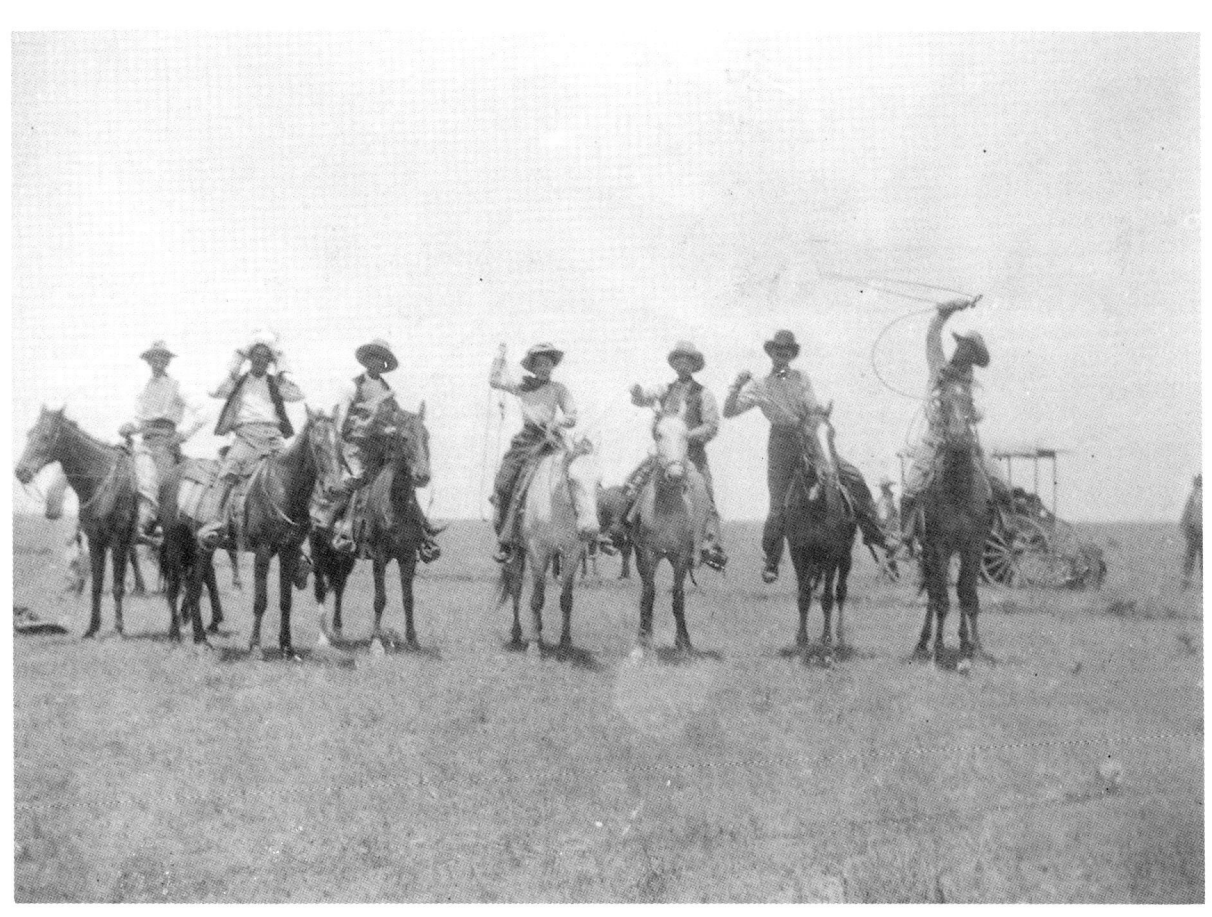

The Dust of Tommy's Toyota

Mirages shimmer on highways miles away.
Soon we'll see the dust of Tommy's Toyota
bouncing from mailbox to box. Jets
tow contrails, hawks glide across blue skies.

We gave our children thrills no carnival dared,
coyotes and cougars, rattlesnake roundups
with neighbors, a billion stars. They moved
to cities that shine at night like Oz.

The hawks are silent, soaring for hours.
The old bull blinks and tries to sleep.
We take our time, knowing we could rock
forever and never escape from fields so flat

they're ours. We live for letters from Oz.
The last thing we need is a holiday for Tommy.
But here he comes, dust swirling
behind his rattling Toyota, windows down,

radio so loud a singer sobs as if kidnapped
down a road that disappears in heat waves
shimmering like lakes so real
only hawks would swear they're not.

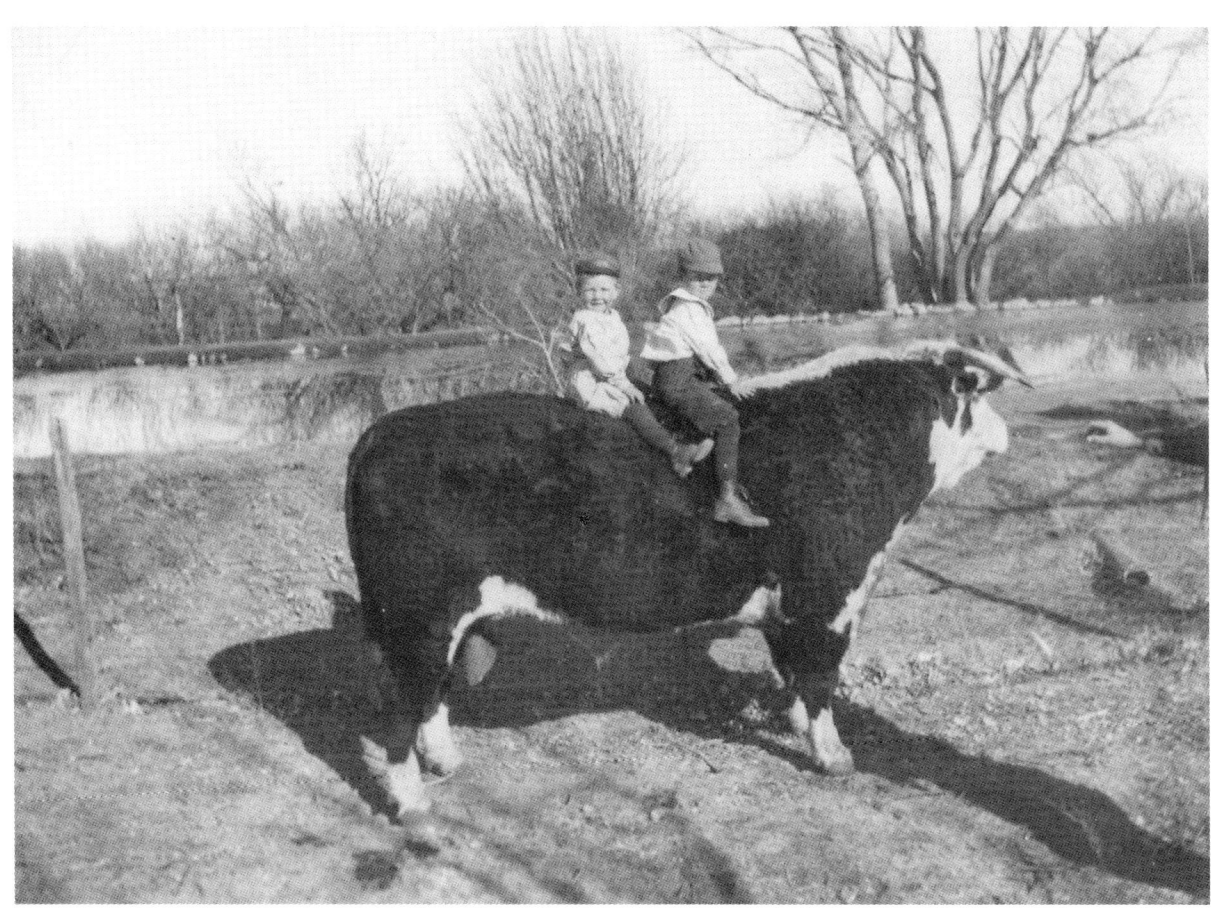

Turning Thin Shimmer into Wells

Not high in bitter-sweet woods frozen white,
but down on the cracked, boring alkali
is where magic happens. We haven't seen
a cloudy sky in months, a glimmer of heat
like lakes in the distance. How does faith grow,
a river shimmering between saguaro
and hearts dry as tongues? Fists dipped in water,
hardscrabble facts. In the Rockies all winter,
snow falls like God's own rainbows changed to ice.
See it sparkle and fall like paradise—
magic, all right, easy, dependable,
changing before our eyes, and bountiful—
snow, the long arm of God. Before the war,
we raised babies there, peaceful and bizarre,
forever Eden in a million pines,
cascading streams and loaves of bread and wine.

Who could bear to leave that land of eagle
and avalanche, always the same? We've seen
old friends turn old: years passed in casual blinks,
like crones in *Lost Horizons.* Now, along all streams,
Don't Drink the Water. No, where earth is sand,
where cold is only dawn, where dry hardpan
burns feet even with boots—here's where we'll stay.
This world is charged with scorpions and snakes,
the thorns and rot of cactus, metaphors
for death we learn to water and ignore.
Prairies were never Eden, even when it rained.
Museums uncover broken bones and grain,
mammoths and massive bears, the people massed

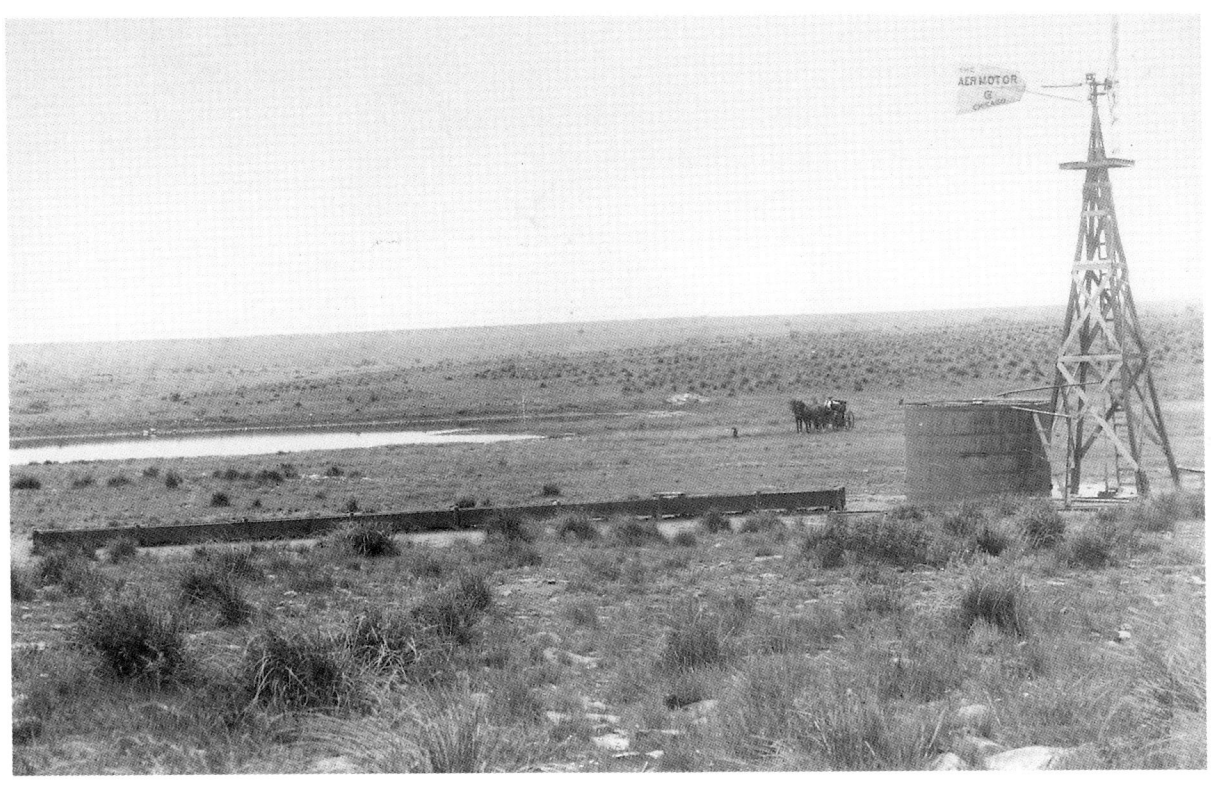

but terrified, before iron. Home is grass
and thorns, as far from snow as Xanadu.
We hold each other, nights, while boulders cool.
We hammer metal vanes and sharpen elms
for frames, turning thin shimmer into wells,
windmills drawing the splash from sand
for cattle in this desert barren land,
more than we'd hoped for, accepting what's here,
briefly, with faith, before we disappear.

Home on the Range

Behind the pose, back of the eyes
inviting little boys to smoke, our Marlboro son
will joke about his Corvette stalled
in a Brooklyn parking garage,
his lonely Appaloosa

back on this wide Texas range.
I taught our children that look, heaving them
over rumps into saddles—no fear, kids,
no worry, Dad's here beside you
on a stallion. At dusk, after chores

our children used to do, my wife and I
walk past the wide corral, past the barn
to a wicker swing hung on chains
in a red oak. Hawks glide
in a hot breeze drier than any smoke.

Summer on the plains is blue
to wide horizons until they blaze,
fireballs bulging massive
as nights draw down the sun.
We rock and talk softly in the dark,

no one around for miles, and wonder
what will happen to the ranch
and moon if our children choose
to live in towns a thousand miles away,
what will the grandkids do.

The First Hard Thunder of Another Dawn

Wife, I wish you'd open your eyes, shove back
the blankets you pulled even last June, wake up
by these windows, even if it takes four cups
of coffee and an hour of silence. Come,

help me watch the dawn, those floating layers
pearl white and almost black over massive thunderclouds
in the west. All clouds were pink minutes ago,
mesas across the plains distinctly pink,

a hue you taught me to see. I've seen them all,
all we ever saw, mule deer and skunks, a trotting coyote
and a prairie hawk, and it's not even six,
cold coffee in my mug. That fat blue jay came back,

as always, plopped hard on the deck and squawked my name,
begging to be fed. Robins, a pair of cardinals,
the saucy male like the brightest red of the sky.
I watched him pecking tidbits from the grass

to feed to his mate, her quick wings fluttering,
her reddish-gray neck arched. I'm stiff backed,
craning to see whatever's there. If you were up,
you'd know the bones to rub, which muscles to knead

and squeeze. And now the prairie's silent.
And now I hear thunder the birds already heard,
yes, lightning, surprisingly bright. There go the deer,
bounding a thousand yards away, another slope

we measured years ago, climbing hand in hand
out of arroyos. Nothing stopped us,
not that earthquake thousands of years ago,
the crack so massive we imagined the crash

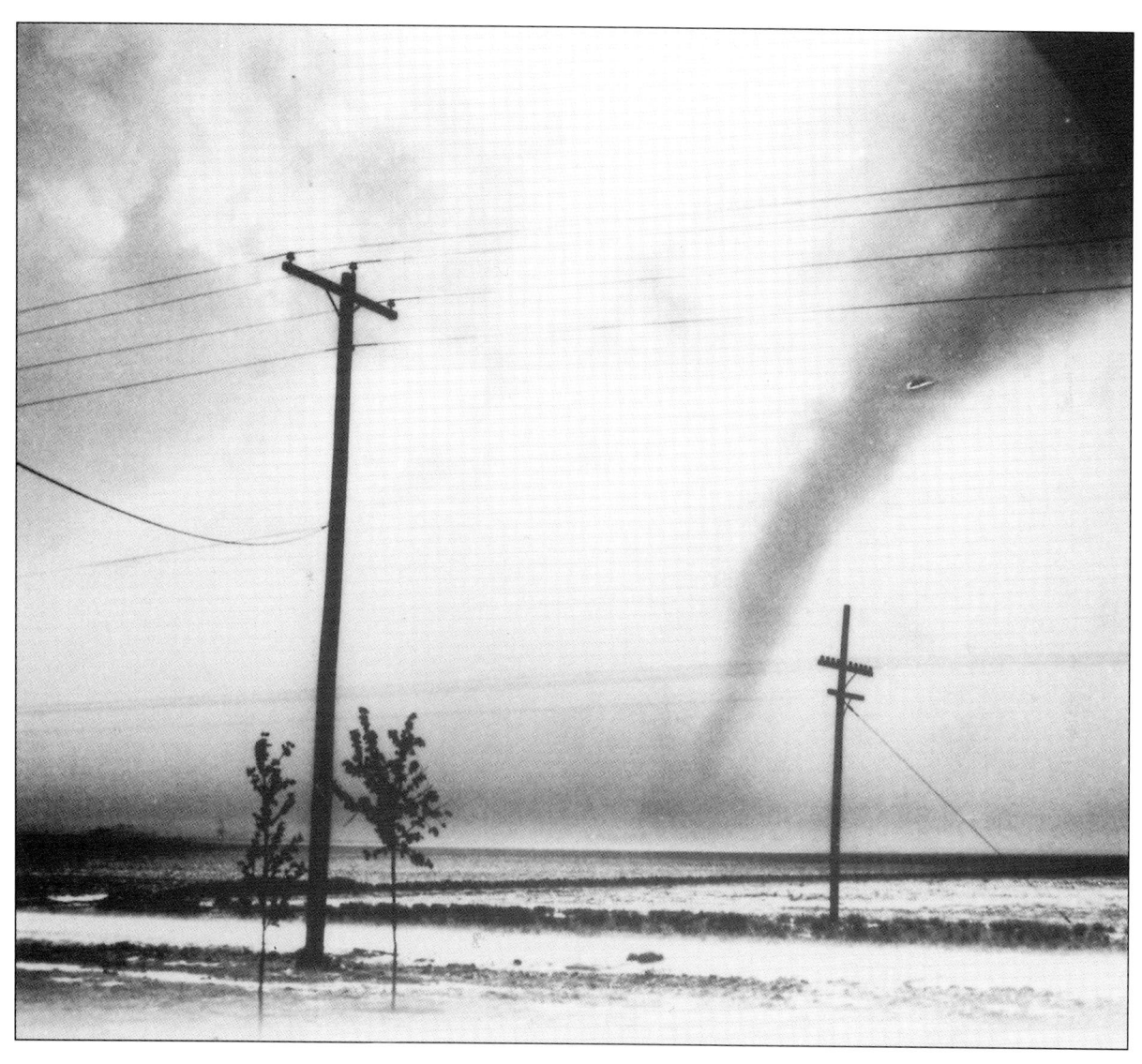

and roar of boulders bigger than us.
And now the thunder cracks and booms,
wind rattles the glass and slams
the blind cord back, back against the lamp.

All the Old Songs

This high, dry region is hot in summer, cold in winter and the wind nearly always blows.

Jim Bones, *Texas, Images of the Landscape*

The Waltz We Were Born For

I never knew them all, just hummed
and thrummed my fingers with the radio,
driving five hundred miles to Austin.
Her arms held all the songs I needed.
Our boots kept time with fiddles
and the charming sobs of blondes,

the whine of steel guitars
sliding us down in deer-hide chairs
when jukebox music was over.
Sad music's on my mind tonight
in a jet high over Dallas, earphones
on channel five. A lonely singer,

dead, comes back to beg me,
swearing in my ears she's mine,
rhymes set to music that make
her lies seem true. She's gone
and others like her, leaving their songs
to haunt us. Letting down through clouds

I know who I'll find waiting at the gate,
the same woman faithful to my arms
as she was those nights in Austin
when the world seemed like a jukebox,
our boots able to dance forever,
our pockets full of coins.

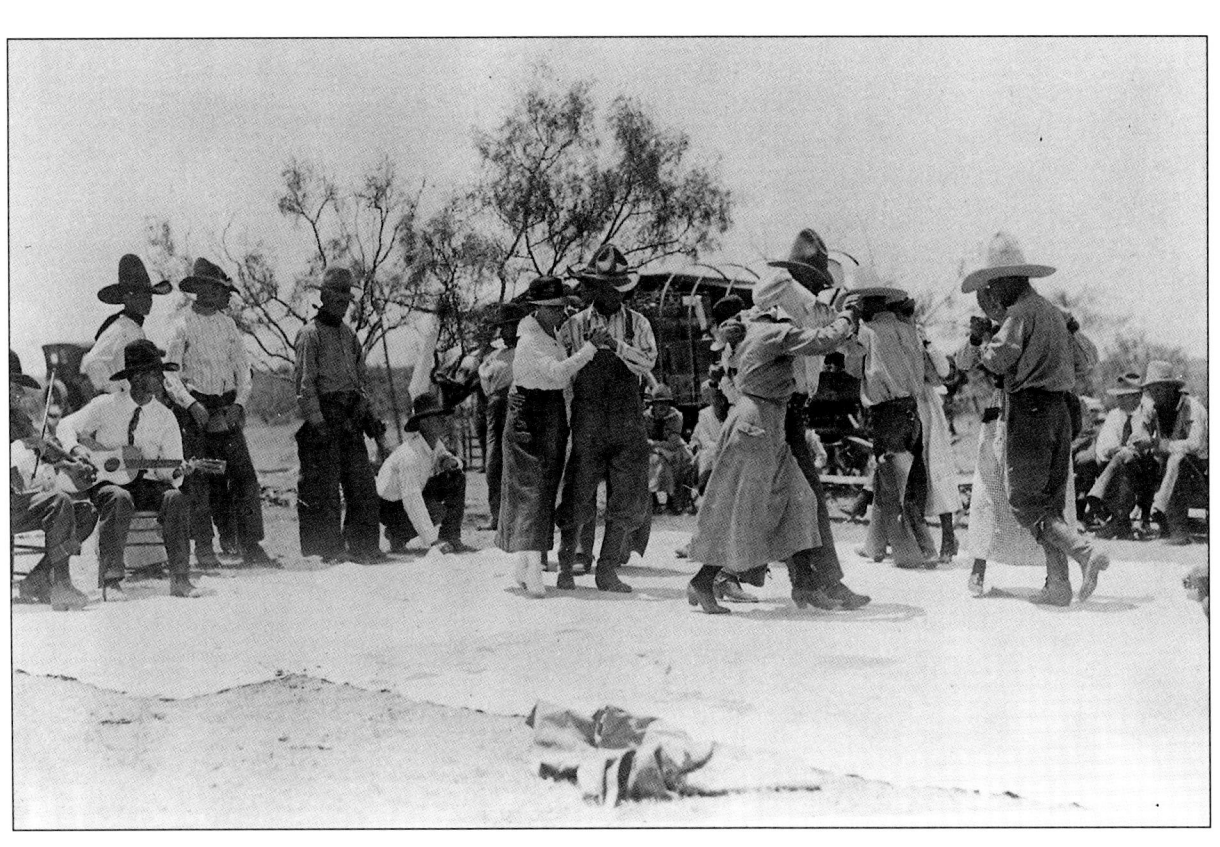

Fathers and Sons

Shoulder, hip, and boot he'd kick, then stirrup over
and sit that horse like a god, my father at dawn
on a gelding I thought was a stallion, if only
I'd known the words. Five times a week he rode off
on that great silver-blue, the only Appaloosa
in my life. I thought he'd never fall. I called goodbye
by the corral, shivering in a coat under the moon,
waving my hand-me-down hat at my brother, who waved goodbye,

riding off with my father to work. All chickens squawked
and came to the grain, pecking like prayer. All logs I chopped
splintered as oak does, the better to burn, as he taught.
Alone on the ranch with my mother, I stacked cords
and tried to ride bulls, just calves, but they hated to play;
no snow, but the clear day cold. At night under lights
I would hear them, coming back, clopping softly and safe.
I burst from the door into darkness, both men outside,

rubbing down, geldings tired and unsaddled, snorting,
dropping their heads. Brushes stroked the sweaty coats,
crisp bristles flicking sparks, hot horses munching
at the trough, the slurp and deep-bass crunch of oats.
I remember them mostly at night, my father taller, and boss,
but both men big as mystery under the moon and stars—
childhood a happy island before Pearl Harbor was attacked,
my father's last good winter with a son who rode off
to war on a battleship and never, never came back.

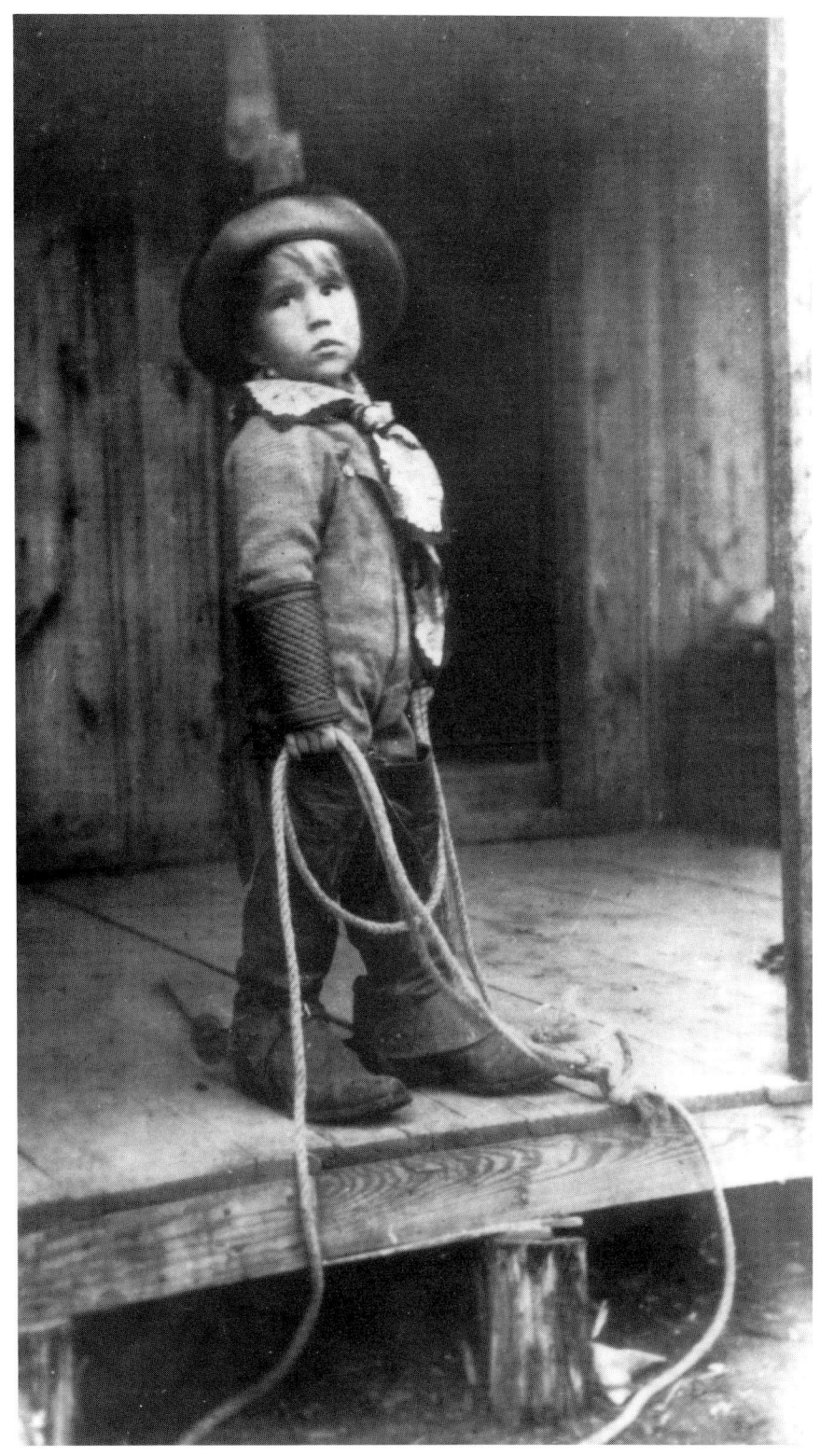

Before Flying Off to War

We kept that woman weeping shamelessly
on stage, singing in a sequined western dress.
No one ran to her rescue, not one stepped up

to take her hand. She died in song
in the spotlight, accusing our cheating hearts.
Her earrings flashed, the mike a weapon

she jabbed at her mouth stretched wide—
white teeth and dark vibrato throat,
red lips that drawled a long slow moan.

We needed her tears before going off to war,
her sobs enough to drive a sane hard boy to drink.
Our wives squeezed our fists for pity. Grumbling,

we ordered another round and slouched.
Moaning to hear her weep, those good
rouged girls leaned over and kissed us.

We clinked brown bottles to theirs
and led them boldly to the dance floor,
humming all songs as if we owned the bar.

For Friends Missing in Action

Taking off at dawn, I saw the snake
but didn't swerve, West Texas rushing
past my wings, falling as I climbed with a sigh.
Tucking the wheels up, I turned toward the sun
plunging up from Lubbock, horses and farmland,
snakes and rabbits squirming out of burrows.

We flew where we had to, boring holes in clouds
and spinning out of control to master wings
and rudder, trimming to keep us aloft,
sparrow hawks learning to hunt,
pilot training easy between wars.
Old pilots taught us to fly, heroes we envied,

saluted, but swore we could beat in a dogfight.
We swaggered and wore silk scarves, tossed
call signs to the skies like highballs,
trusting our fists and intentions,
believing those jets would save us,
those wings would bring us back.

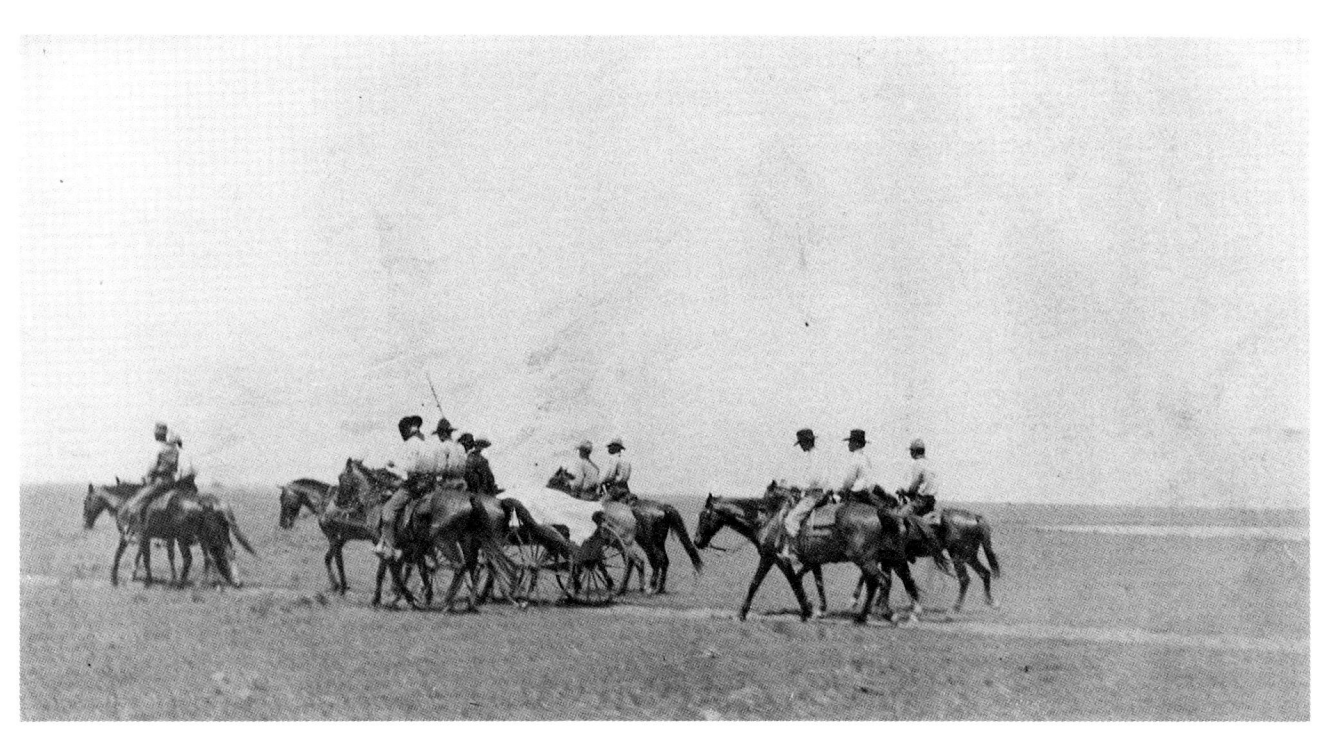

Sipping Iced Tea in Silence

Waves slap the shore
like babies patting their bath.
Corks bob and pop up for air.
Motorboats roar past,
dragging wakes. Miles away,
jets scratch the sky like diamonds.
Buzzards patrol the shore,
dragging their shadows.

Straddling a boulder,
we flick away the day for bass.
Here's where our children will fish
when their own are grown.
They'll cast and wait all day
if it takes it, or rock
softly on the porch swing,
sipping iced tea in silence.

They'll dream of their own
grandchildren, wondering
how many steps the baby took
last week, how many teeth
the toddler has. Like us,
they'll wind the years like string
and count the vapor trails,
the silver ripple of waves.

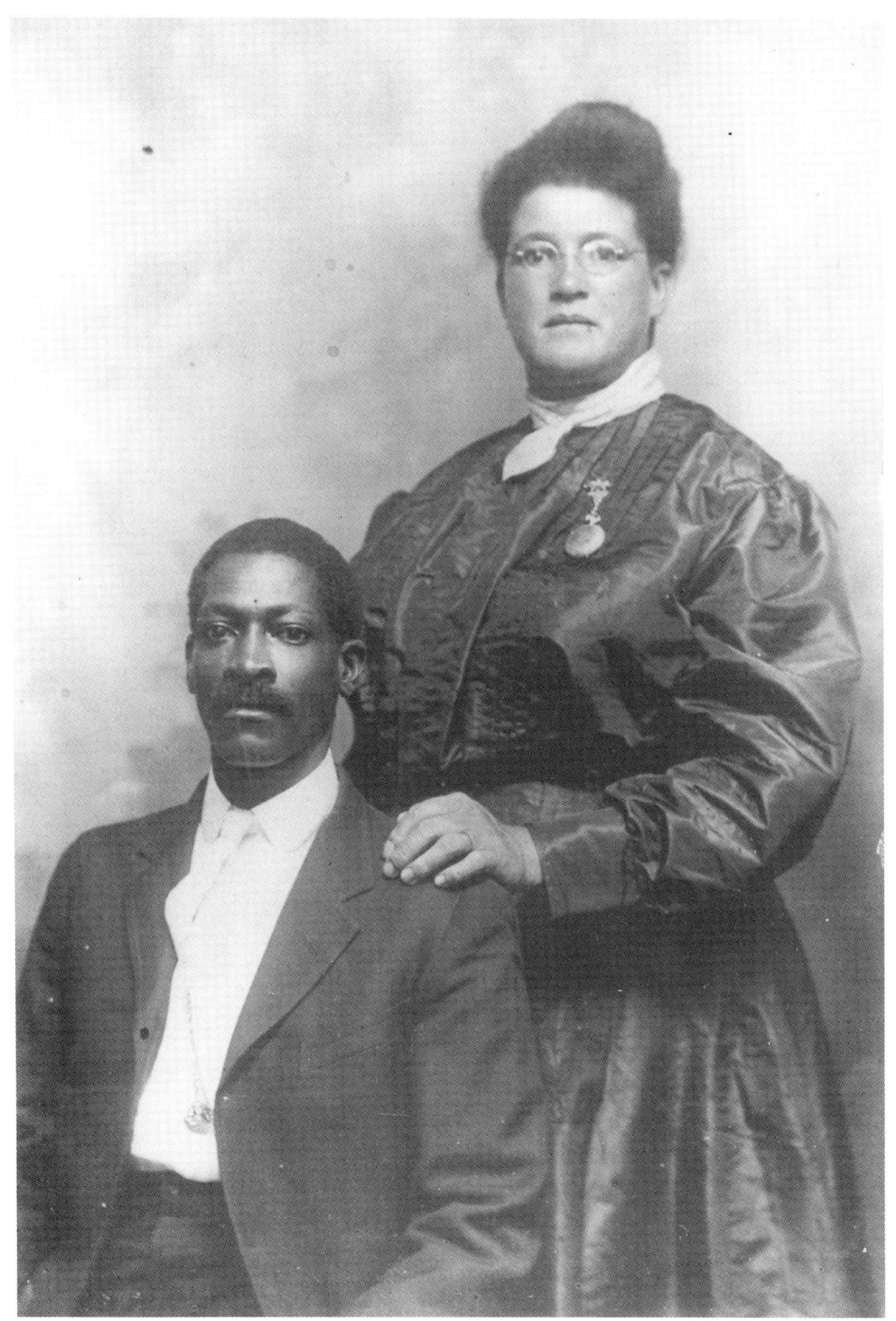

The Last Bale before Christmas

There's almost magic in planting. Full moon
or new, the plowed fields moist where drills
will drop the seeds. For weeks, my wife
counts jars of preserves scrubbed clean,
counts the trips I take each day to town.
Our children rise and leave their coats,

walk sleepily to the road for the bus
as they've done for months. The tractor coughs
and lurches off, groans no different to neighbors
passing by. By noon, I'm back, tractor parked
like a horse with the reins dropped.
I stop to wash my face and arms,

then go inside for an hour.
Truckers suppose we're having lunch.
After school, our children see the fields
plowed brown and never know, except the smell
of fresh-turned earth they'll learn to till
soon enough. In days, if it doesn't hail,

the dirt crust rears and tumbles,
the cotton's up. Strangers speeding past
catch flecks of green, glance, and glance again
at pale plants flicking by like spokes
of wagon wheels in movies spinning backward,
the cycle almost over when it starts.

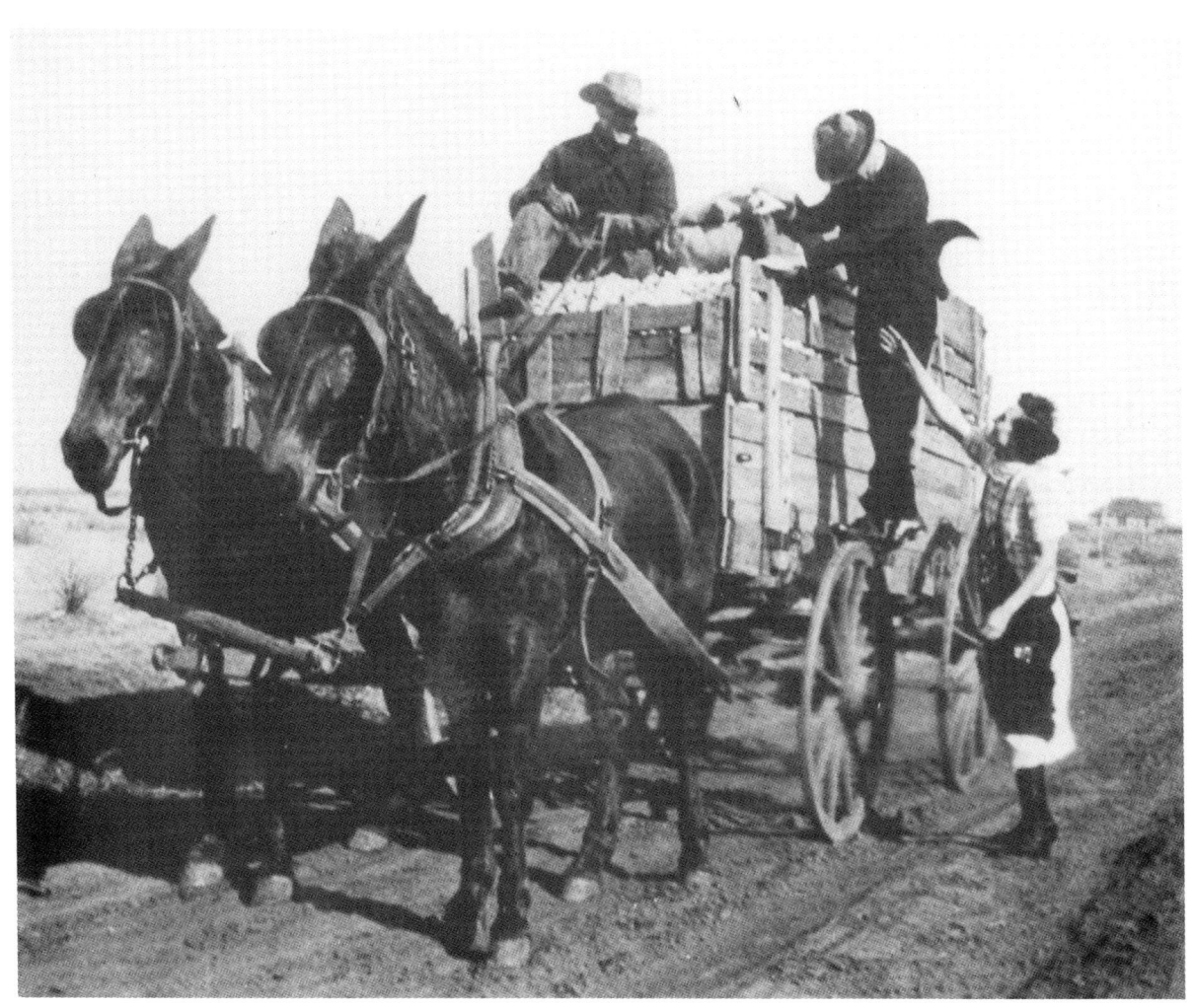

Learning to Live with Sandstorms

Spiders clinging to webs ride out the storms.
We trust these walls, the sturdy posts.
My father cursed the plains. He swore
he never saw storm cellars until West Texas,
tornado skies in June and fickle wind all year.

His Ozark sky was a tangle of light
through branches, forests so thick
he never dreamed sandstorms could choke us,
all Ozark rains distilled by baffles of trees.
On the plains, a glacier of dust piles up

and barbed-wire fences let it. Windmill blades
can't blow it all away, forever spinning.
Wind whips whitecaps on lakes
we could wade across, mirages in our fields.
Our barn and bedroom sink.

We shovel drifts to open doors enough
to squeeze through. Rock softly in my arms
and hold me, though, this fireplace ours
for an hour. Too soon, we'll sleep
without a breeze, no storms in the dark

to haunt us, no buzz or clatter,
not even spiders. Too soon, the windmill
will rest on the ground, at eye level.
We'll dream of dawn and grope for cords
to raise the blinds but can't see out.

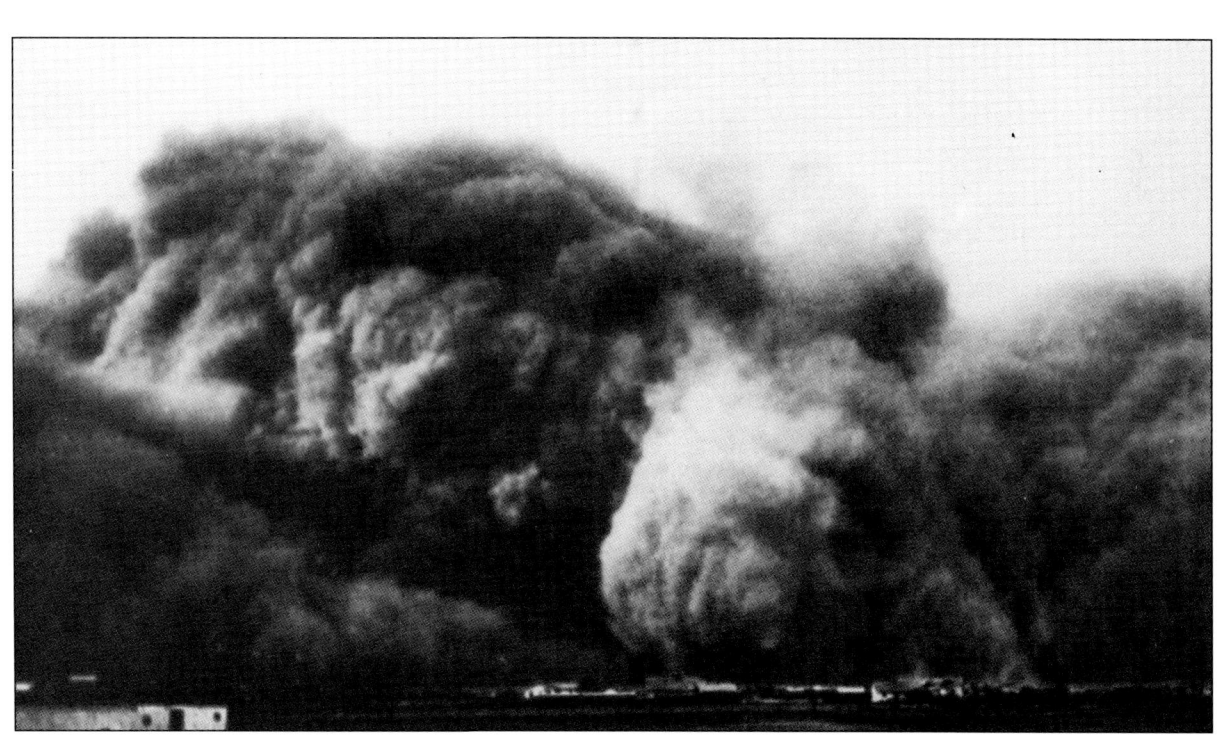

Where Seldom Is Heard

Tired cowboys when the wind is wild make music
with their ears. Slouched in saddles, they twist
their heads like antennae, picking up squeaks
like the twang of mouth harps, songs from Nashville
Saturday night. Hawks hear music all day long,
squeals of mice and tympanum of claws,
wheeling, gliding back to catch the song,
the slightest sound. I watch that goshawk

dive, one more sad song recorded with the eyes.
Rattlers go their own way, alone, flicking
split tongues like tuning forks. All prairie cries
worth hearing they can taste, tongues stiffening,
their fangs and beady eyes like crystal sets
they tune the old way, twisting between feast
and famine, rhythms of the heart, the breath
of cottontails the only song they need.

Coyotes make music on the moonlit ridge,
howls that turn their hunger into moans.
Lower, slower, others sway from the carriage
of legs, tarantulas haunting the shadows
of cactus, eyes below curved furry legs
that climb the skulls of cattle, where they drowse
in the echo chamber of the brain, laying eggs,
each needing at most one meal a day,
a little night music, a careless squeaky mouse.

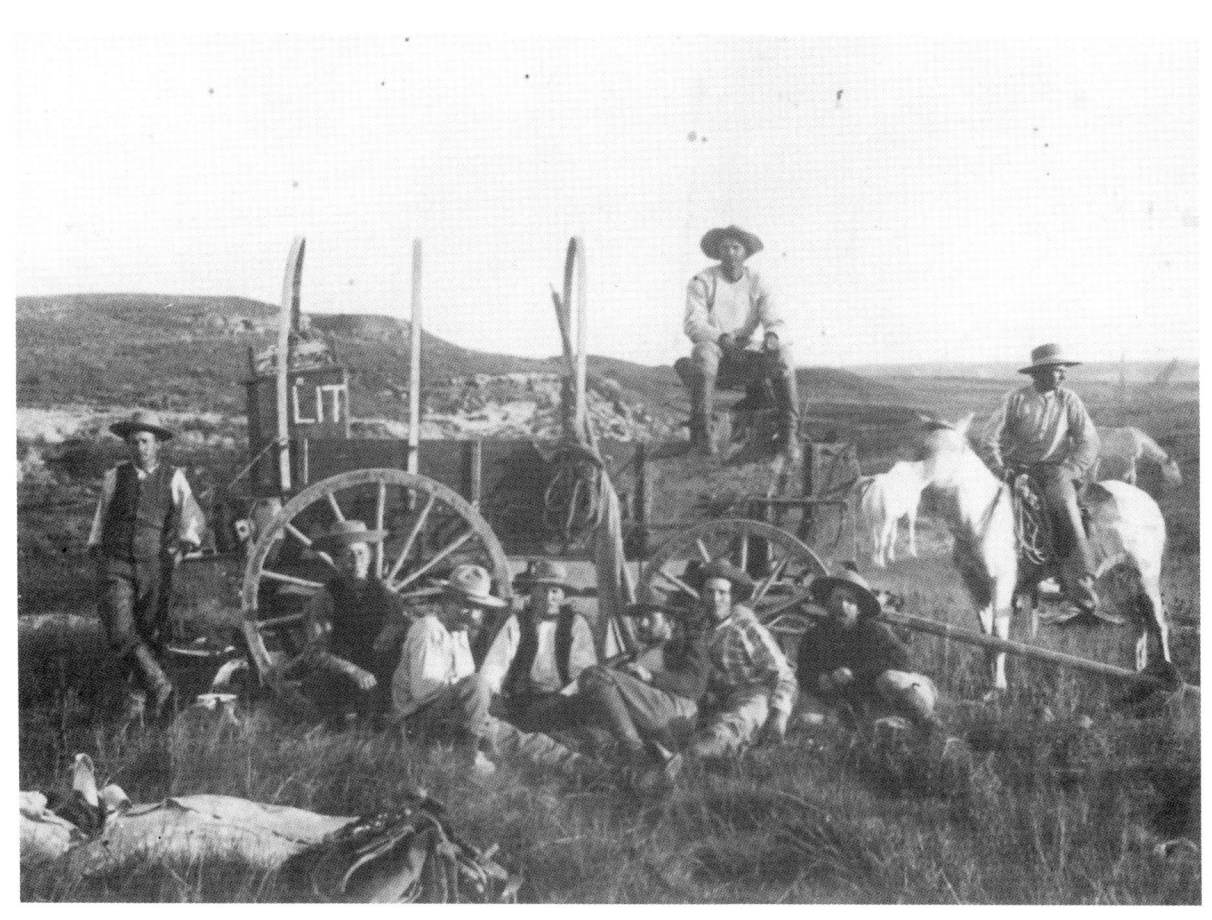

The Summer Our Grandsons Turned Twelve

When that old, fat black lab wobbled,
both of us stopped talking and watched him hobble
like a bull-beast nightmare staggering down the stairs.
Creaky, spoiled-rotten Dino plopped by our chairs,
blessing us both with sweet-sour apple breath
like some old monk's who knows all foibles

of the human heart, but rest assured, he loves us.
Five years after his brother died, sprayed by skunks,
battered by gout and fights with stray dogs,
he slept inside on winter nights, wheezing, our bodyguard
barking for sunshine. One black eye, scarred,
saw visions. Only the other, pearly blue, could focus.

Sleeping, he snored, kicking the floor like clubs.
How fast he aged, twelve years like months—a pup
when our twin grandsons kicked and stared at mobiles
hovering above their cribs, cooing and twisting
when they heard that happy, high-pitched yip,
the ball of fur we held for them to touch.

High Plains Drifter

After years of buckshot and sandstorms
a man turns sour, no more Mister Niceguy,
all grouch and red meat, *Dang,
why don't you dust?* Riding at noon
he hears rumors: women from town
ride over dunes at night with wineskins,
veils on their faces. Herding strays,
a man begs for tunes after days on the plains.

Cactus alone can't make a shade,
out hunting for supper. Killing takes timing,
leading a dove by the barrel
down a valley of cactus. Squeeze,
and the shot hurls hollow. Stunned,
the dove falls tumbling
down steep angles of the wind.

At dusty supper at campfires,
a man longs for honky-tonk songs
and women in deerhide chairs.
He imagines fiddles and strumming,
laughter and clinking of glasses,
locked in each other's arms. Rattlers
and coyotes circle the camp and lie down,
fearing the flames and the dancing.

Meanwhile, his wife has a daily affair
with the wind, southwest and lean,
the silent type, a whistler

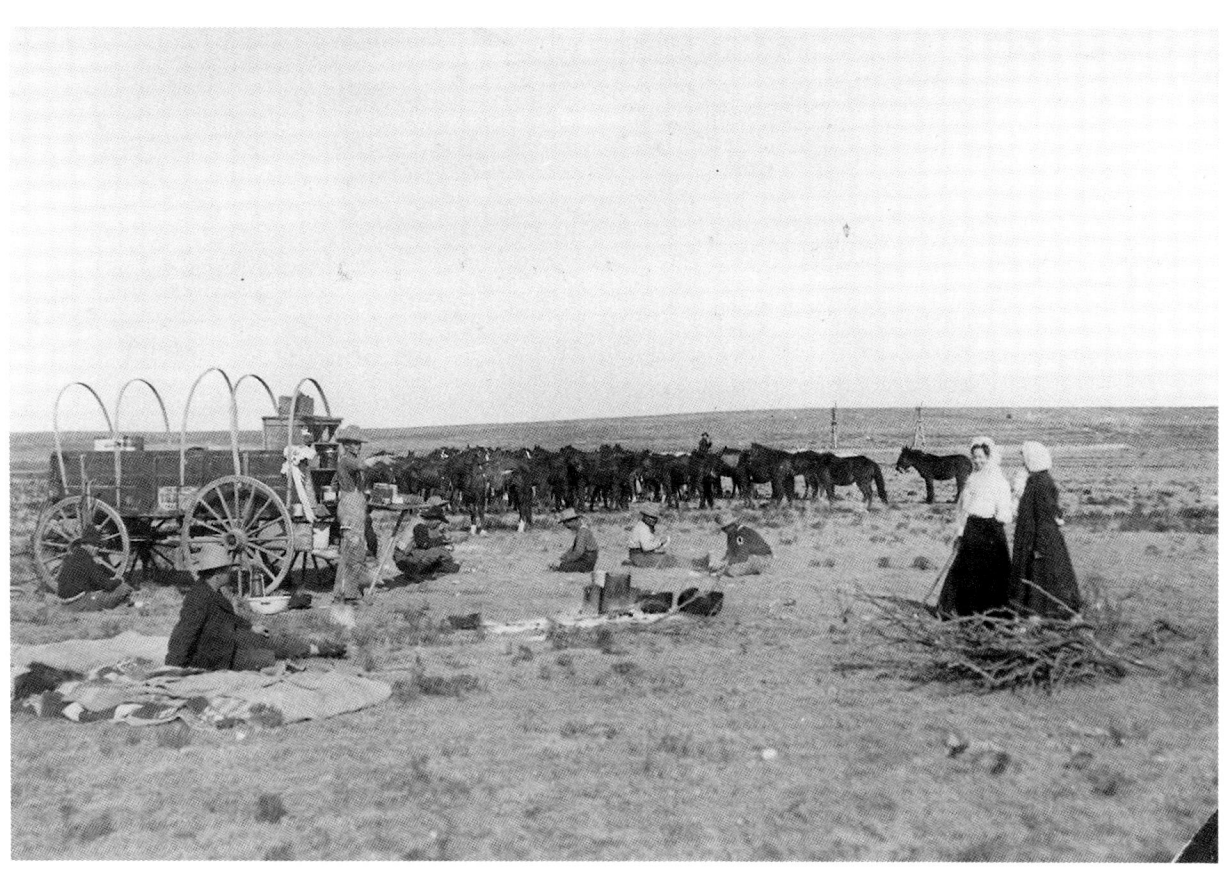

who taps on the glass,
slips in and strokes her hair
and sweaty neck. Slow as a breath,
he swirls her yellow curls
like corn silk, leans back and rolls a smoke,
watching her glossy lips twitch
and whisper while she dusts.

The Last Saloon in Lubbock

Bulky in coats, we hummed the old songs
badly after days of riding herd, barbed wire
and steers too dumb to know deep snow
could freeze them. We broke our backs for pay

to shove those swinging doors. At Earl's,
rouged women gave us the songs we needed,
the swing of their crystal earrings
pumping our blood uphill, a smoky dance hall

never deserted. Long mirrors lined the walls,
moose heads and posters of laughing girls
in feathers and red, stiff petticoats.
When Earl moved heads and all to Austin,

he left us alone in our pickups, driving around
and around. They've torn the tavern down,
another place we went to get away
from skies more lonely than ourselves.

Call it a call for order on the plains—
Tear down the honky-tonk walls, who needs them?
That part of me that needs a mob
drove by for weeks to watch the wrecking crew,

nothing but echoes of hard-voiced singers
and the clink of steel on steel,
not girls in spotlights moaning the songs
I longed for. They've hauled the last beams off,

only a bulldozed lot and ghosts with throaty tunes
and the flash of starry earrings.
Never mind the moon, the vacant field:
when I drive by at night, they're here.

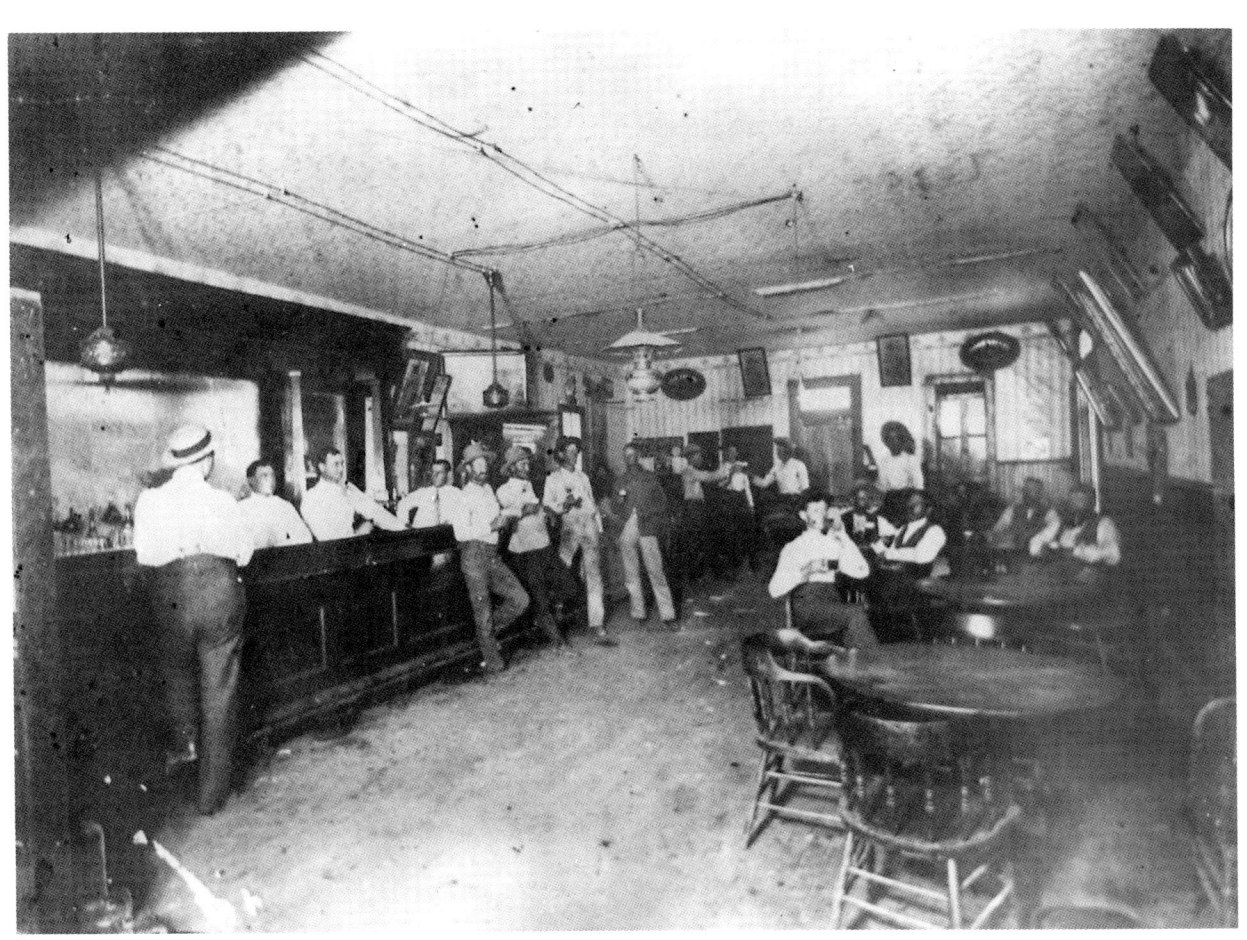

With Horsehairs Dipped in Oils

My wife's green eyes are jade and rainbows.
With horsehairs dipped in oils,
she brushes corrals and cattle on canvas,
the burnt sienna sand and pastures of our boots.
Combing October lawns like yarn,

we heap dry leaves on flames that float away,
always a breeze to make chimes clang
and jangle on the patio. Friends disappear,
and nothing we do could save them.
We store the rakes away from pups

gnawing our gloves. Rocking,
we watch them sniff the yard for bones
the old dog buried. We watch smoke drifting east
toward slow whirlpools of wings.
A neighbor's tin roof shimmers.

Prairie cattle go mad when the wind dies.
They stomp, lashing their tails at horseflies.
We survive hardscrabble drought
like spiders that spin their webs in wind
and anchor them to thorns.

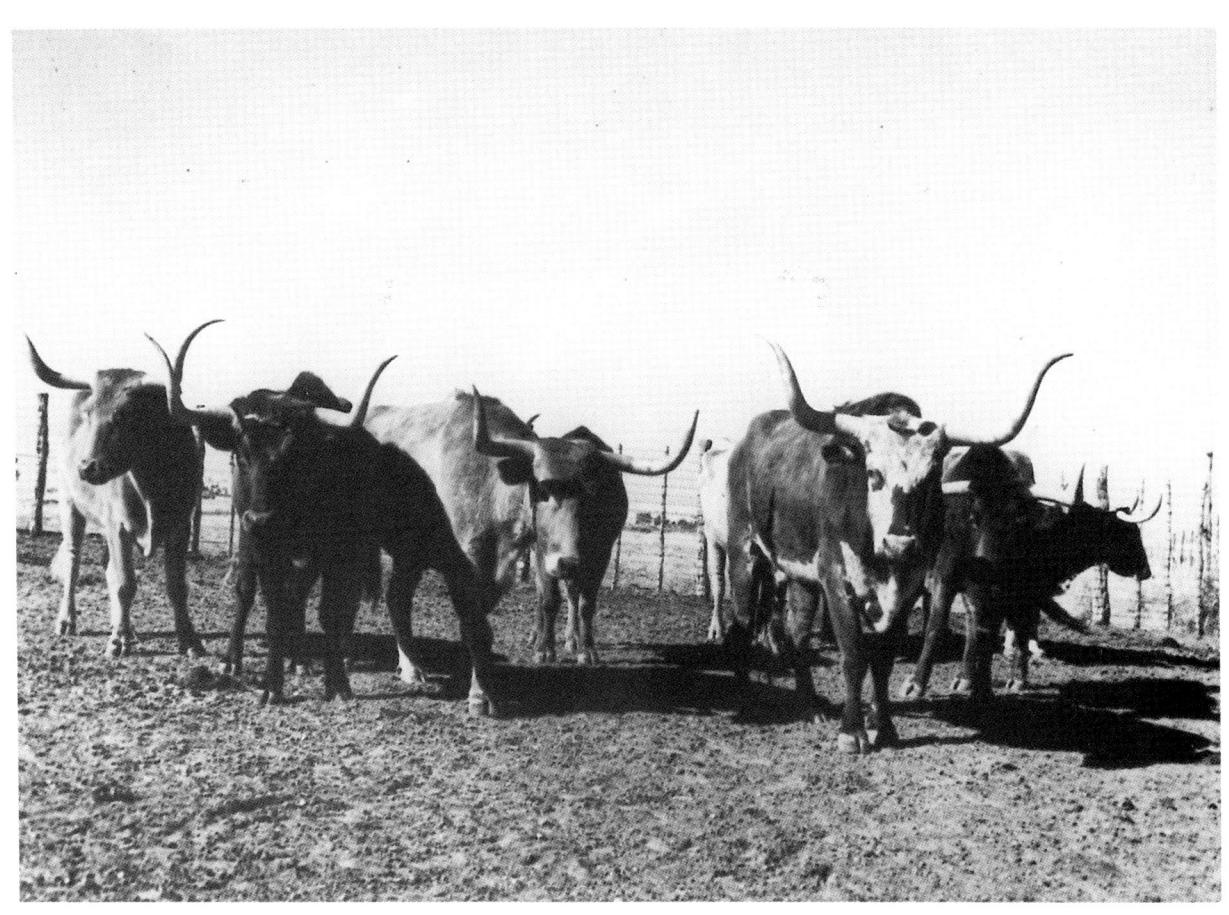

Granddaddy's Knuckles

Cotton spun from his blades, and grain
taller than men. He taught me to plow,
his rows so straight I could follow.
I believed whatever he put in the earth

would grow. When he prayed for rain,
it rained. Now, his plows have no answers,
parked in the barn. Granddaddy's grip
is there on rods rough as his palms

which swung me up to his neck.
I rode his massive shoulders,
plowing thin fringes of his hair,
ducking under beams of his ceiling.

When he tipped his Stetson,
hawks dipped their wings good-bye,
gliding on thermals. I touched his scars,
his leather skin like bull hide.

I asked how he learned about snakes
and coyotes, the secrets of owls,
why all his hair turned white.
Now, when I swing my grandson up

to my shoulders, he strokes my knuckles,
my thinning hair. Holding his arms,
I feel him leaning, staring at my face,
amazed I could be so old.

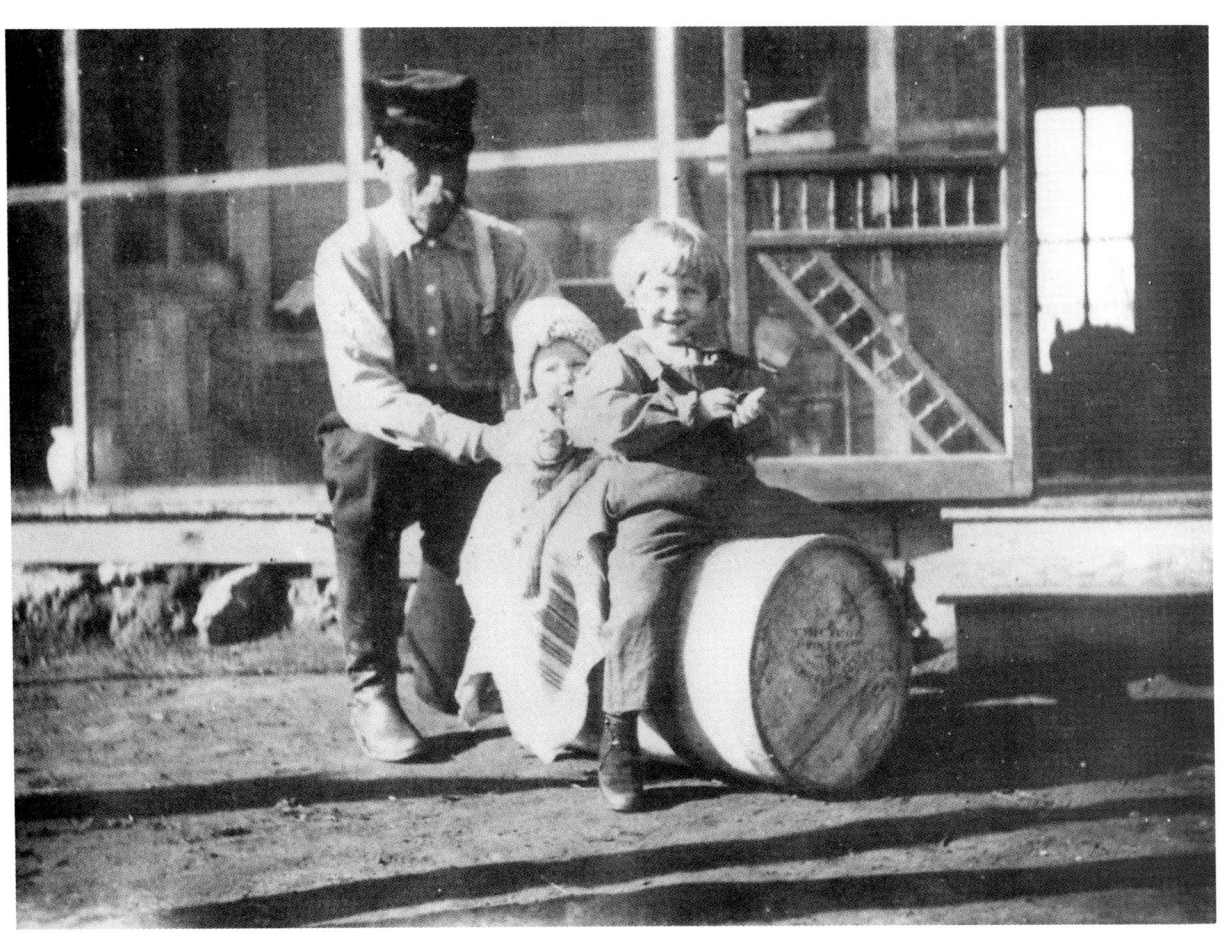

Rain Dance

Hardscrabble homes are dust,
silt in the windows,
webs in the drains.
For months, the only rain
was rumor, puff-clouds

like artillery shells
aimed elsewhere. Mornings,
we whisk oiled cloths
over all bed posts
and even the wood grain shines.

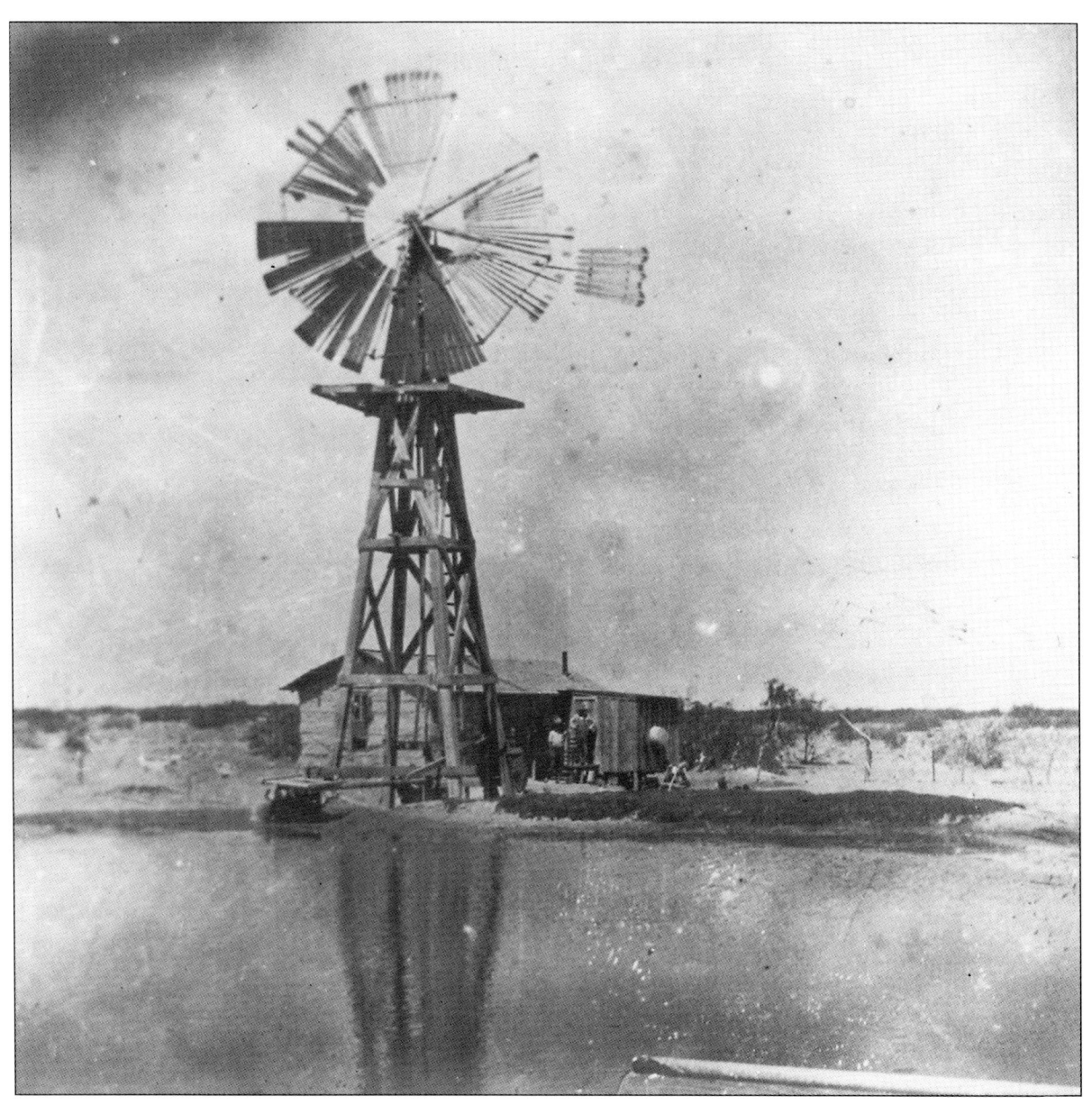

Saying the Blessing

I can't say anything new to children
on their own. They need my blessing
as I wanted my own father's love,
but nothing more—no roof

or weekly allowance, no easy advice.
I'd say it all again, abridged
and edited, if they'd let me,
convinced the old songs are the best—

the thunder of prairie rain,
the sober mourning of doves,
the joy of work in the wings
of hummingbirds, the holy Psalms.

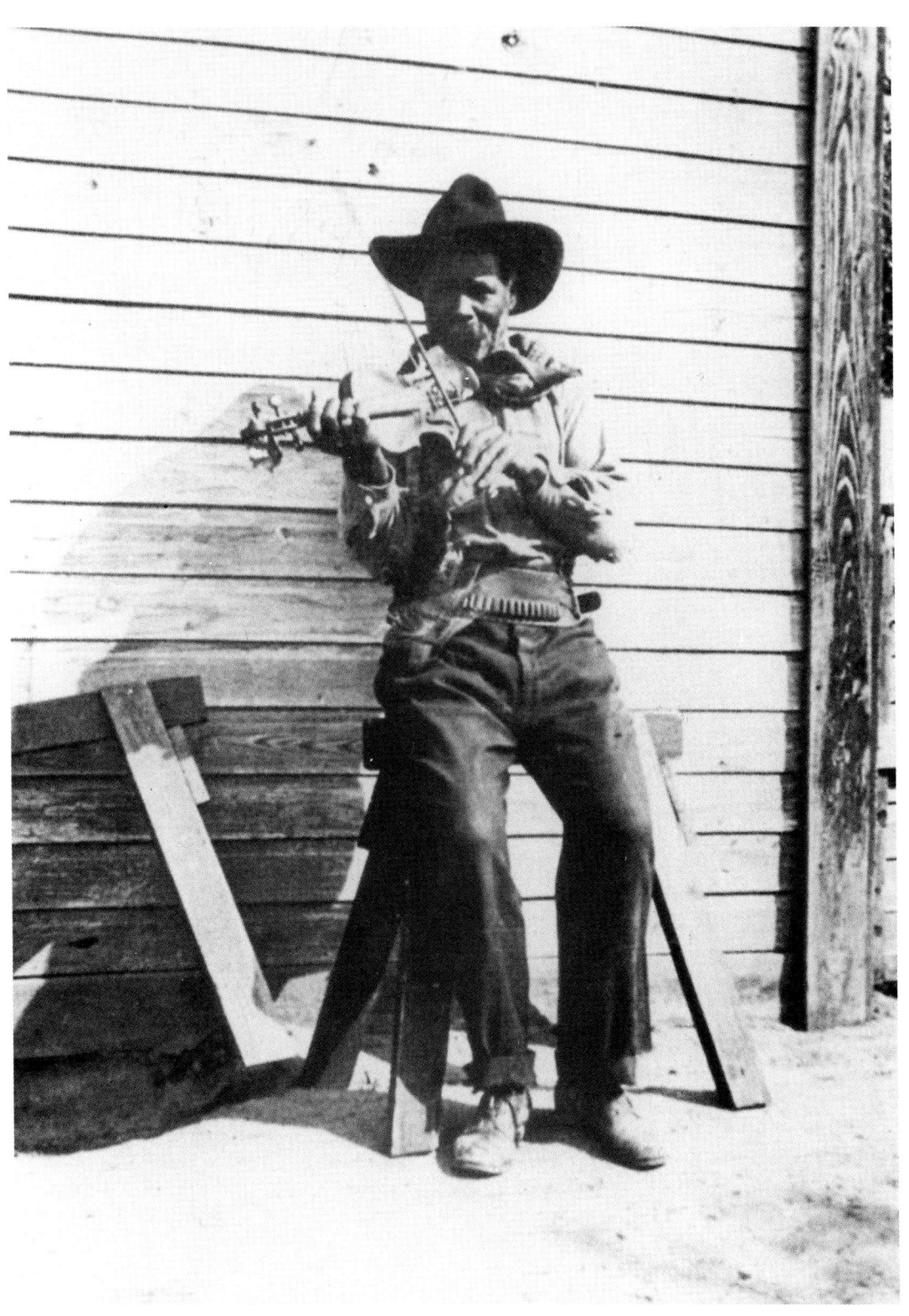

It's Still the Same Old Story

Often I rang her doorbell after midnight
in my mind, hat in my hand and hoping.
If a man answered, all hair and husband
in his underwear, what would I do?

Two years since she flew away, taking her name
like a house key. Coiled in an Air Force cockpit,
I fed on dials and dog fights, emerged months later
with a chest of wings, Caliban in blue,

highballs and takeoffs at dawn the way to strut.
Pilots worshipped the god called luck,
two-headed Buddha called throttle and stick,
power we wielded with our fists. I thought of her often

after lights out or alone at forty thousand feet. Once,
I cursed an engine fire at night, spiraled
and set it down at the base in her home town,
time for a telephone. I flipped to her name

and there it was: I remembered the number,
even the lick of the tongue of her dachshund.
Taxi idling behind me, I stared at that doorbell
and almost stalled, reached out and pushed.

All that, decades ago. Someone I flew with
has gone to the moon and back, others shot down
over Laos and Hanoi, the endless guilt of surviving.
But here is her photo on this cluttered desk,

her paintings on every wall, our grandchildren
clattering pans in the kitchen, and when I rise
and go there, she leans down, gray-haired
and laughing, watching them roll the dough.

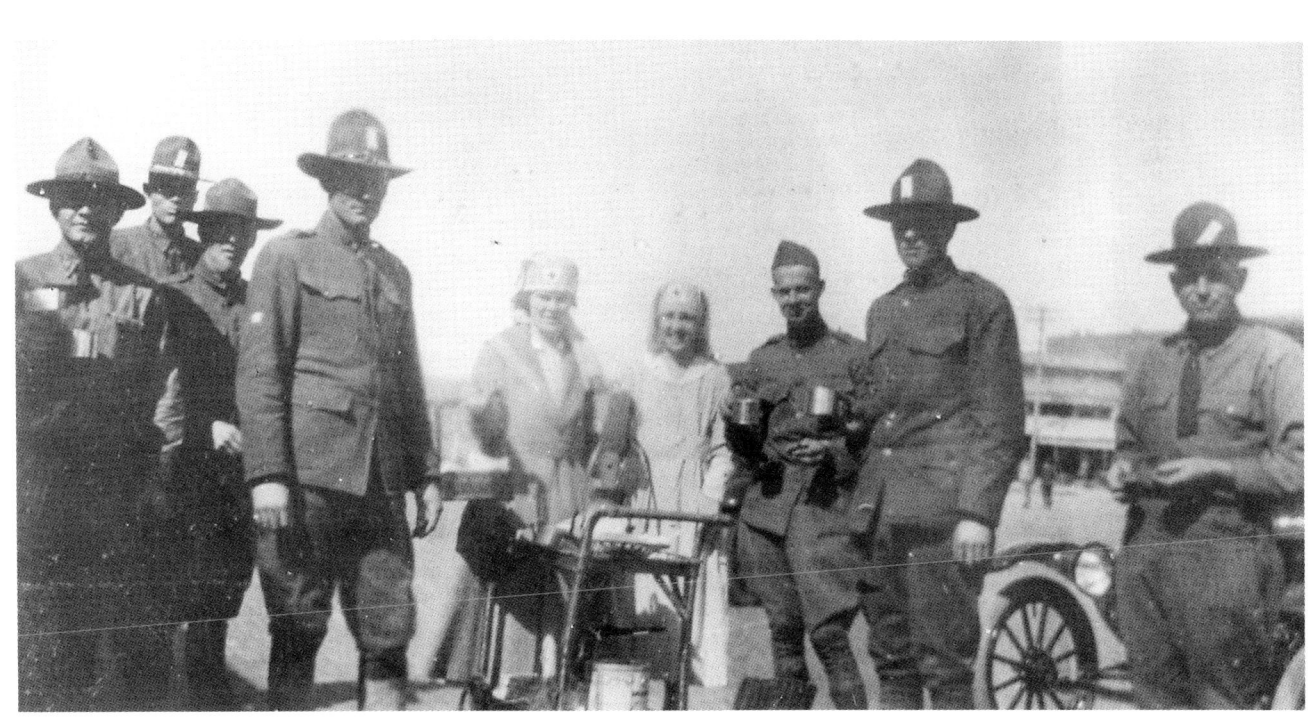

The Silver Coronado Missed

He reckoned they might look a hundred years and never find that place, but he was glad that Mary Dove believed the promises.

Jane Gilmore Rushing, *Mary Dove*

Historical Markers

Our tires crunch down off the highway,
the sign like a miner's claim, *Here,*
Coronado's men crossed *here,* a gravel turnout
with a trash barrel. Wind whips past the car,
the fields so wide we're stranded, a barn

blurred in the shimmer, a mirage we swear
is water. In this heat, nothing lopes.
If coyotes sniff us, they blink and listen.
Nothing's here, not even cattle.
Coronado's horses were lost, following cactus

staked like markers across the plains.
I hear the clink of armor, the thin
curse, Spanish word for *God.*
Squinting west where we're headed,
I hear the clank of pans in their wagon,

the thunder of eight hundred hooves.
Soldiers slump in the saddles,
cursing the last buffalo wallow,
canteens already hot, following Coronado
sweaty in his high-peaked Spanish hat,

no gold, nothing between camps
but white bones scattered, a desert
unmapped where they might die without water,
nothing to mark their route, to pause
and lift forgotten names to God.

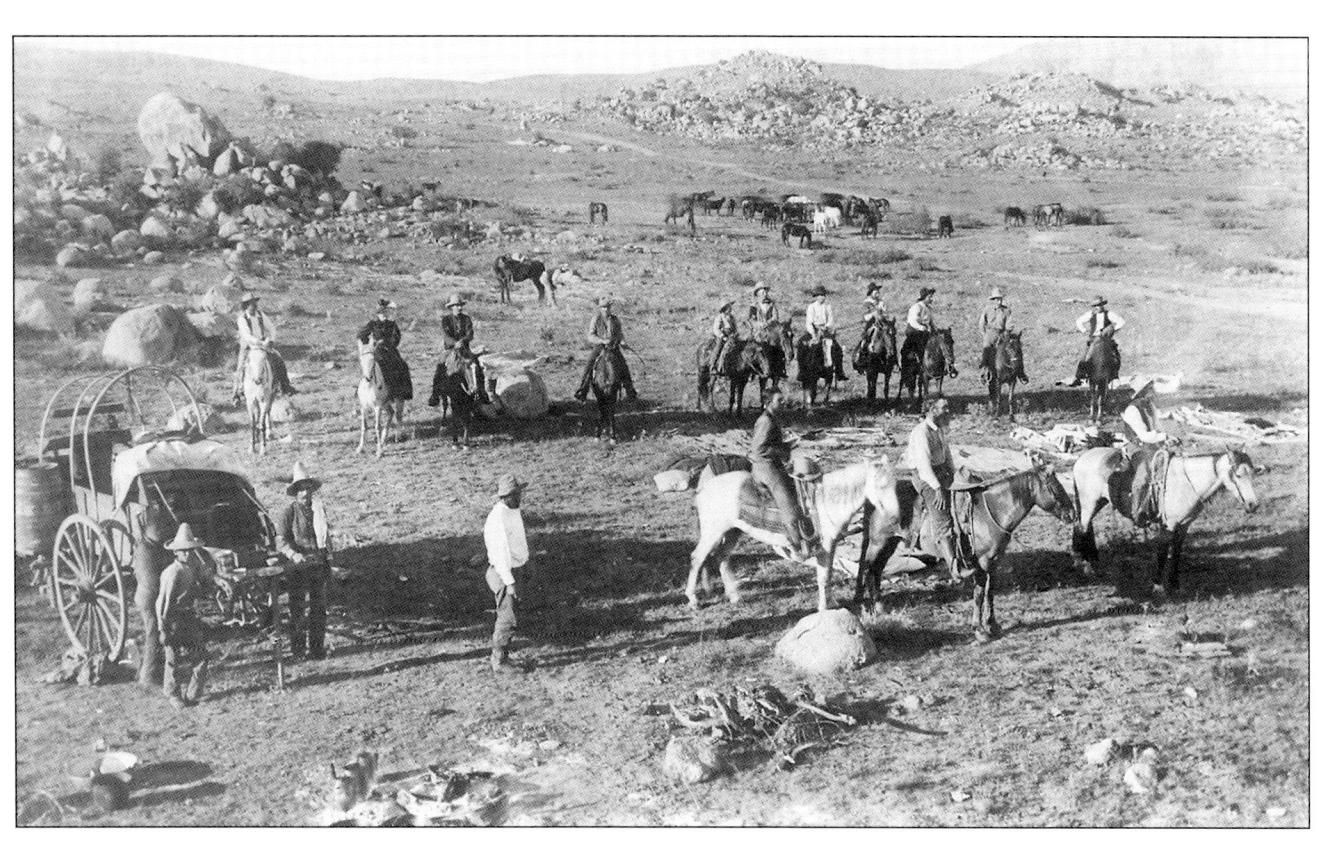

Steeples and Deep Wells

No sense of guilt: that must be
what they sought, driving bullnecked oxen
to the plains, teams stubborn as mules
grazing swaying grass knee deep all day,

wagons stranded like crippled buffalo
a thousand miles from Kentucky loam
and lakes, pleasures of the flesh
where sin came easy. Here they found no trees,

no stones to hide behind. If any came blameless,
here their faults were plain.
No wonder they shoveled dug-outs first,
somewhere to sleep out of sight.

On land so dry they dug deep wells
and raised plank steeples fast,
as lightning rods. If they wondered
about chances left behind, the sun

burned the truth of what they were,
one crop away from being meat for buzzards.
Rain fell like manna and saved
their starving crops. Believing signs

of planted trees all winter,
they doled out grain and shivered.
They shared their meager fields with hawks
and ate the flesh of wolves.

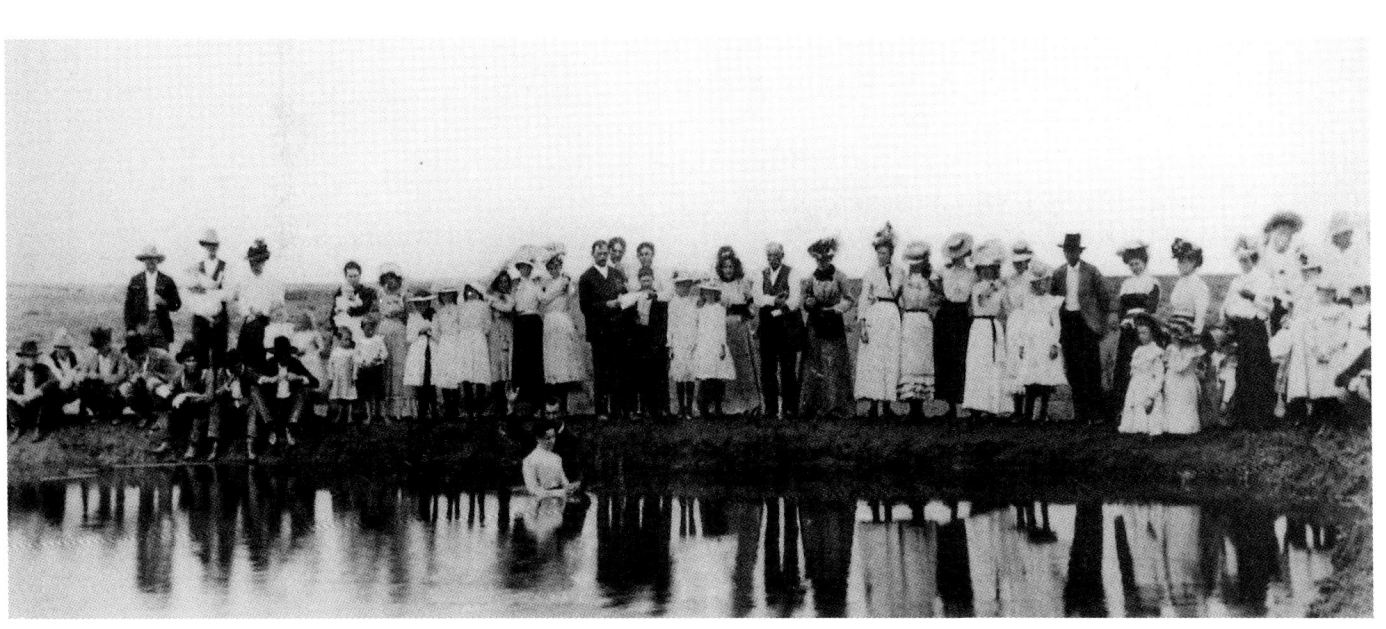

Fifth Grade

I saw her back at the blackboard,
her chalk squeaking something
I should know. I thought of the runway,
a million acres falling away
below the cockpit, then *click!*

into the clouds. My boots
toe-danced the rudder, and I banked
through bumpy air. I let wings
balance the needle and ball,
wings that broke through the clouds
into the sun, the wild blue

the second my teacher called me
back down to school, classmates
along all aisles laughing
as if they'd seen those skies,
those marvelous wide wings.

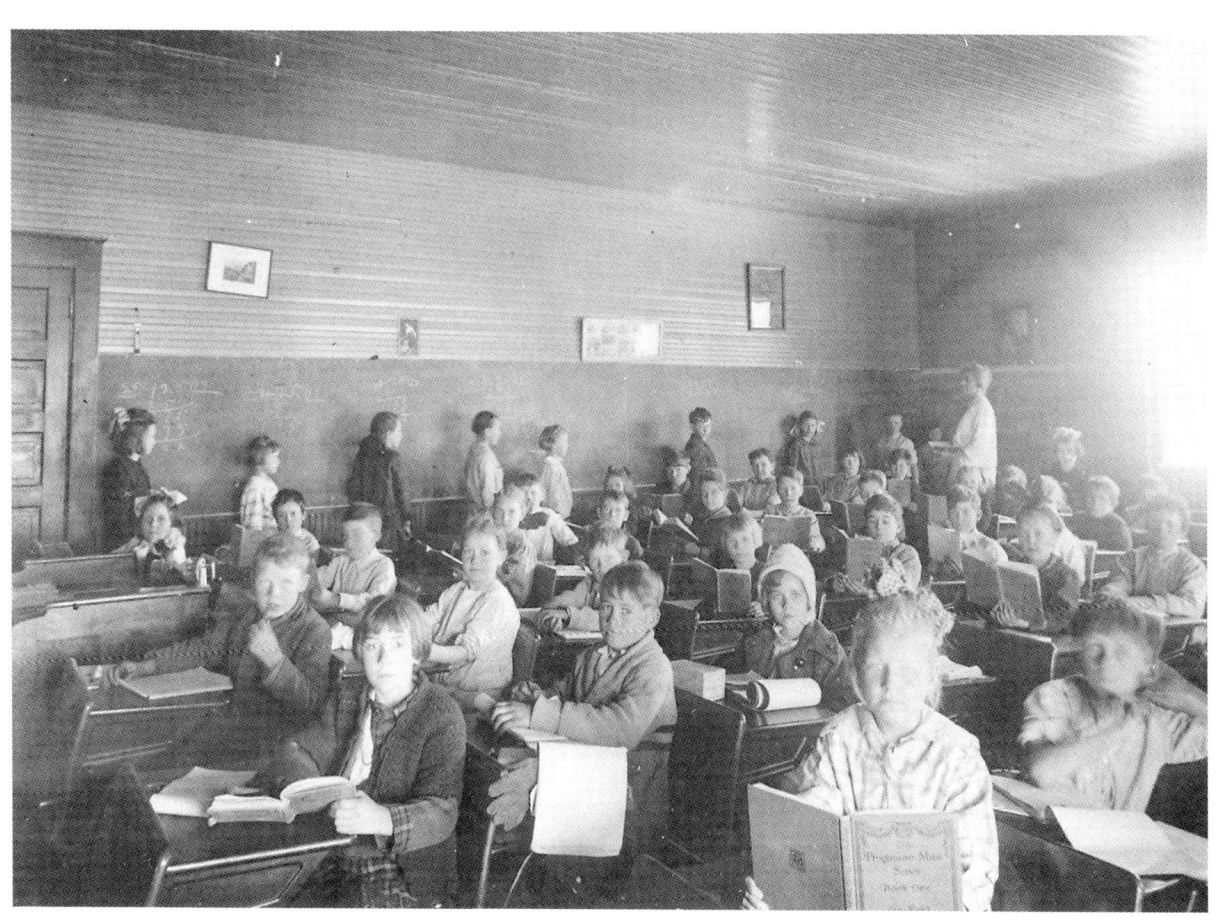

Seconds of Free Fall and Chaos

My bored brother dragged me
away from kiddie land, shoved me
roughly to the adult ticket booth,
the line dividing me from men.

Thrilled by tickets snaking from his fist,
I entered the kingdom of risks—
the Hammer and Zipper, the roller coaster.
I flinched when the Hammer

slammed down, when the Zipper toppled
and flipped us. I held the bar
in a car jerked up a track
and watched tree tops and tents

fall away. My brother leaned close
and hissed how many fell
from these seats last year, flung out
over screaming mothers. He raised both hands

and made me, the cross bar loose on my lap.
Older boys tossed their hair
and laughed, the heads of girls
snug in their elbows.

Our car crawled on cables
grinding like bicycle chains
about to break, all rides of childhood
behind me, my arms high in surrender,

my skull wobbling
through tight turns, mashed down
like being born again to lights
and dazzling screams.

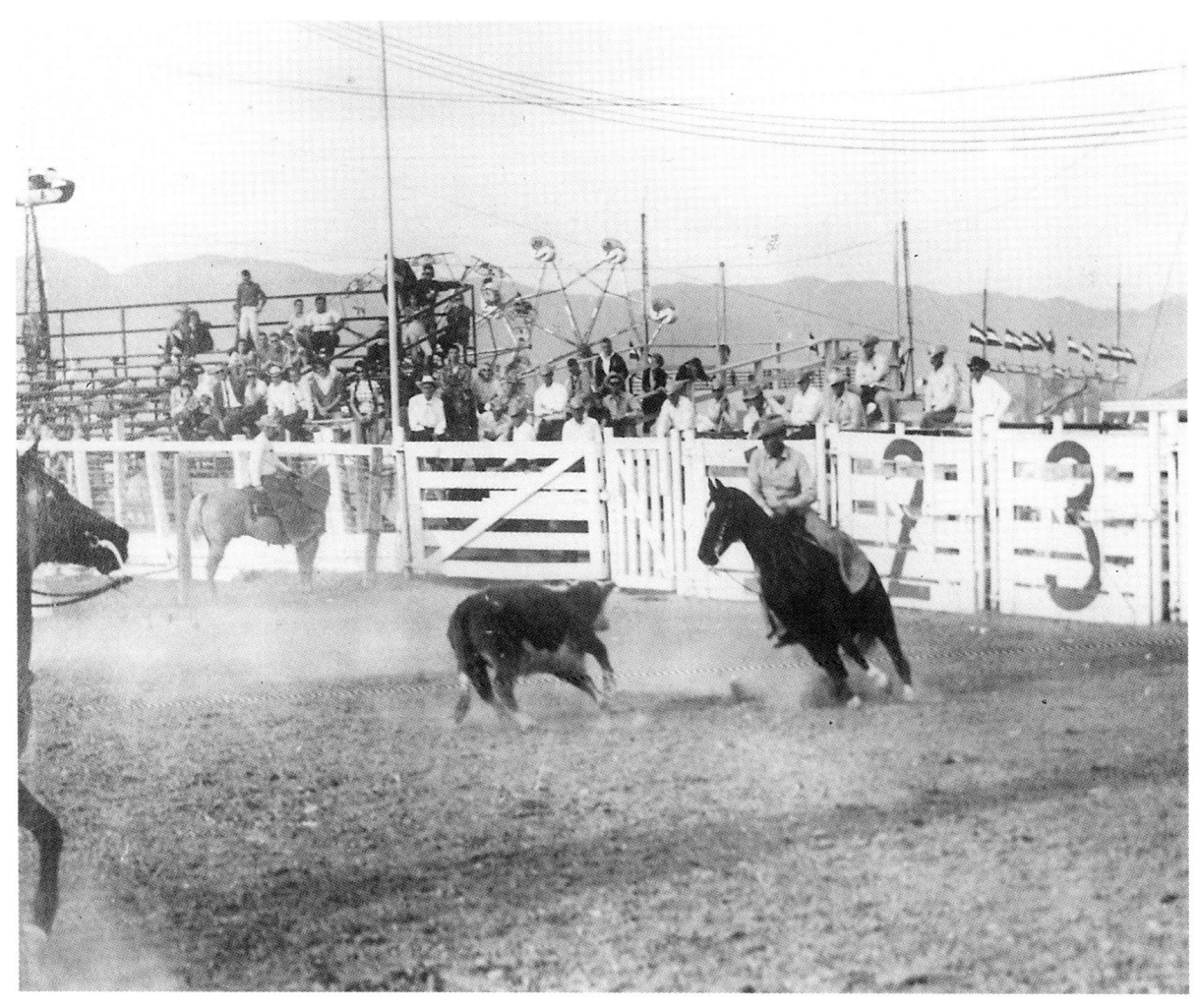

Hosanna in the Family

I ripped the sack and flipped the grain.
I'm not St. Francis, but the chickens loved it,
clucking for manna. Our collie dog came running,
soggy and shaking, our boys like prophets

out of breath. *You boys baptize him
in the trough?* Wide-eyed, the youngest nodded,
believing water could save us. Bedtime,
they watched TV, sleepy, the dog sprawled,

not even blinking at the Cosby show.
My wife's bare toes played mischief
with my feet. Bill Cosby winked
and wouldn't leave, like me, a born-again mate.

My wife led our boys upstairs to bed
and light shimmered in a negligee.
I rose, and turned the baptized dog
outside, barking hosanna at shadows.

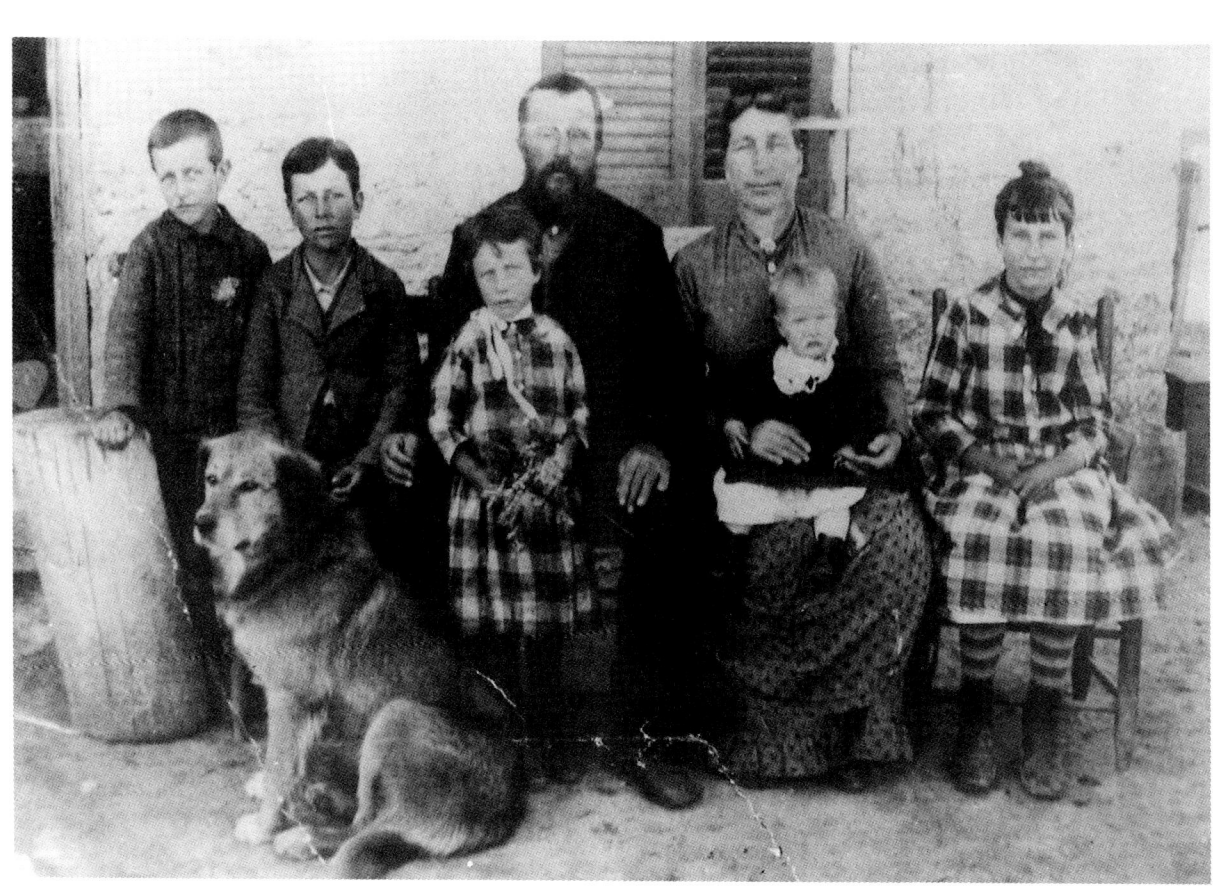

Starting a Pasture

This far out in the country no one is talking,
no rescue squads row by in boats to prairie land
so dry the Ogallala water table drops
three feet every year. The digger rams down
through dirt no plow has turned. In the heat
I let my mind run wild. For days I've thought
the world is ending, the red oaks turning red
again, the last geese there could be
stampeding from the north, surviving
to show us the only hope, the tips of their
arrow formations pointing the way. So many birds,
if the world doesn't end this will be for Canada
the year of the locust. I shake my head
at my schemes, and sweat flies: cattle
on cotton land. The market for beef
is weak, the need for cotton constant.

I might as well raise goats and sheep as cows,
or trap for bounty the wolves and coyotes
that claim my fields at night. I might as well
rent a steam shovel and dig a lake deep as an ark,
empty my last irrigation well to fill it green enough
for geese on the flyway both seasons. I could
raise trout and channel cat, horses and bees
like the pastures of heaven, gazelles and impala
imported from other deserts, two of each kind
of animals in a dying world.

 Sun going down,
the last hole dug, the last post dropped
and tamped tight enough to hold three strands of wire,
I toss the digger in the pickup between bales

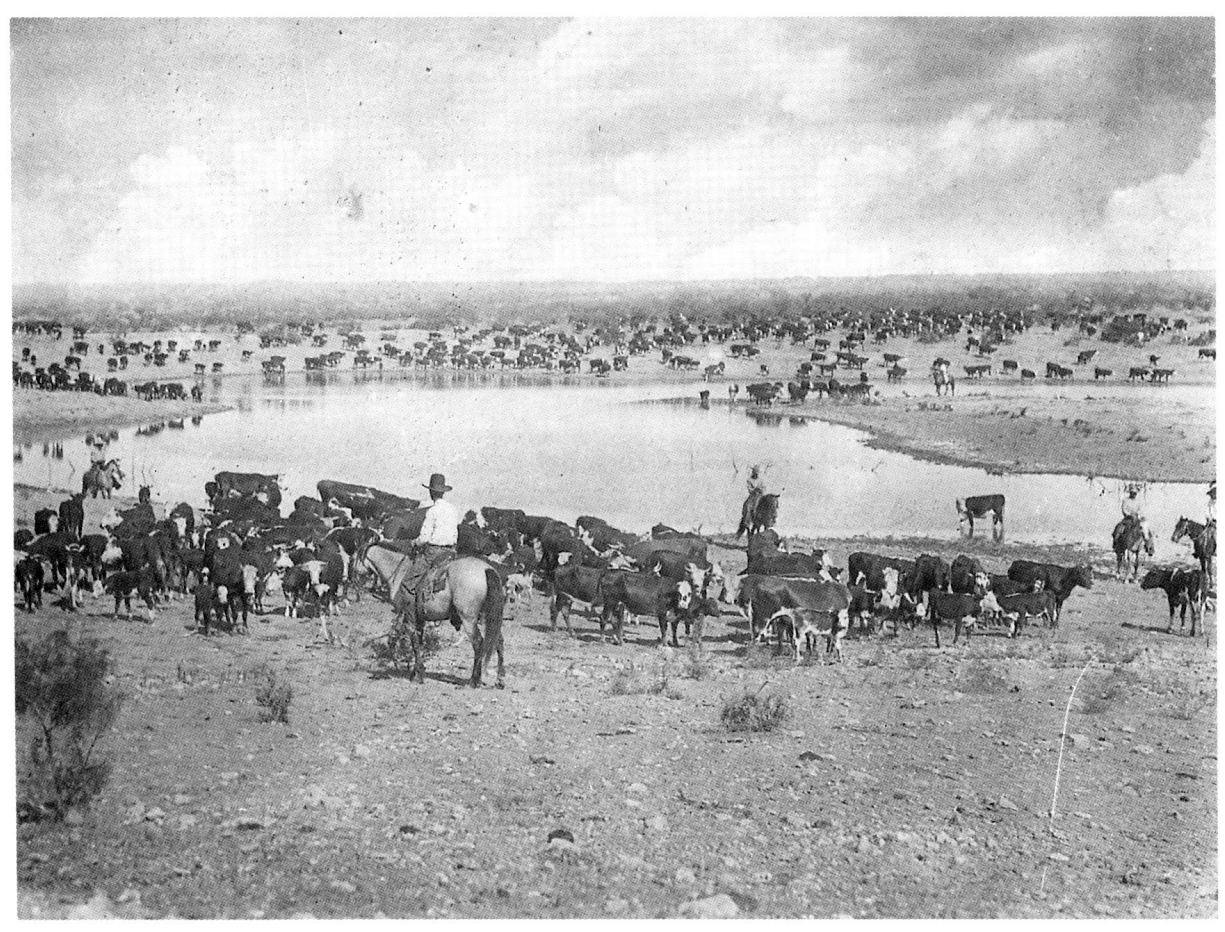

of barbed wire ready for stringing, the calves
I bought last week already overdue, the feed bill
mounting. My father used to say a man could lift
a bull if he'd practice on a calf each day.
Pulling my gloves back on, I lift the first bale
out and nail the end, uncoil the wire and nail it
tight to the posts. And as it turns dark
I go on stretching and nailing until I don't care
how many neighbors drive by with their lights on,
honking, sticking their heads out the windows and laughing.

Turning Fifty

My wife sips tomato juice
in turbulence. In clouds, we sway and bump
with plastic glasses balanced in our fists.

Her hand flies high in a down draft,
falls hard to the tray, and wide-eyed
she laughs. Seat-belt signs flash on,

attendants down, strapped in. She glances out
at lightning. The plane slams hard,
a door pops open and luggage tumbles out.

Somewhere, a woman screams. The captain's voice
comes on, mellow as Musak, *Folks, lean back
and enjoy the flight, and we'll have you in Dallas*

right on time. My wife shakes a wrist
to get the cold blood pumping. Her hand
is messy with a cracked plastic glass of ice.

I lean giddy to her eyes, my hand slick as hers,
my juice glass sloshing like champagne,
and lift it dripping to her lips.

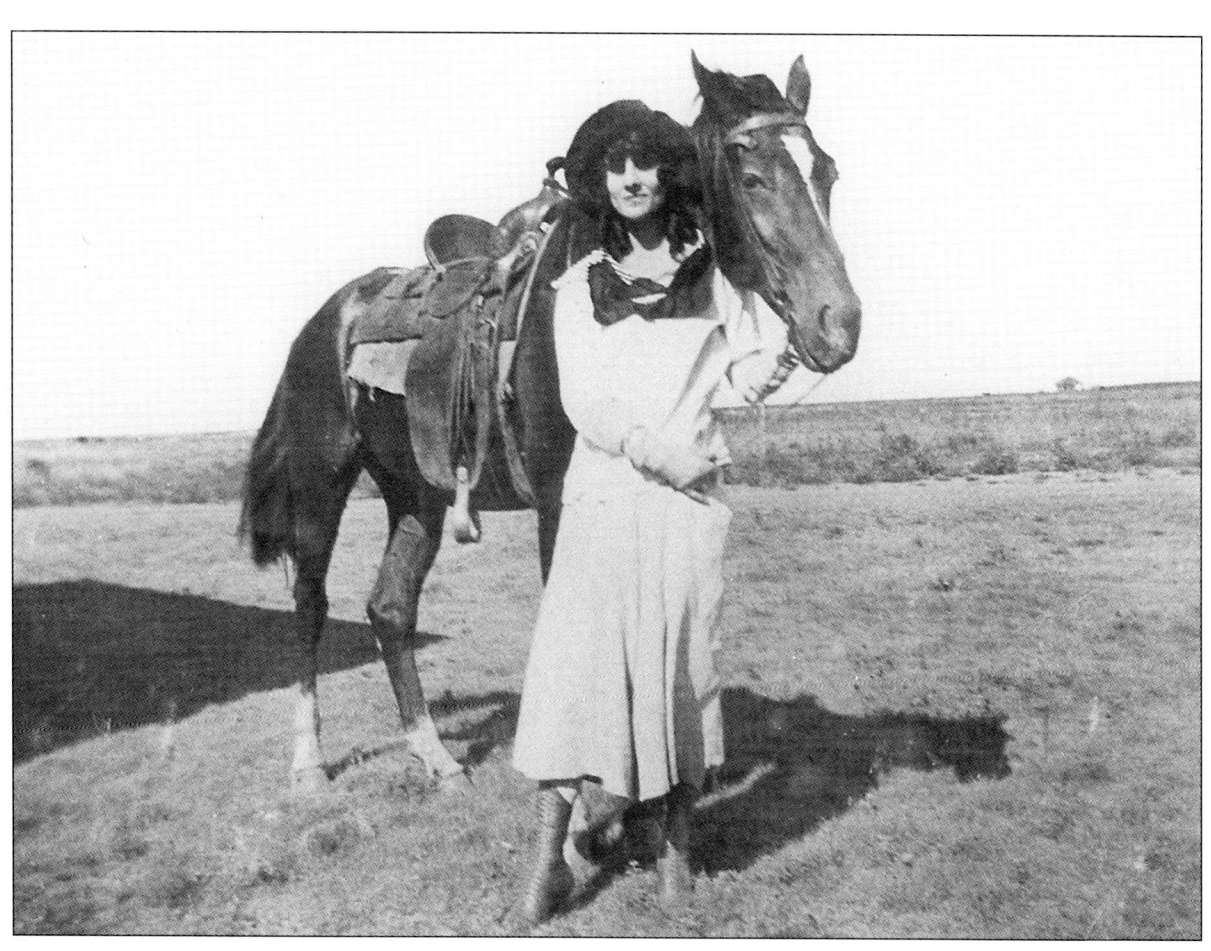

Plowing with a Six-Mule Team

These are the golden apples,
the hearts' harvest.
After months of drought,
fires rage on grassland
on the plains.
Hawks glide in autumn,
no fierce mating,
nests finally empty.

Fall cotton dies,
white as a bride's
percale sheet, tight
and fitted to the bed.
Nights when you roll
to hold me, a breeze
soothes through windows
we leave wide.

All summer, sun
blazed for this harvest,
the moon full enough
to plow by, the tractor
rigged to enter the rows,
my hard hands stiff
from hoeing all summer,
ready for frost.

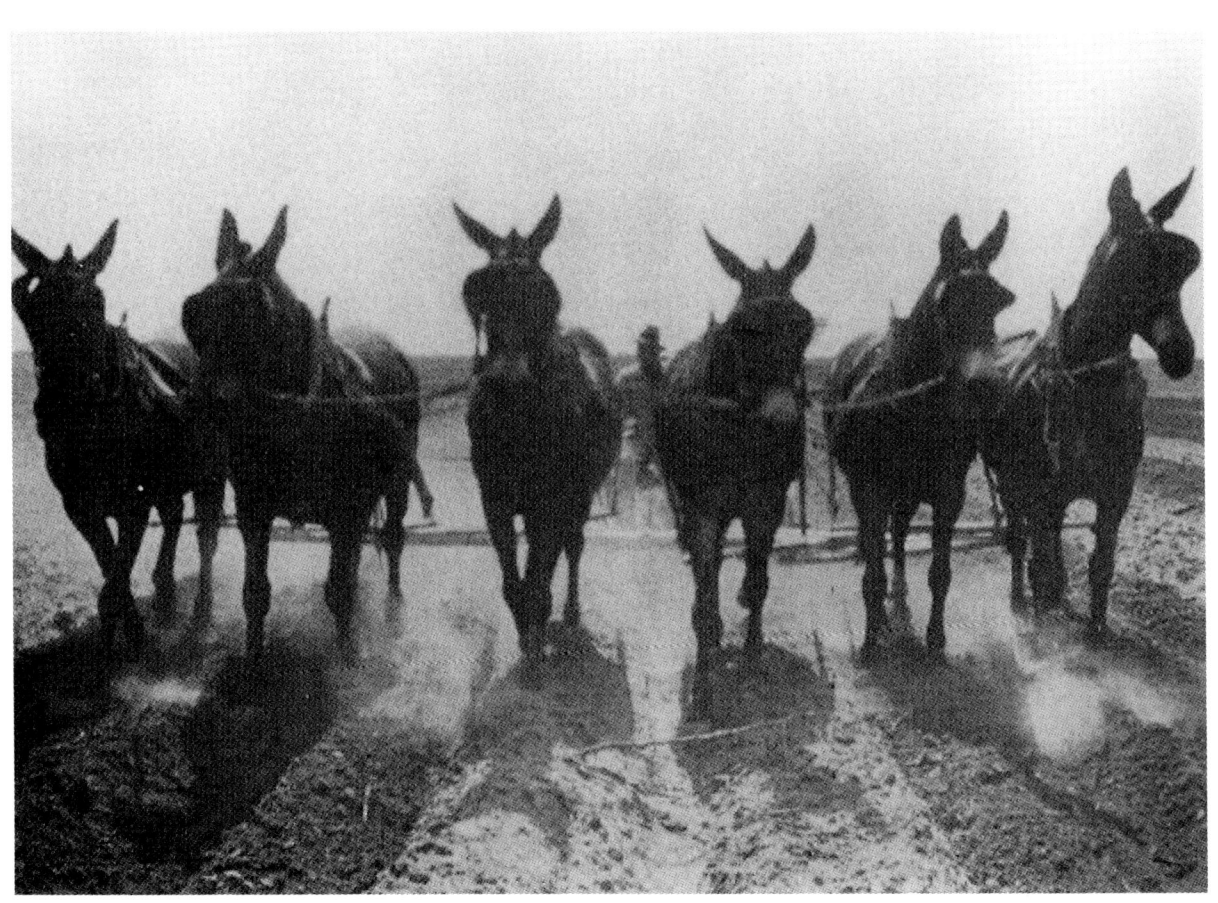

Heart Attack

I take my collars to the wash, dump them
and the sloshing starts. I settle back
in a plastic chair and nod, rhythm of water
floating away the day—the barbed wires tight,
the grinding windmill gears I fixed. I'm lost,

alone in town at midnight without her,
in a Laundromat. I cock my head
and see two empty rows, a dozen washers closed
like portholes on a ship. I've had enough
of cruising bars with boyhood friends who always

stayed out late, but now turn off the late news
early and hug their wives at home.
My wife's been gone too long, his doctor
and teams of nurses slaving to save her dad.
His pulse, thank God, is back to normal,

that muscle tough as a bull's. I remember him
standing guard when we drove off at night,
backlit in the door, holding his glasses.
He never waved goodbye, not till we tied the knot,
a father who took all duties to heart.

When the rumbling steel machine stops,
my work clothes tumble and plop. Shoving up,
I feel my fingers numb, tingling
like when his big fist squeezed my hand
like a son's before the honeymoon.

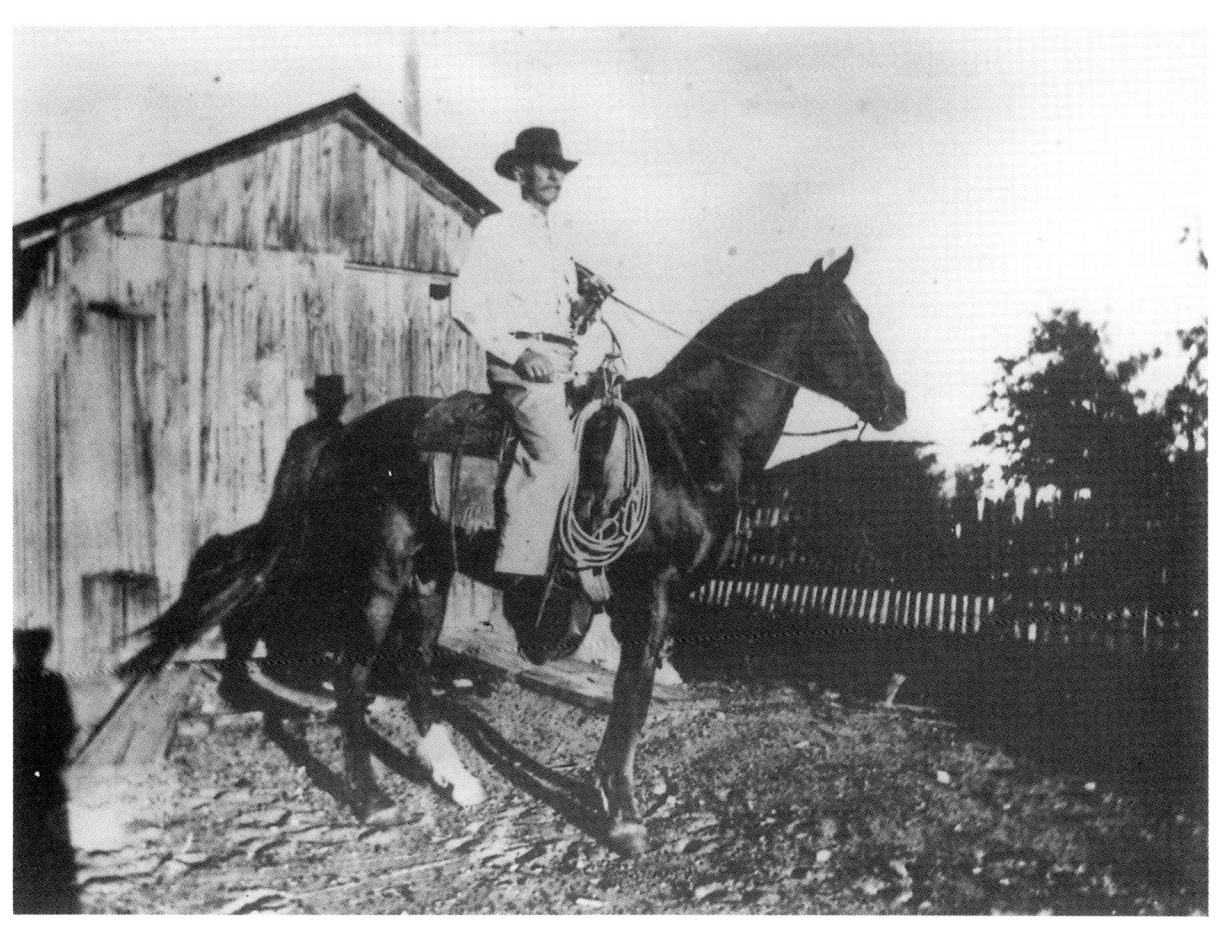

Caught in a Squall near Matador

Thrashing through weeds, splashing mudholes
near the door, we burst into the shack
and throw down on all corners of the room.
Rain clatters the tin roof
like a thousand rattlers. One by one
we jerk tumbleweeds aside,
the way sailors home after long rain
flip back the blankets.
Cursing the rain, we prop the shotguns

and sling holy water from our Stetsons
all over the blessed floor. We kick weeds
to the grate, crunch them like quail bones
with our boots, dig in our jeans for matches
to make the bunched weeds blaze.
Ghosts shiver across the ceiling
and bump the cedar rafters, coiling
in cobwebs thick as gauze. Weeds pop
like firecrackers. We're warmer

than anyone who wintered here.
The jimmied door clacks shut, and rain
splashes in each time the bent door slams.
Doves we've shot today bleed in the creel

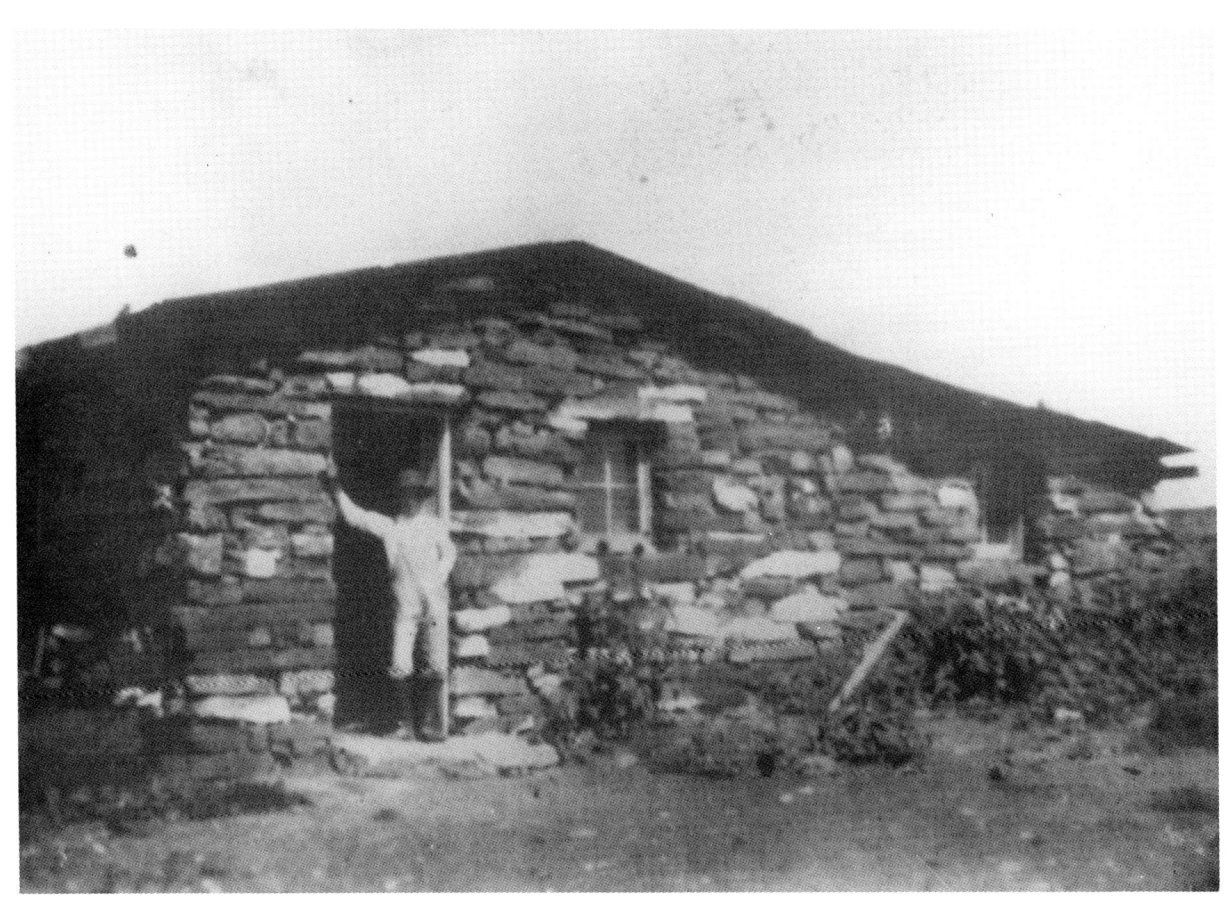

we stuffed them in. Rain turns to hail,
ice battering the tin roof like shotguns.
The fire breathes fast as we feed it weeds.
Now where weeds were stacked
we find old magazines and hunting maps.

We slap the covers to life, reborn
free of the dust. Grizzlies rear up
and we fling them to make flames roar.
Bigmouthed bass leap, tails slapping,
shaking the hooks all the way to the fire.
Symbols of windmills and shelters on maps
all lead to this sheepherder's fireplace.
And deep in the dust, a calendar,
a pastel maiden kneeling on a stone

as if praying beside still water, knowing
the shepherd whose hands find her
will take her in and let her lie down
at his table here in mesquite pastures
after the seasons she was doomed
to kneel exposed on her stone have gone by
like sheep to the slaughter. One of us
rolls it like a scroll, the calendar
soft as old vellum, and lays it

on the creel of doves. Tonight,
after the thunderstorm moves on
and we are home, feasting on dove breasts
dark as hearts, we will think of living alone
in a cabin at night, nothing but weeds
and sheep outside, our lady of the lake
above our tables, rain the same
month after month, and we will listen
to our women's gentle voices.

Turn Around, Turn Around

Stacks of photographs pile up under dust
in the attic—these, of our honeymoon,
these, of our first house, those ponies
grazing across the road. Look at us
with babies tiny and flat in the scrapbook,
years quick as flashbulbs. And these
brittle prints, our own grandparents and parents
like a time warp. Last night, it seems,
I watched our son at dusk follow his sons
on birthday bikes down the sidewalk,
under oaks and mulberry trees like a tunnel
even when he was their age, our first year here.
His wide-muscled back hid them from me,
glimpses of kids wobbling on tires
and training wheels. Camera around my neck,
I waited till they rode back. Again today,
here they came, flying down the street, big twins
on ten-speed bikes, our son staring in wonder
at his sons, fifteen and muscled, both of us
clicking as they raced by and waved.

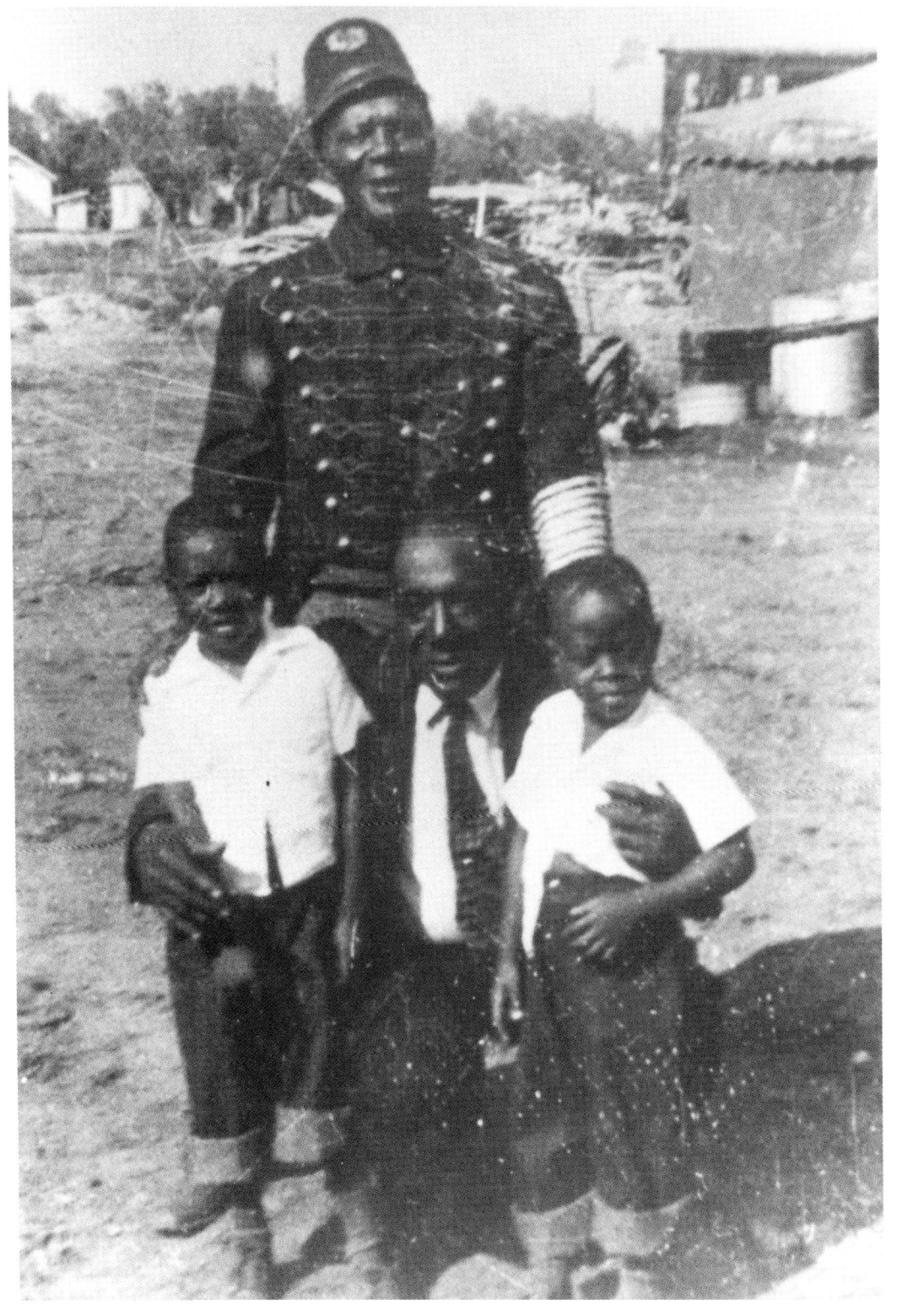

One Thing Leads to Another

Sometimes two hands take mine, or even ten.
Sometimes, all seven grandkids mount me
like a camel, hanging on humps of shoulders,
tugging my beard, the littlest fist

gripping my lip like a sultan's spoiled
family camel, patient while the children play.
We pose for the birdie on birthdays, always
some grandson making horns with his fingers

above a cherub's head, another giggling
and squirming, one sneezing, the pose clicked again,
again. I never failed at math as a schoolboy,
but struggled, adding up answers on fingers

under the desk on tests. Now I'm over sixty,
stunned by how fast men and women multiply,
how one turns into two, then three, then doubled,
and now fifteen. Birthdays, I'm surprised

by *Here is the church, and here's the steeple,*
open the door and see all the people,
toddlers wide-eyed on my lap watching magic
of my stiff hands that lock and open like a door.

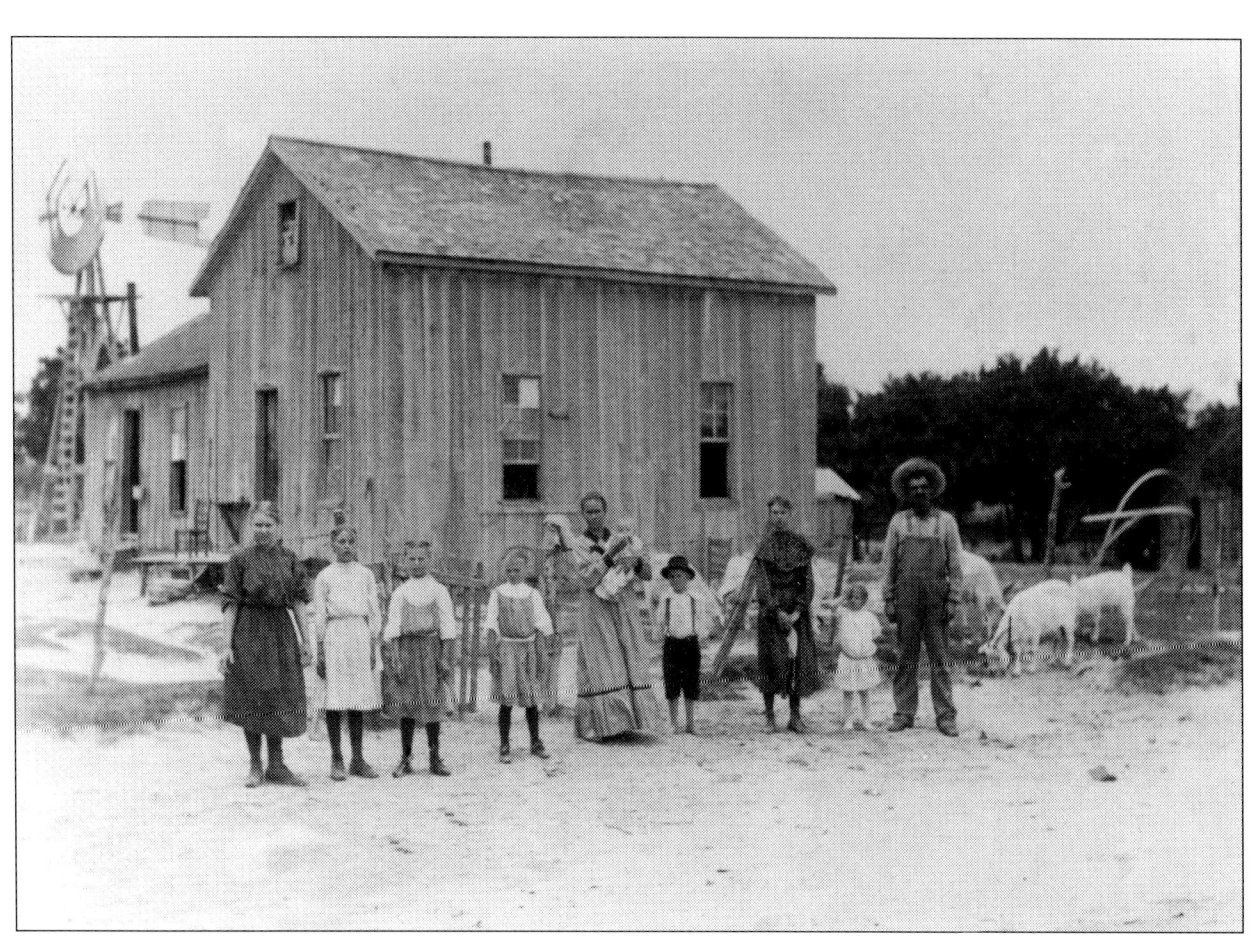

The Middle Years

These are the nights we dreamed of,
snow drifting over a cabin roof
in the mountains, enough stacked wood
and meat to last a week, alone at last

in a rented A-frame, isolated,
without power in the Big Bend.
Our children are safe as they'll ever be
seeking their fortune in cities,

our desks and calendars clear, our debts
paid until summer. The smoke of pine
seeps back inside under almost invisible
cracks, the better to smell it. All day

we take turns holding hands and counting
the years we never believed we'd make it—
the hours of skinned knees and pleading,
diapers and teenage rage and fever

in the middle of the night, and parents
dying, and Vietnam, the endless guilt
of surviving. Nights, we lie touching
for hours and listen, the silent woods

so close we can hear owls diving.
These woods are not our woods,
though we hold a key to dead pine planks
laid side by side, shiplap like a dream

that lasts, a double bed that fits us
after all these years, a blunt
front-feeding stove that gives back
temporary heat for all the logs we own.

Neighbors Miles Away

We reached Estacado just after dark, and drove to Dr. Hunt's. We suddenly stopped in front of his house, as a buggy wheel locked around a fence post. It is needless to say that here was a joyful meeting. I don't mean with the fence post but with our relatives.

George M. Hunt, *Early Days Upon the Plains of Texas*

The Last Good Saddles

We've worked these plains so long we're broke.
Two old neighbors can't make the dust feed calves
forever. August this hot makes yucca
drop its pods; snakes hibernate till dark,

horned owls believe they're wise,
grasping the limbs of live oaks.
Black buzzards glide, patroling all we own.
Wherever they swirl, coyotes are sure to follow,

starving for cow bones broken,
tumbled down steep arroyos. Soon,
we'll round up strays enough to drive
to two corrals, brands on their flanks

better than fences to keep two fools
from quarrels—this calf is mine;
that, yours; the brittle grass they find
on open range good to be chewed over and over.

Rolling a smoke the old way, we listen to thunder,
the distant rumble of rain. Too late
to do much good this season even if it floods.
You spit, and wipe a stiff glove over stubble.

Buzzards seem fatter than these steers.
But let's go, coaxing our sorrels back
between mesquite and cactus, the simple oats
they work for at least enough for them.

Tonight at the campfire we'll sip cold beer
and quarrel about taxes and the price of bulls,
about drought and stalled squall lines,
about whose old bones first felt the rain.

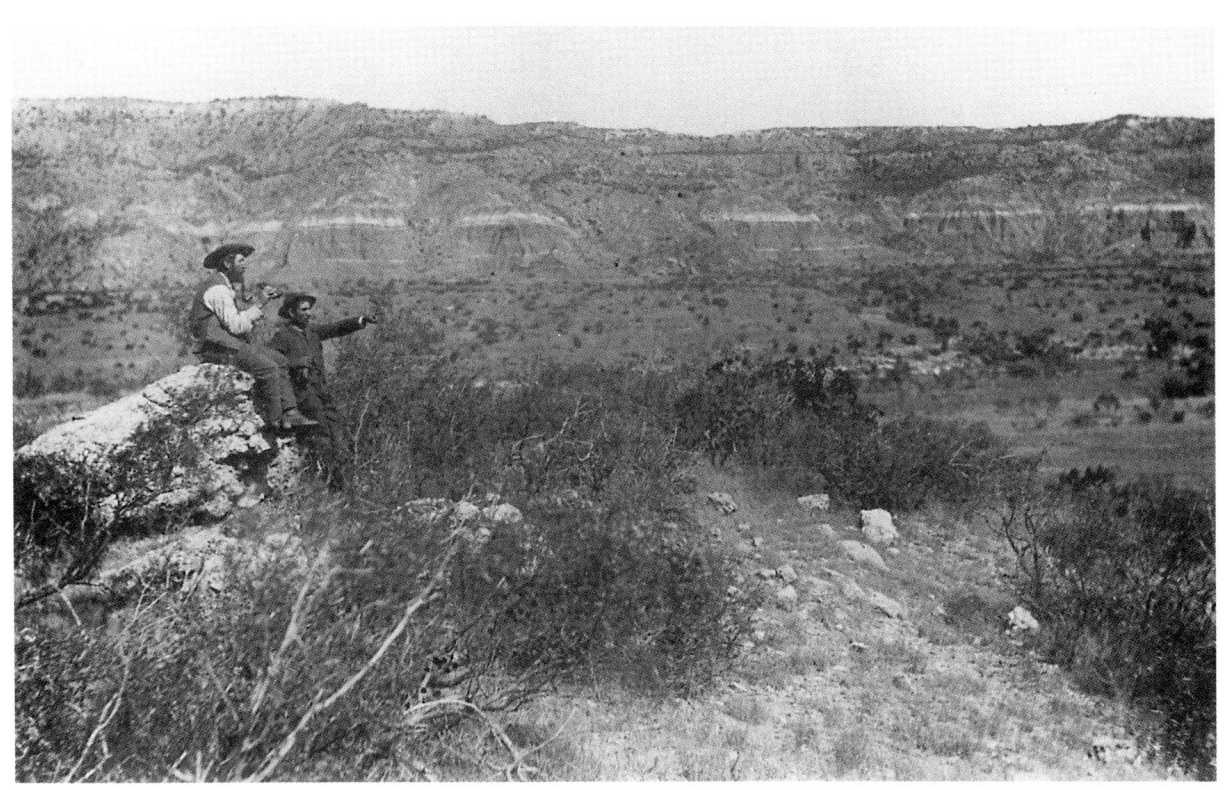

Dogs in the World They Own

This is the rage for order on a ranch,
dogs barking at cars and pickups on the road.
Any post inside the fence, they own,
wetting the weeds, the shadows of clouds.

Skunks waddle up and die in their own
dark smell sprayed at the fangs of mad dogs
ripping them apart. Coyotes know
which fields have dogs, and lope for miles.

Sometimes a prowling cat hears snarling
too close to outrun and climbs the only
light pole in the yard. Dogs bark for hours.
The hot sun melts their tongues.

Even after dogs lie down, the cat stays there
all night, stares at the woman
who comes at dawn coaxing with water,
a saucer of milk. The cat stares,

cramped like a skull on a post. And then
one day it's gone, the dogs patrolling
their dirt, hawks wheeling overhead,
all gates and grazing cows in place.

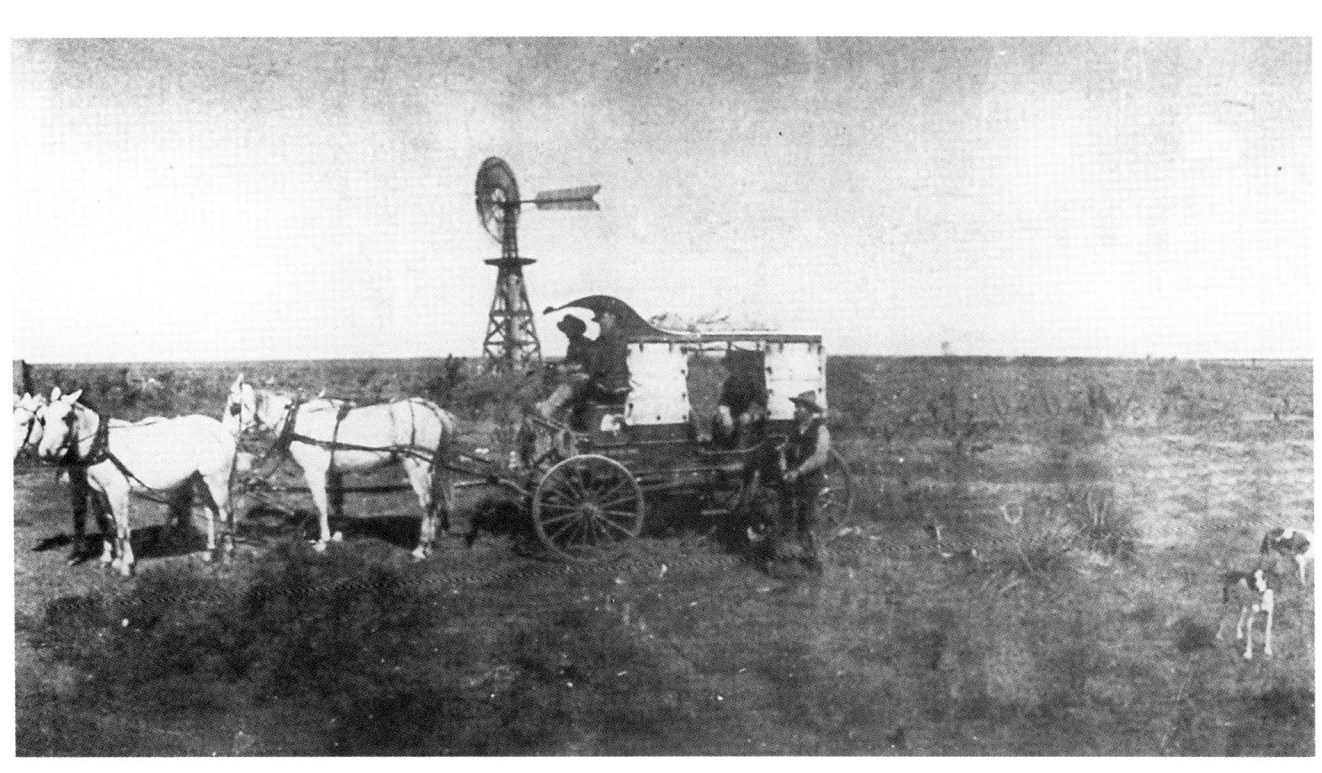

Neighbors Miles Away

Blistering heat shimmers our fields
like lakes. It seldom rains.
Surveyors rode here hung over,
swearing they'd mapped these miles before,
cursing sextants and starving Comancheros

who left these plains to settlers.
Coronado's army crossed four hundred years ago,
coughing, praying for clouds, crossing themselves
and grumbling, tugging their stumbling
Spanish mares, rumors of gold

on their minds, a thousand miles
from leaky galleons anchored in the Gulf.
Our wells flood the dung and hoof prints
of their route. We pump the purest water
three hundred feet to grain

they never dreamed could grow.
This sky is what they saw,
these level fields. We're not alone.
When we drive straight roads to town,
neighbors miles away look up and wave.

Goats Imported from Austin

Goats stumbled on shale, a rocky mesa
Daddy fenced for kids imported from Austin.
He swore *cabrito* would be worth the smell,
a market killing, but hated goats—

cattle the only odor for a man. Coyotes and rattlers
roamed those acres until he claimed them.
Goats climbed the hill like big-horn sheep,
playing king of the mountain, bold on the bluff,

staring at greener pastures. Other goats popped up
like penguins, searching for all he saw in the distance.
My brother and I fed goats by hand, lugged oats
to kids with nubbin horns, bellies that bulged

and muscles butting us for buckets. After chores,
we dragged our wagons to the top. Where the cliff
dropped off, we risked the bumpy ride downhill,
tumbling, bending the wheels and tongues.

The goats ignored us, picking their paths
up and down like angels. After frost,
our father slaughtered them all and hung them
one by one from rafters, smoking the meat

for winter, the market for cattle and goats
collapsed, the start of the Texas depression.
Drinking windmill water to swallow,
we chewed tough jerky for years,

salt-cured and stringy. We learned to curse
the dust of a ranch that failed
and played field hockey without a stick,
kicking the tiny hooves like pucks.

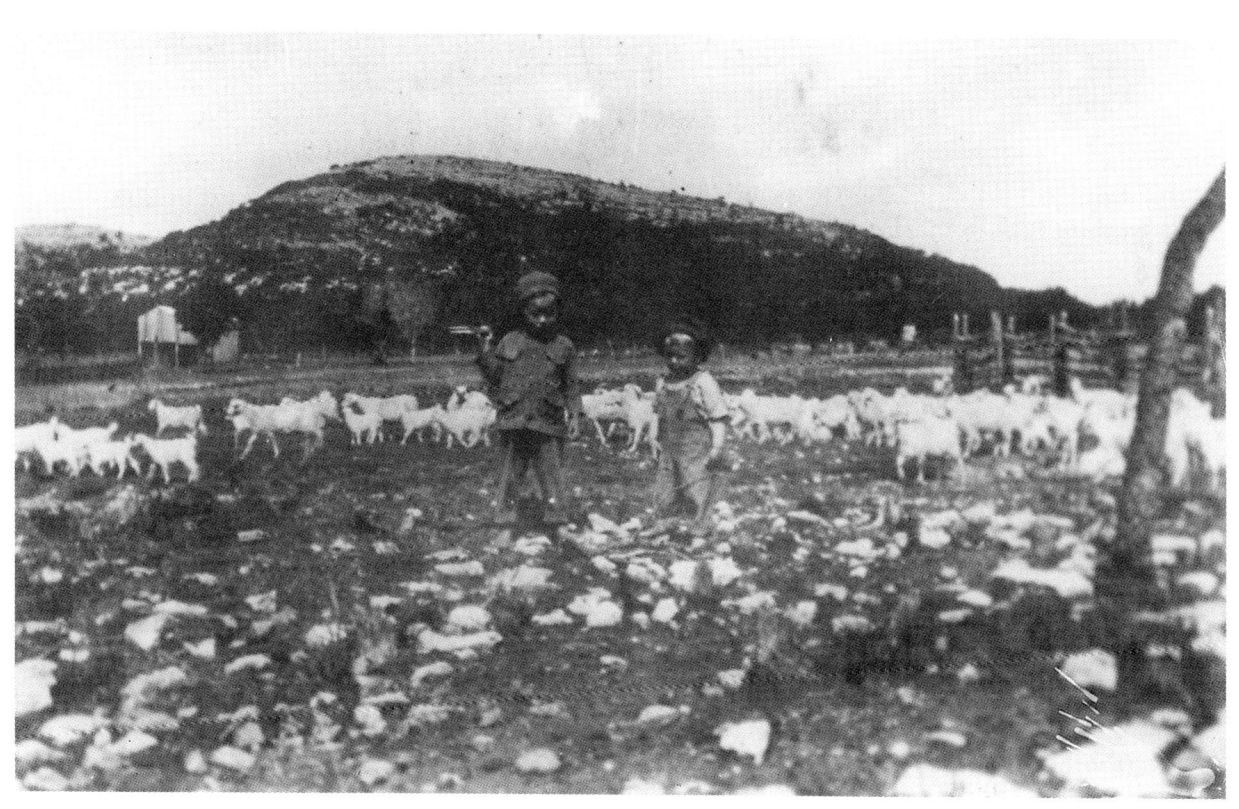

South Plains Fences

All trash ends here, tumbleweeds snagged
on barbs rusted so red the fence wires
blaze at sundown. Mourning doves dart by
as if expecting to be shot. The land is flat
to four horizons. With farms exposed
no wonder neighbors fence their crops.

This orchard turned the plains to pears,
my herd to beggars. The man who planted trees
left heirs who wanted derricks. He rode
along the fence each day in summer,
fed pears across the wires, my horses
sleek and dreaming of his trees all winter.

The house he built stands boarded tight.
His farmland, fallow all year, turns to dust.
Heirs the plains wind scattered
bind sections of land in lawsuits
tighter than wire. Oil drillers
from two states wait for the word to dig.

Dust flows down turnrows over dunes.
Roots never watered struggle
through last year's drought. The only rain
pounds down out of clouds black as Bibles.
Branches bent down like bows glow
with pears stunted like clusters of grapes.

My horses canter along the wires,
nicking themselves on barbs. I bring
bushels of pears to the fence all summer,
debris piling along the wires like corpses
in a flood. Pears black as oil drop off
and ooze back into sand no fence keeps out.

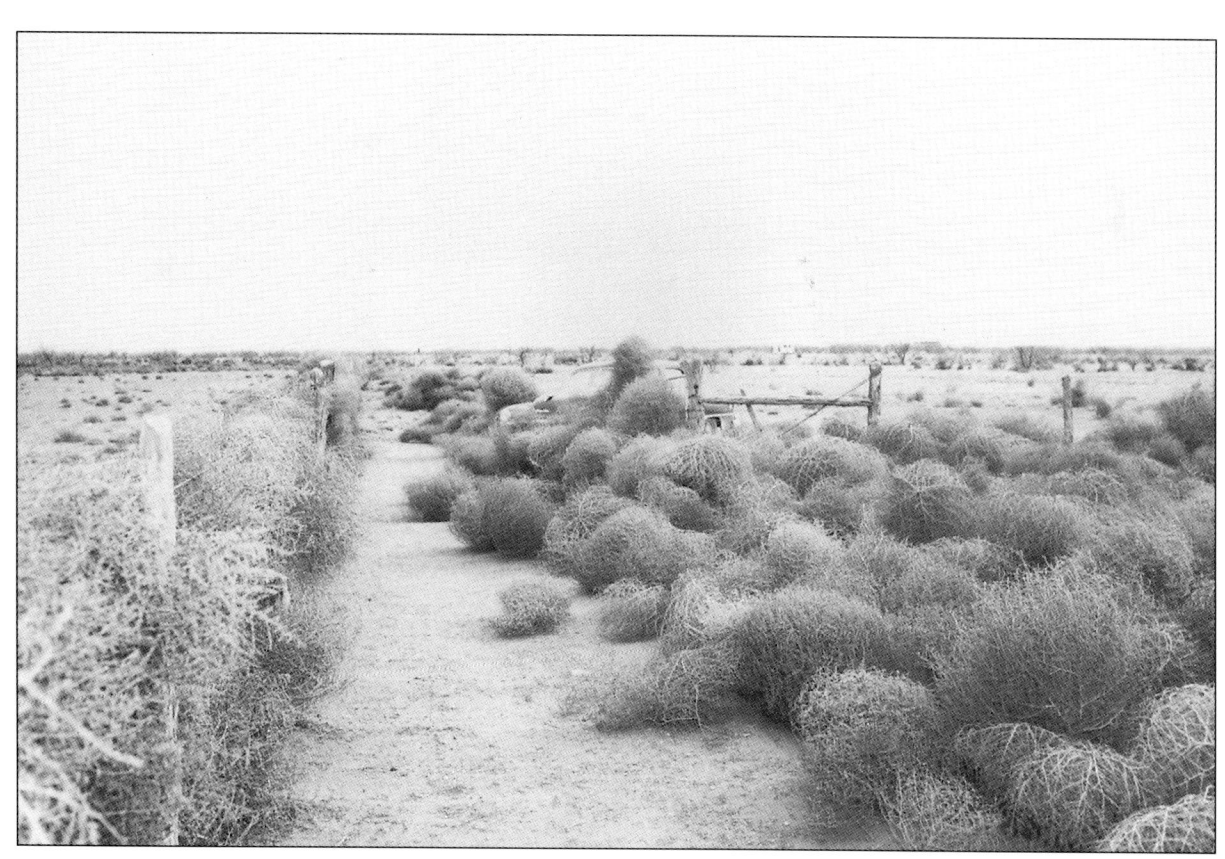

Loading the Summer Cattle

Any good gust spins whirlwinds on the plains,
dust devils swishing tails through blank,
blue summer skies. Ease back on the reins

and hope they pass. Blown sand
can beat your eyeballs full of glass,
your gelding blown off balance, staggering.

Nothing stuns fat steers caught on the range,
grazing the last good stubble, butts to the sun,
nothing on their minds but grass.

If they hear sudden gusts of air brakes
down at the loading dock, the clatter of tail gates,
heat muzzles them. They drop their bone heads

lower in the dust and bite off yellow stalks,
ignoring shouts, the bawling calves, the rumble
of trucks from the slaughterhouse.

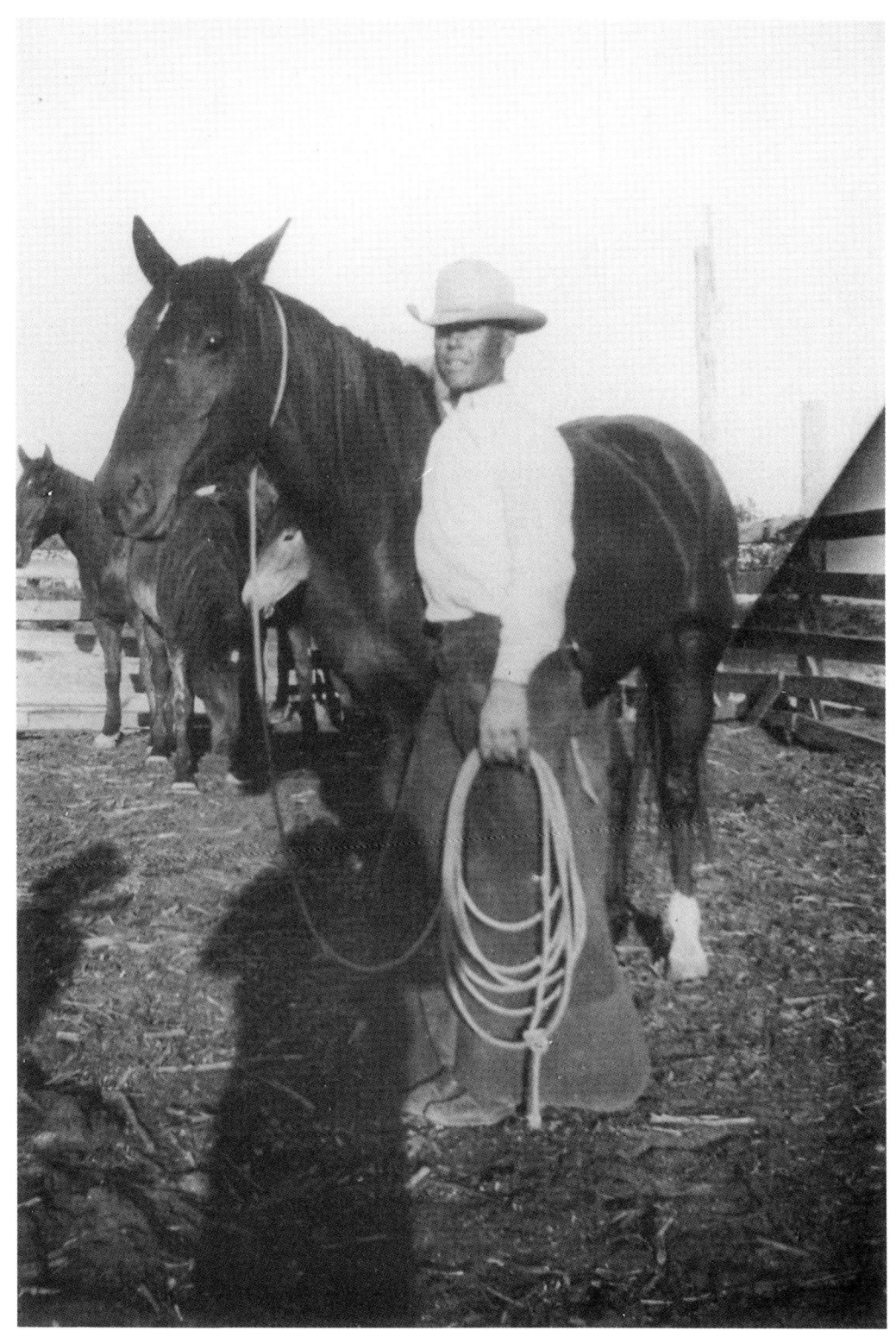

At the Stone Café

The waitress leans across with ketchup
for our chicken-fried steaks and beans.
Rouged, perfumed, she exposes a flared
white cleavage. She is some local boy's
Sweet Darlin'. She waltzes off,

humming some country and western tune
that makes her human. Sunlight slices
between her thighs. At the counter,
she cuts a pie for two cowboys she knows.
One rises and whispers in her ear. She winks

and flips his hat, leans back and sips her coffee.
They turn and study whoever enters without boots
and spurs. Some laugh, some hunch on their elbows,
their voices muffled under fans' *whop-whopping*
overhead. Some tilt their rawhide chairs,

legs crossed, their beveled boot heels cocked.
They ignore us, holding their smokes
in stained fingers fanned out.
They stare at each other, squinting
and nodding slowly.

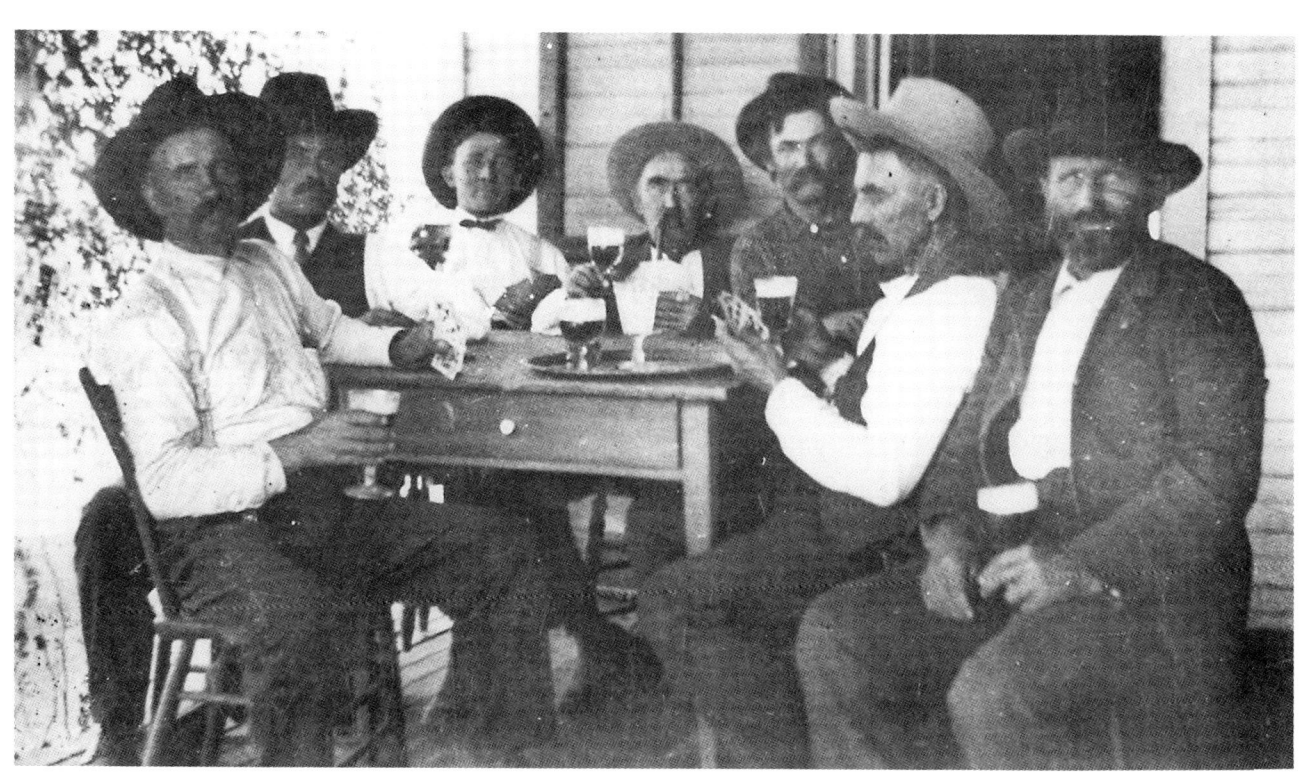

Goat Herding on Hardscrabble

Old age is a salamander trapped in clay,
waiting for rain; a boa constrictor swallowing
a fat goat bulged in its throat, then lazy all day
in the sword grass, almost asleep, tongue fluttering

with each easy belch. Old age is a marsh in the Kalahari,
shallow and pink with flamingos, sloshed by hippos
and water buffalo, zebras and hinds, another safari's
elephants, a thousand crocodiles, not enough hope

and wading space for all, for summer's coming. My thumbs
and big hairy knuckles still make fists. Last week,
I swung a sharp axe hard against the plum trunk,
alive one year and dead the next. My gray beard's

wiry as steel wool, my sight still sharp enough to read.
Spring storms keep coming back, the same wild winter geese
that flew away last spring. Out here, I keep a rifle loaded,
knowing coyotes and bobcats starving for goats

will hide until they see me leave, then stalk
and pounce on a kid that strayed, its bawl and whine
swallowed by the storm I'll listen to inside in the dark,
a hundred goats today, tomorrow ninety-nine.

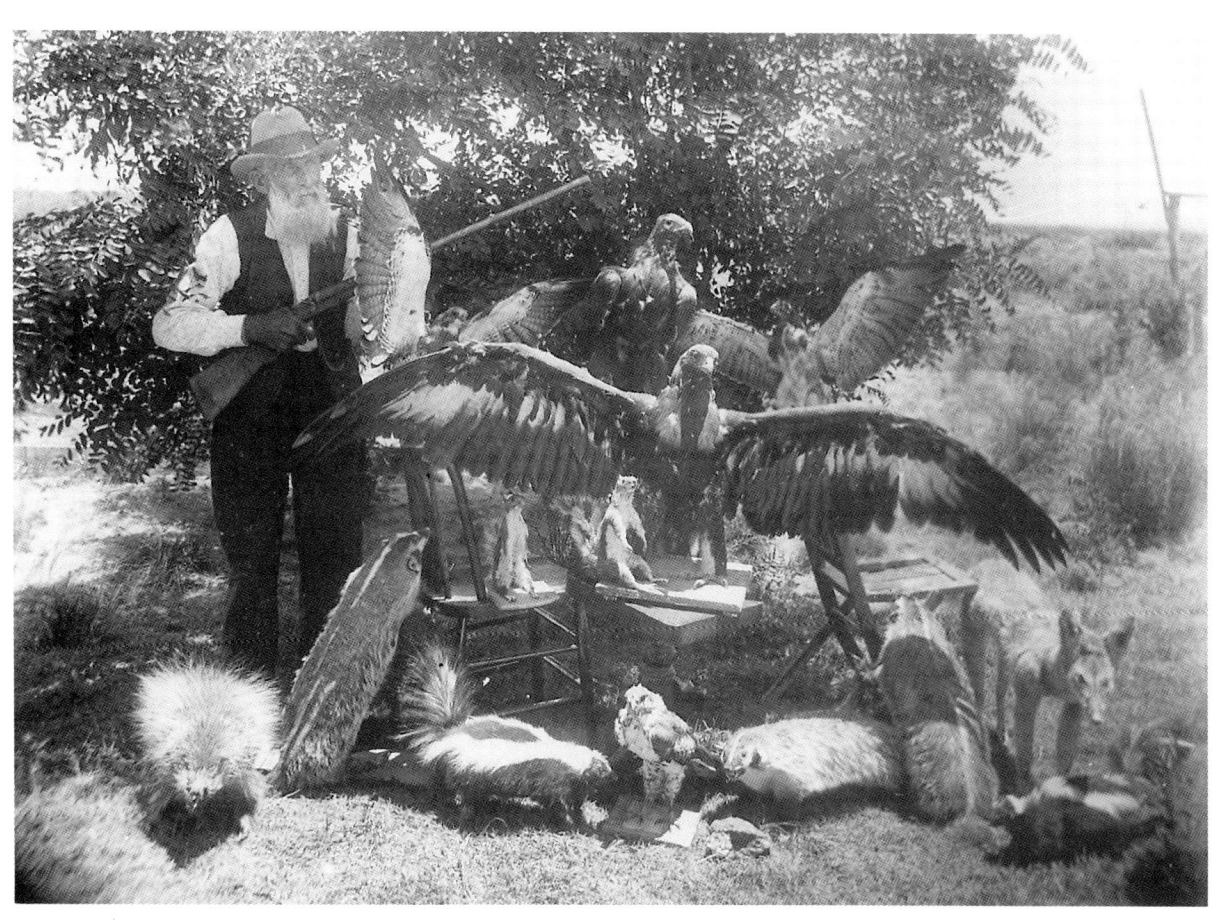

In a Dry Season

In drought, we mulch stalks
after harvest. Cold winds
can't blow stiff fiber and clods
like adobe. Willows and oaks
hoard moisture underground.
We do what we can, our house
dry as an ark, roof patched,
lightning rod lashed tight,
waiting for rain.

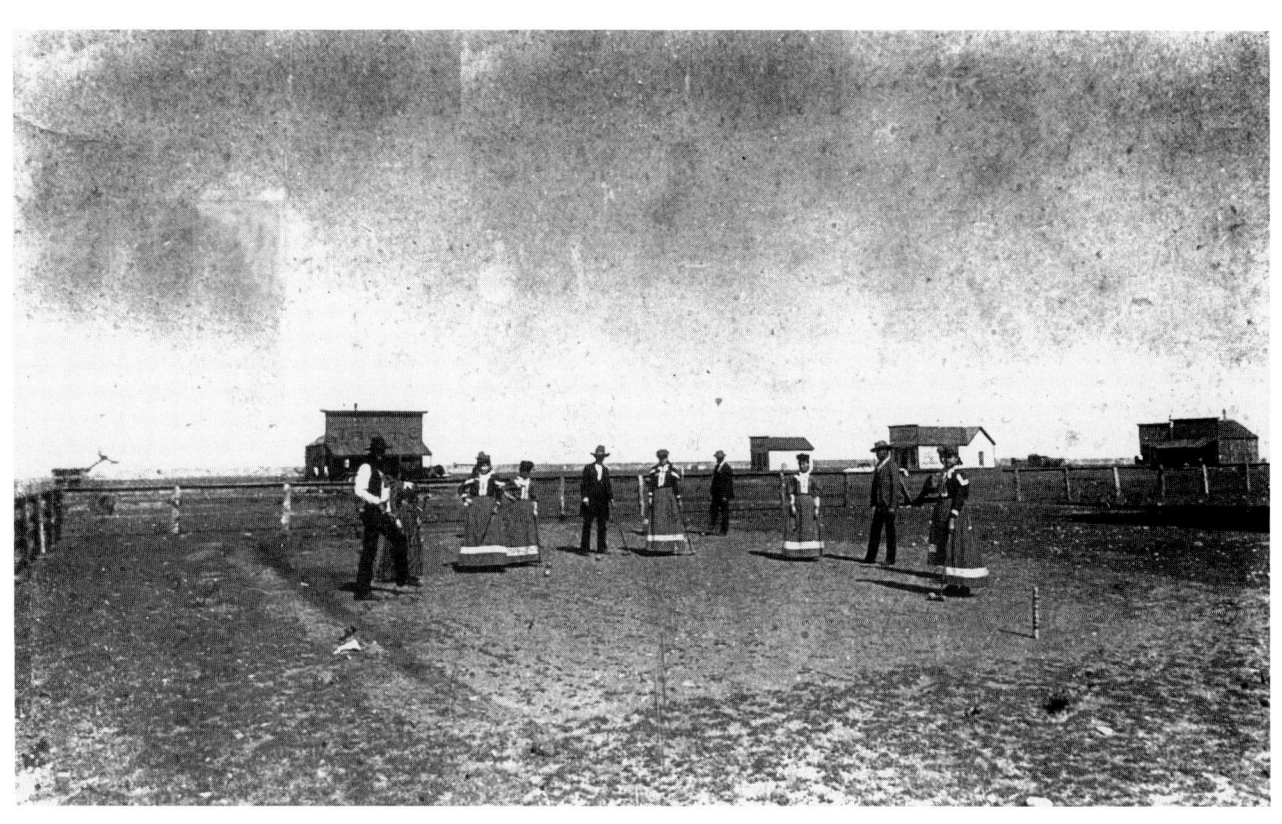

Aunt Myrtle's Albums

Her poodles taught fat cattle how to run, nipping
their flicking tails. I was a summer cowboy on her ranch,
a nephew roping green mesquites. Her dogs trotted off,
too dumb to know a roped stump was a bull.

Picture frames crammed her mantel, sisters
and nephews, babies of brothers around the globe
like faces she prayed to. Honey lined her walls,
jars of sticky comb and gold, alfalfa honey.

She stirred hot tea too sweet, and sometimes hugged me.
In a trunk, I found a picture of her on Guam, a Marine
with captain's bars, but younger, cleaning a bayonet.
I asked what her medals were for, if she had killed.

She watched the walls and rocked, and let our sips
be silence. When clouds threw thunder down like bombs,
only her parrot talked. Some nights, I ran to the porch
and watched, thunder so close the dogs shook.

She taught me cattle bawl because their world
is stubble. Without babies to wake her,
she could have flown to Cancun, the beach at Maui.
Nights, she opened albums like code, faces

sober as stumps. She showed me a pound of photos
in her purse, her husband Uncle Roy long gone,
brothers and uncles lost in two wars, a world
of nieces and nephews climbing high wires in a storm.

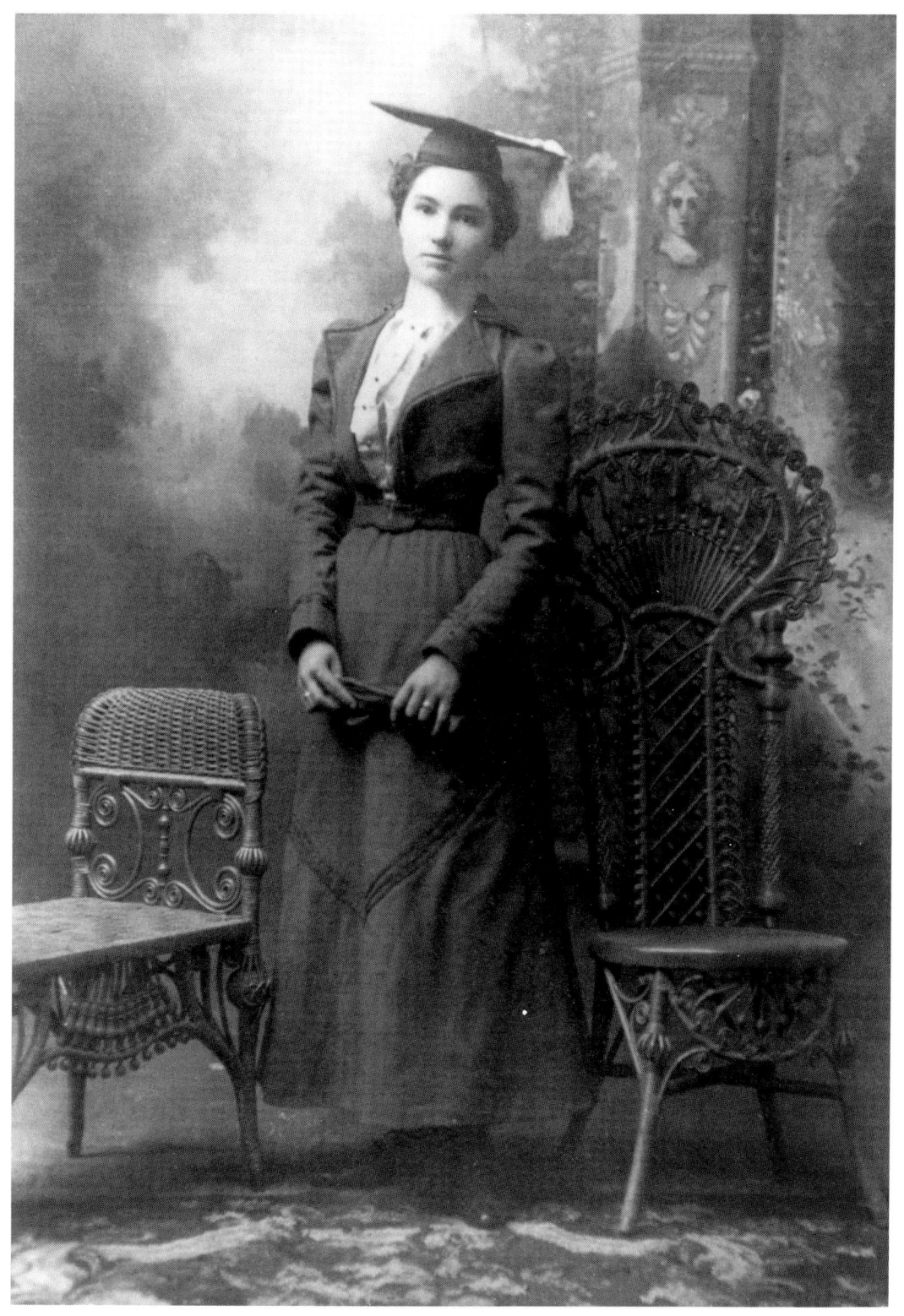

A Hatch of Flies

Dad, with his belly full of jelly biscuits,
swung both heavy legs, and hounds jumped back.
Watching, they arched sad, pouting folds of skin
like brows, hide dangling from their backs
and throats like fat men's after crash diets.
While he mounted, those bloodhounds whirled around
and whined. He clicked his teeth and sighed,
bowed his stallion's neck back south,

and I followed, my pony bouncing my butt
like the fattest hound up and down out of canyons.
I watched the last stars disappear, the orange sun
swallowing them all. An hour on the trail already,
my first time out, the posse only us
and deputies Daddy kept around
for talk, inside by the fire most months.
This would be easy, a runaway to be found,

said to be dangerous to no one, but a blizzard
was roaring down from Kansas. Always he caught them,
boys from reform school, robbers, or shoplifters.
Even when the moon was full, not many killers
on Texas plains. Owls and hawks surrounded us,
I thought, coyotes and antelopes keeping watch,
backlit by skyline. Oh, I begged him for months,
already five, let me play cops and robbers,

begging my sheriff daddy until it was safe
to take me. Now the hounds found the trail,
barking and howling, warning the bobcats away.
We followed, almost a gallop, sliding down shale
to a canyon, dogs tracking the boy from his home.
Whining, they leaped back and sniffed at his feet
between cactus. I heard the lazy, ferocious drone,
and then I saw the flies, buzzing, but not like bees.

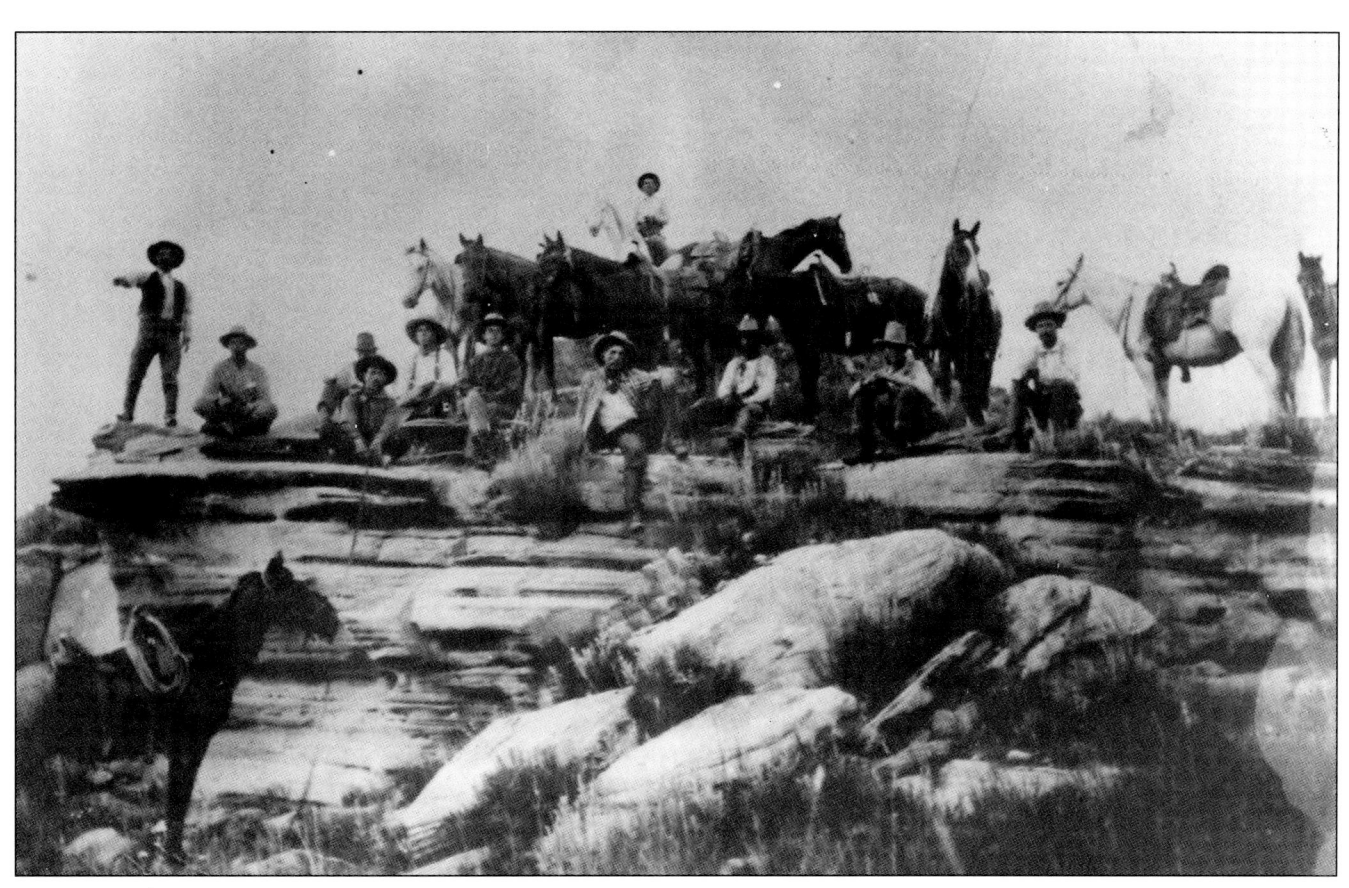

A Wide Continuous Sandbar

We built our tabernacle barns for the gods
called crops, storing new grain in silos.
Each May, I dribble seeds and cover all
like tracks. Even the breeze and shape of rows
seem the same, a seam of mud at each edge,
a wide continuous sandbar. Tomorrow
I'll cut the stalks with blades Grandfather saved,
six months a puff of dust. How many crops
since our married children were babies?
When maize is the faith we plant, we give it back
to the dirt in rows in spite of aphids
and hail, hoping for harvest after drought
and showers twice a season, if it rains.
Born on the plains, we worship the god
called If: if our children come, they'll come—if all
is well, that many weeks away. The birth
of grandbabies may save us till old age
if the sun lasts long enough, if God's still
in His heaven, if we're still on the earth.

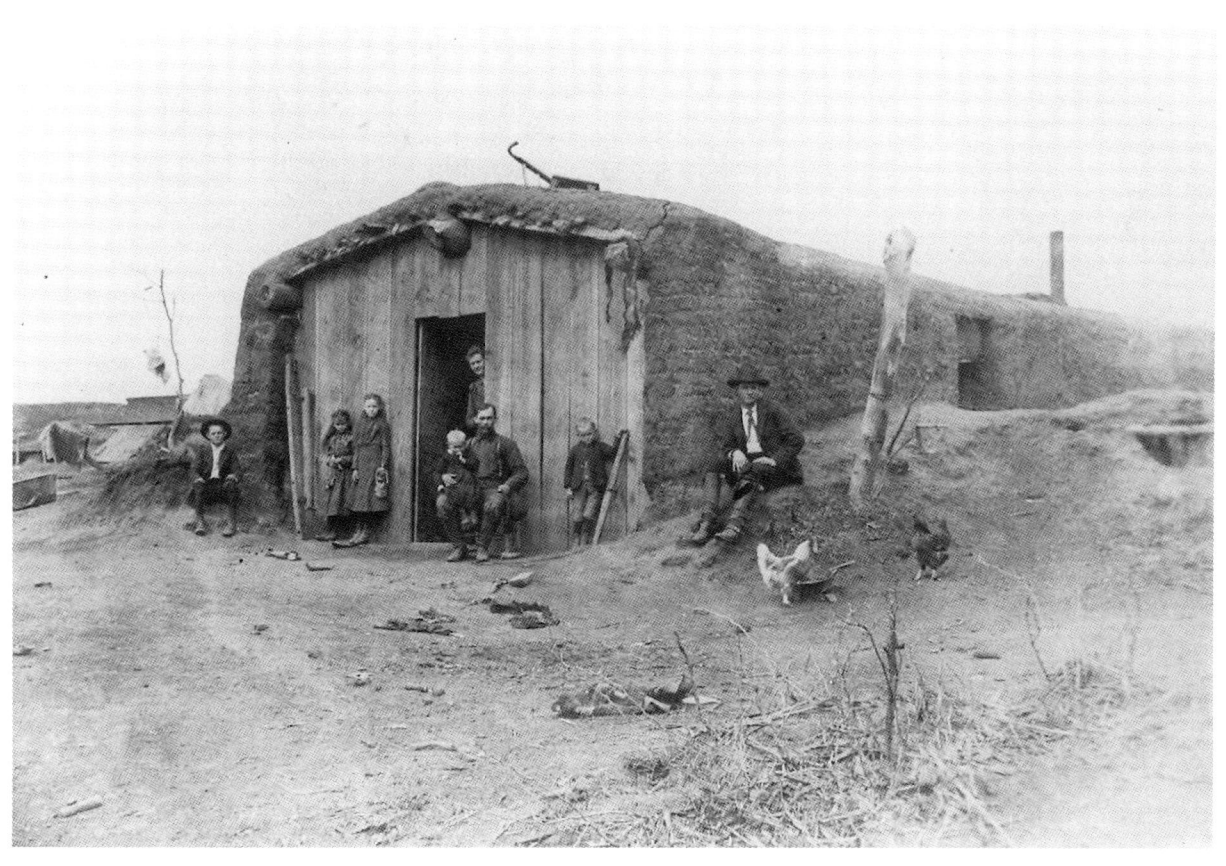

Grandfather's Matched Palominos

Here's the hack Grandfather bought in Austin,
saved by a tarp like an awning against dust,
the droppings of barn owls. A postman
and circuit rider before World War I,

he brought parcels and the gospel to cowboys
and squatters, married a rancher's daughter
and bought this buggy for their babies.
Mules could pull it, but later Grandfather hitched

matched palominos, the only vain things he owned.
No other horse or Model T could beat him to the hunt
or steepled church in town, the first shack on the plains
with bats. He gave up all he owned for war,

forty when he left for Flanders, captain's bars
he bargained for like Faust. I knew him old,
a humped man laughing at my hand stands
and wobbly somersaults. He applauded

and tossed me candy he kept like magic
inside his roll-top desk next to his rocking chair.
He never showed the scars, the pistols I wondered
if he brought back. He gave away his medals,

everything but Bibles and the ranch.
Mother's brothers sold the ranch and left her
with investments and what was still in the barn
after auction, a saddle with a broken horn,

assorted ropes and bridles, the branding irons
they didn't take, a framed tintype of two palominos,
the hack with a cracked leather whip
my mother claimed he never, ever used.

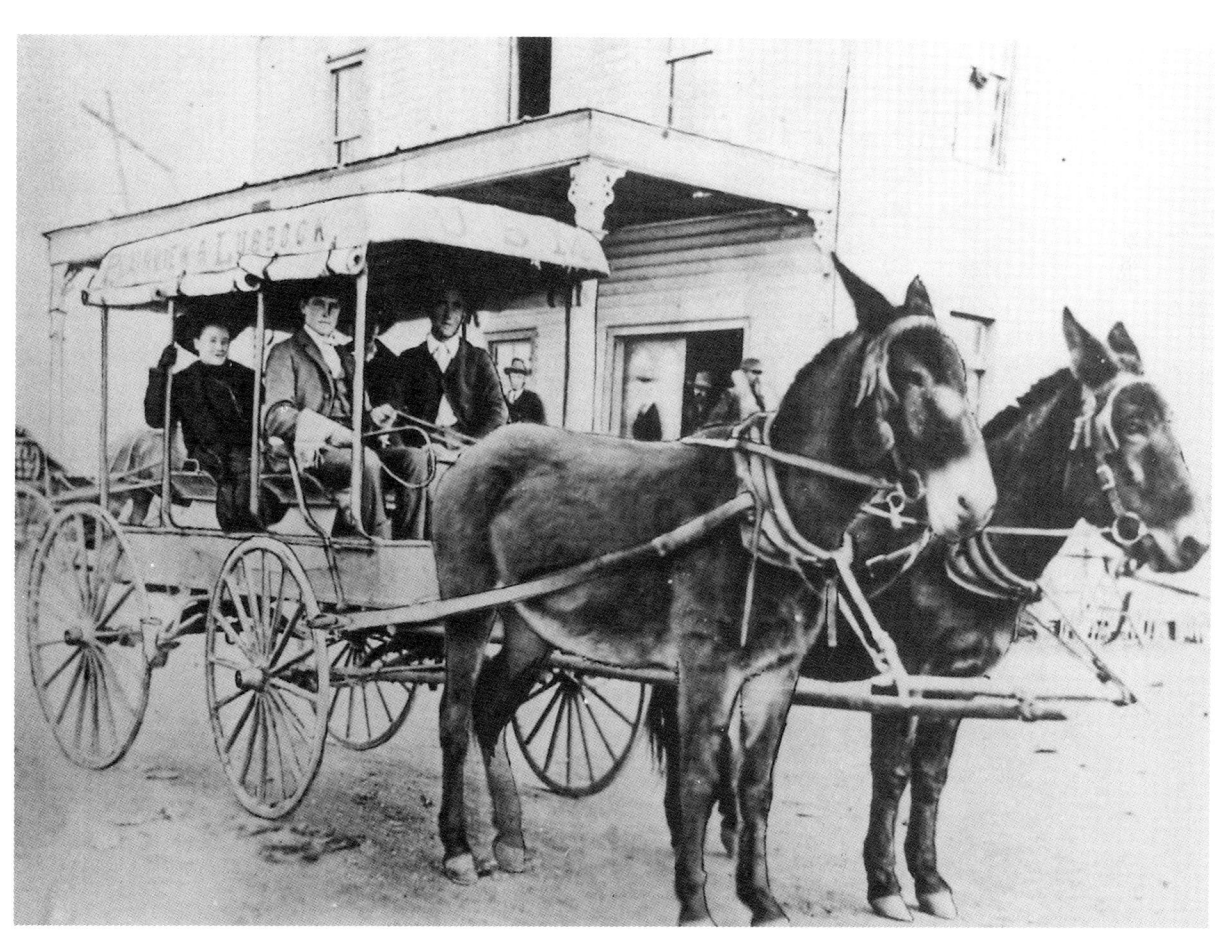

After the Madness of Saigon

Today I'm sneezes and sniffles, turn my head and cough.
Dogs slink and drop their ears and whine when I jog by.
They've seen that look on cave men flinging firebrands
from the rocks. Pockets turned inside out say to the world

I'm broke, no patience with myself, so watch it.
I may kneel down and take your paper from the street, flip it
closer to your door. If there's a nail, I'll take it, too,
the worst of broken glass some schoolboy tossed

to hear the bottle burst behind his pickup roaring by
at midnight. I'll turn and fill somebody's dumpster
with trash and road kill by the curb, and crushed
magnolia blooms from last night's storm.

Finding another old vet at my door, I'll fling
the screen door wide and loose the puma for her daily prowl.
That sad old friend and I will rock on the porch
with dozens of others, telling dumb jokes and screaming,

sipping coffee, scarfing on pizza and beer. Stuffed,
we'll cruise the neighborhood, helping up bums from doorways,
patching the widows' roofs, as if healing the deaf
and crippled, paying all people's debts.

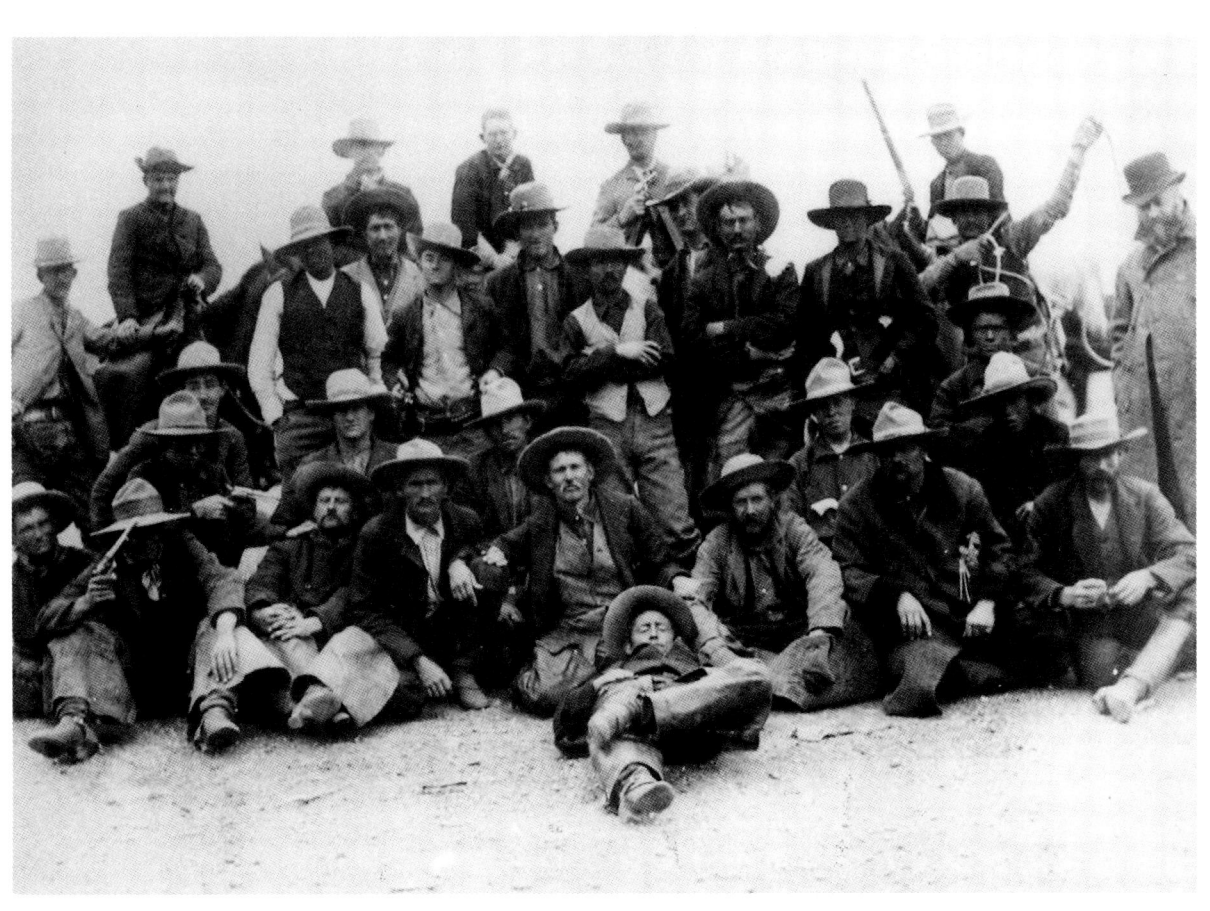

Living in Old Adobe

A moon like this is money. Fat cattle
believe it's dawn, grazing by the barn,
addicted to alfalfa. The moon is ripe
for coyotes. Skunks waddle boldly by,
pretending we can't see them, two by two

into darkness. The porch swing groans
on hooks as old as us. Granddaddy
built this porch to last, oak planks
imported from forests. How many nights
did they rock here, seeing the stars we see?

Did they hope a burly grandson
would hold his own wife close on chains
we didn't hang? Now we're their age,
or older. Grandchildren we adore
are sleeping tonight in Dallas.

They dream in beds and cradle, starlight
flooding their ark. Dolls and bears
are locked in their arms, animals we gave,
accepting these creaking chains,
coyotes a mile away, all waddling skunks.

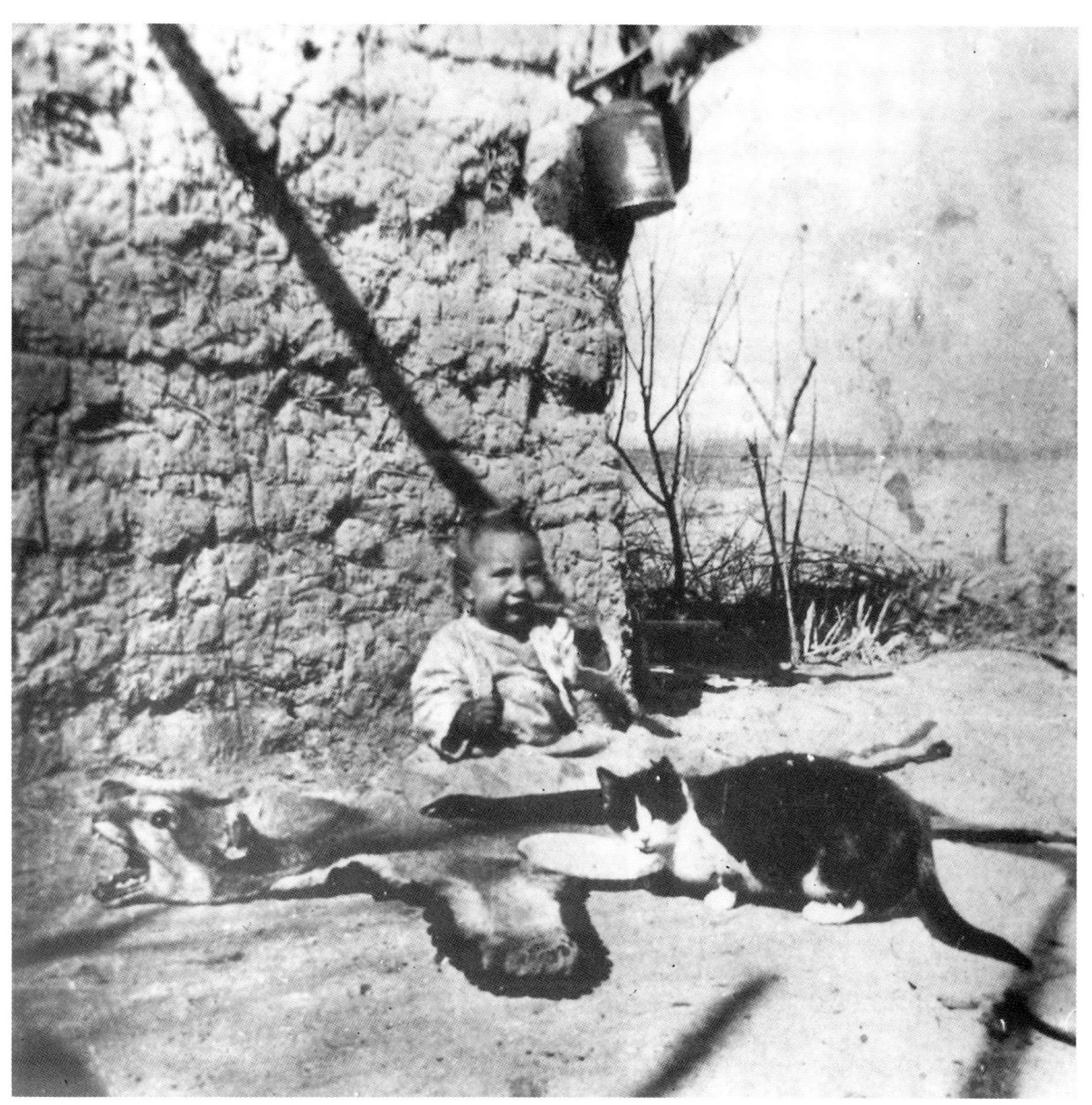

All Occasions

All occasions invite his mercies, and all times are his seasons.

John Donne, *LXXX Sermons***, 3, preached on Christmas Day 1625**

Hosannas Dangling on String

The sun seared flecks of gray
and silver in your hair, a flash
of blue light in your eyes.

Shadows left this covered porch
an hour ago—dusk, the start
of what we now call night.

I like the long boring hours
before midnight, the stars
flung out to wide horizons,

always a breeze to make chimes
ping and jingle on the patio.
I don't need light to grope

and touch what matters
while the habit lasts,
the rising up and falling

of the sun, the blaze
of lavish hours, the swift
and silent dying out, after wild

hosannas dangling on string.
I know the halo of your hair,
the deep-set hollow of your eyes.

Wife, I'm stunned by more
than this screened porch
that shudders when I walk

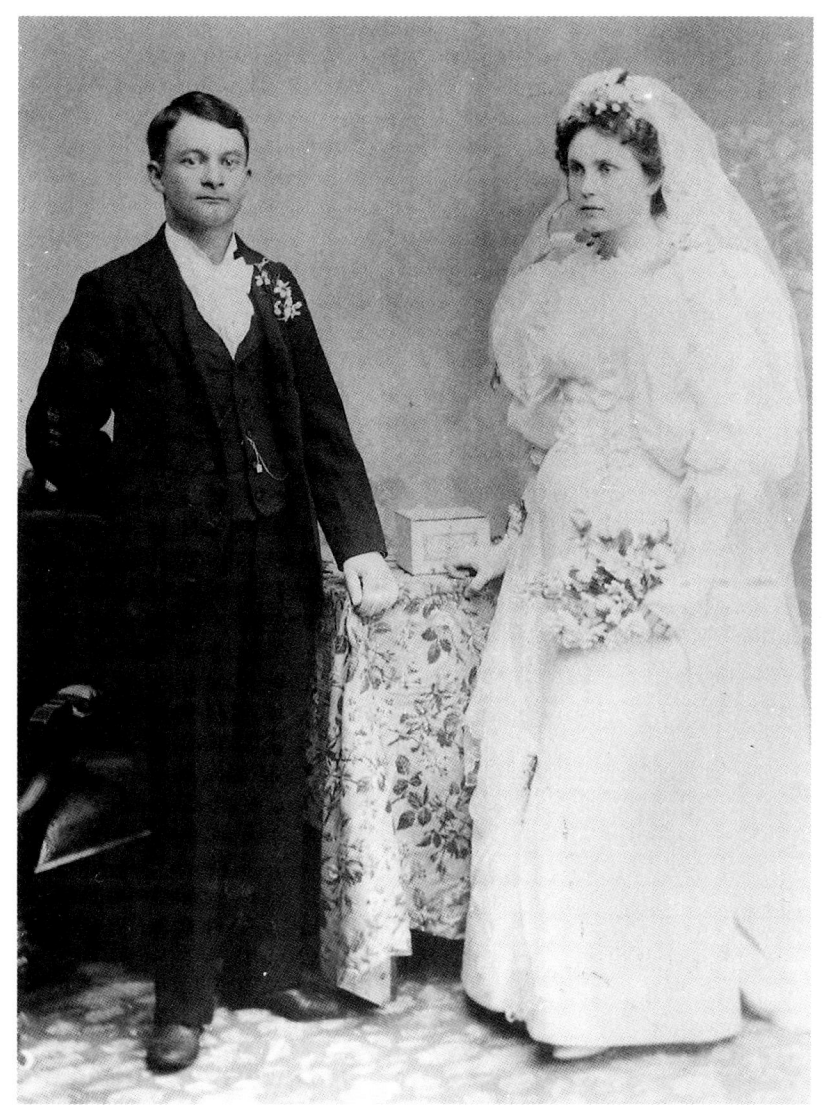

and fall back with you
on the swing, extravagant habits
I don't understand, secrets

familiar, within reach,
even the calm and steady
squeezing of your hand.

Nearing the End of the Century

I'm trying to light a candle in this cabin
a thousand feet from the dam, in a storm
that knocked transformers out at Abilene.

Thunder cracks and rumbles down the canyon and back.
The pine door shudders, and glasses rattle
in the cabinet. Red lights of the clock

flashed off at midnight, and I'm fumbling in a cabin
built by elves, drawers stuck and always misplaced—
sharp knives where spoons should be, candles mixed

with napkins and corkscrews, but matches missing,
like hide-the-thimble. My wife's voice calls
Come back to bed. But I've crawled this far out

on the ledge of my male ego and won't let a little thing
like a match defeat me, turning, bumping into chairs
and light bulb dangling like a snake,

knowing I'm all bluff and blunder in the dark,
trying to build a circle of fire for my wife,
our married children hundreds of miles away

on busy streets, asleep in cities
lit by a billion kilowatts, nothing to save them
from what's coming, not even me.

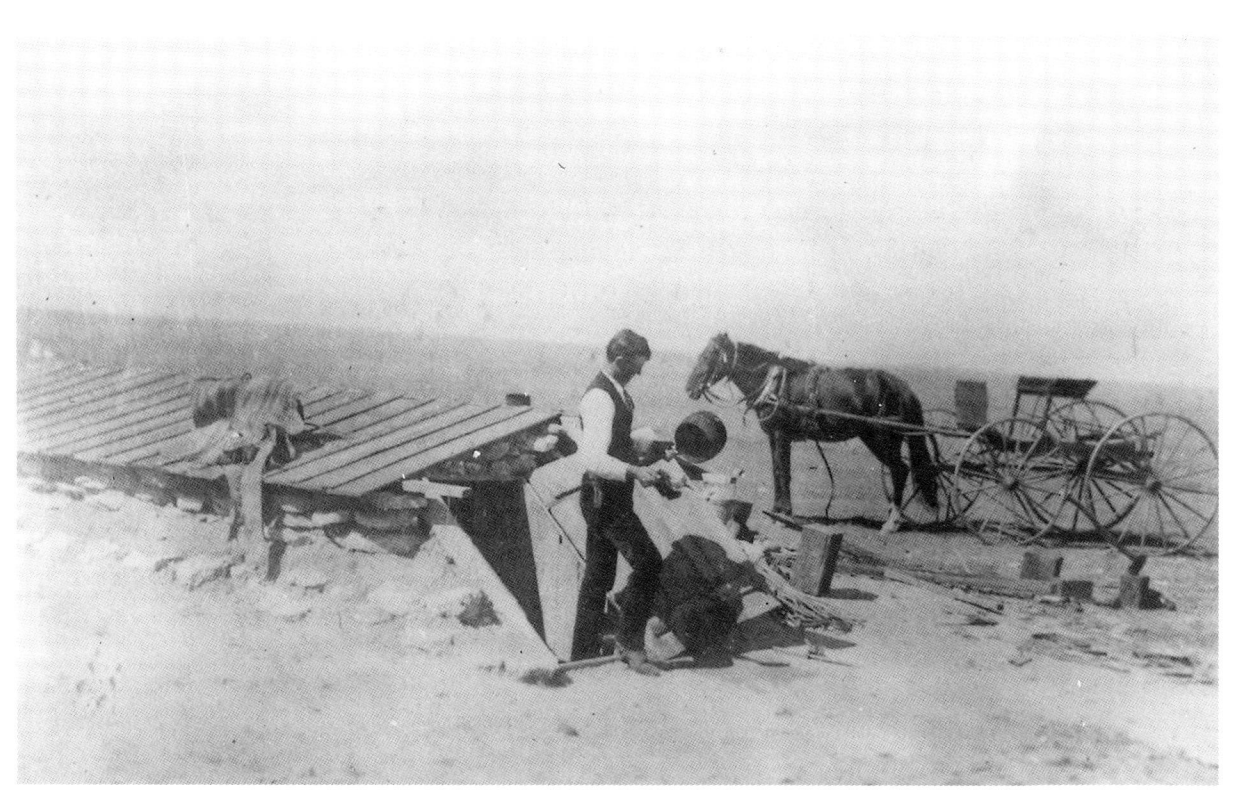

In Hot Hardscrabble Skies

Buzzards convene by the fence, a board of deacons
solemn and formal. Glistening with morning dew,
they strut and turn with the sun, drying black feathers
in the heat. One by one they rise, big bellies
dragging them down, wide wings flapping

awkwardly up, then soaring on thermals,
gracefully gliding for hours. Always they dip
and fade away to something down in the distance.
Year round, they hang in our skies with answers,
arrogant and curt as our bulls,

taut scrotums bold and shoulders massive,
blunt skulls defiant behind barbed wires
stretched to bring a stuttering fool to his knees,
bulls sane unless a cow in heat sways by
and the breeze is brisk. But nothing

keeps those far, dark angels away for long.
Buzzards are wise men following the breeze,
the snot and drivel of their beaks.
If we're in time, if we find the calf
before the coyotes find it, before the buzzards,

we lift the injured calf to the saddle like a lap dog,
or if crows have pecked the eyes or the belly's burst,
we shoot. Those days, when we ride home,
they're already down, bowing as if in prayer,
ripping, clacking their beaks.

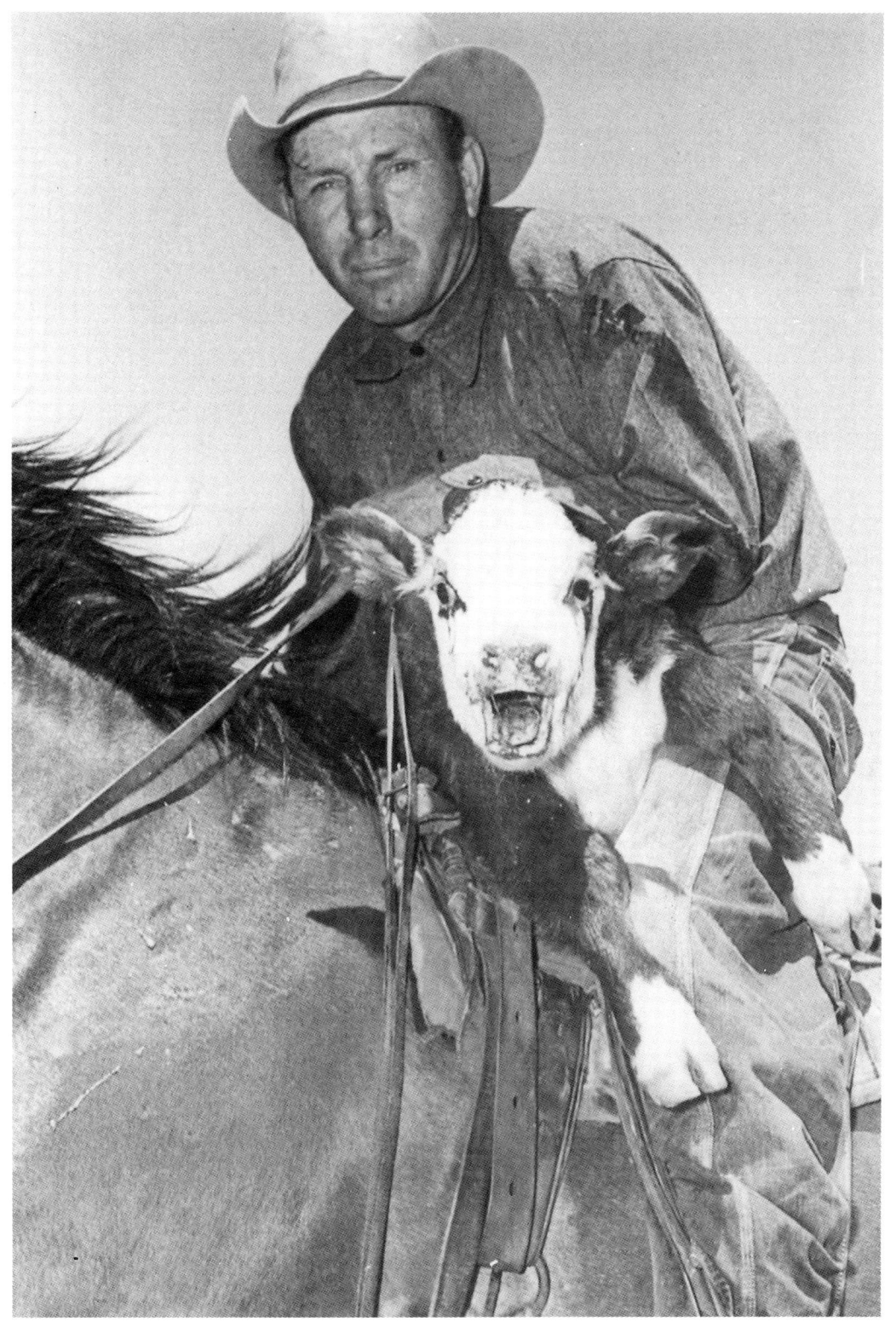

For Dawes, on Takeoff

I could have died
winding down the caprock road at night
driving hard to reach my father's bedside.
Canyon shoulders like the best vows
cave in, caliche ruts that crunch
soft as quail bones.

I drive black roads to work, now,
tar roads soft all summer.
They whine on tires that spin me asleep.
I might die asleep, the calm habit we have
of saying of uncles, he slipped away quietly.

I could have died like Dawes,
suddenly inverted
two hundred feet on takeoff,
ailerons wired so both went up,
or down. He must have taken off
by faith. And rolled,
in spite of everything he tried,
inverted. Head down, yawing,
jerking the stick,
he must have squeezed the last controls
still working, ejecting downward like a dart,
and why not, about to crash anyway.

They found his head
stuck to his helmet.
In trees downrange, they found his arms
flung out from the body as if asking why.

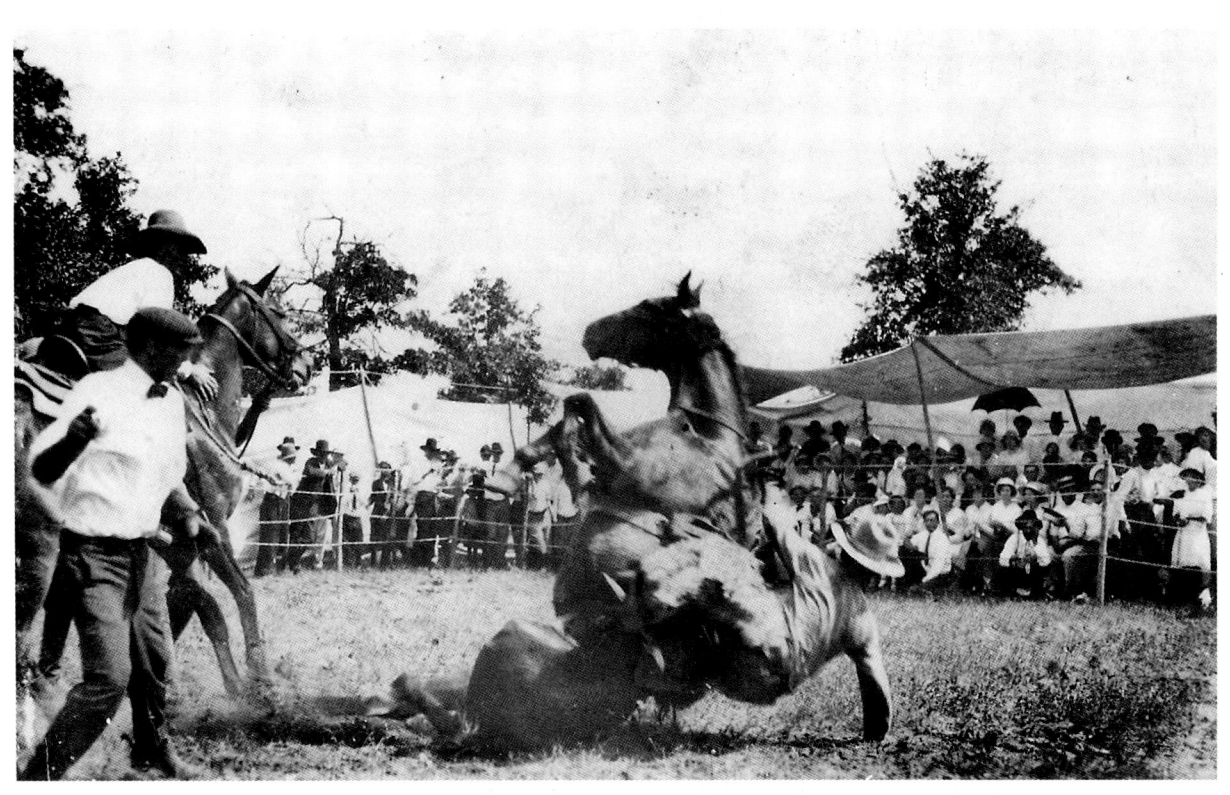

The White-Haired Trial Judge Deliberates

The books, yes all the books
are here, shelved like anchovies
along my chamber walls,
canned applications of the laws.
My thumbs with clean, blunt nails
know how to open
and shut a case. It is not
precedent I need. I know
what to do. They call me
Bulldog Thurmond: I cling
to a case until I find its jugular.
I know what I would rule
were I the appellate judge:
sustain the trial judge.
There is no doubt. The prosecution
has draped its burden of proof
down around my shoulders
like a robe. I know
the word to say.
For a minute more
my lips are sealed. Saying it
is the human duty,
is why they cry Your Honor.

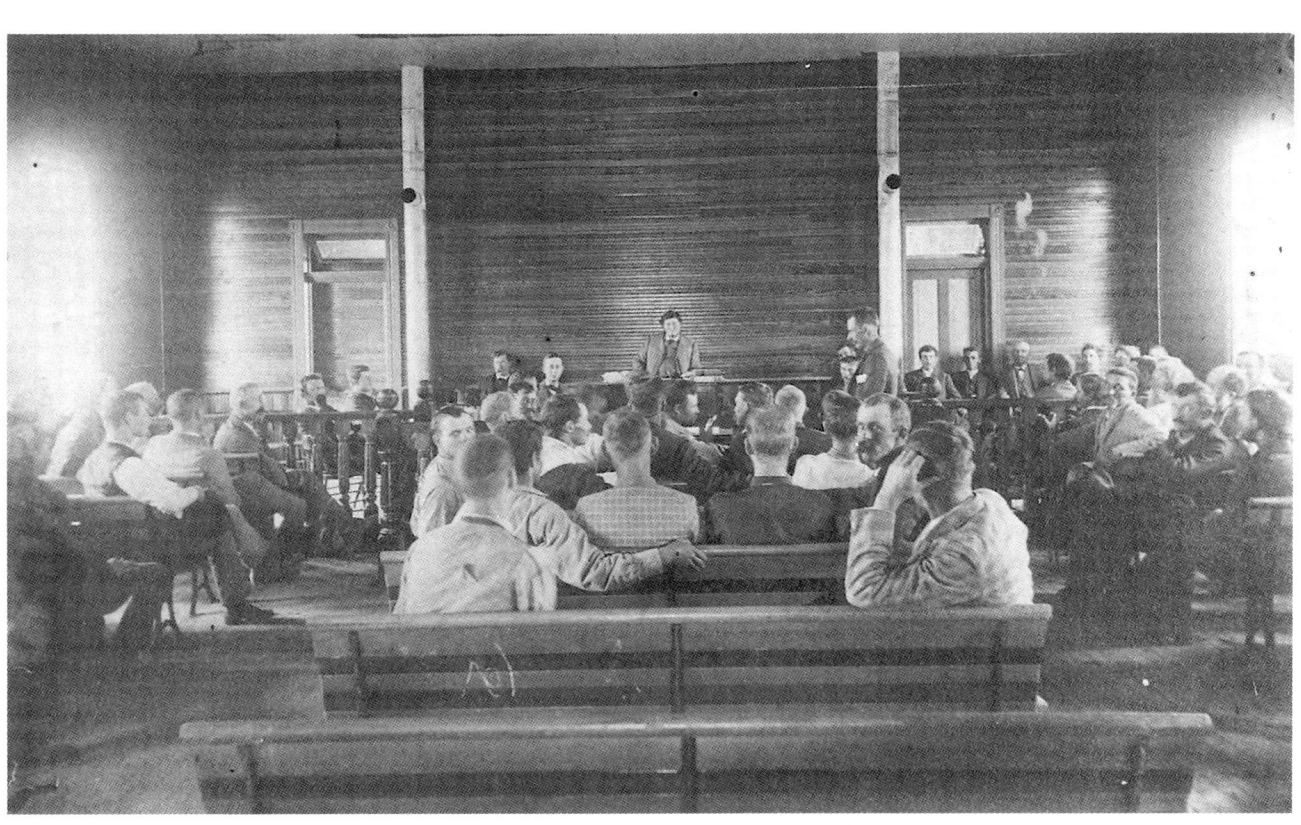

Hardwood Rocking Chairs

Today, there's ringing in my fist, the hand
I pitched with, still strong enough to hold
a ball, that held the pledge and wedding band,
her finger accepting the only gold

I gave. I haven't made a fist in years
to hit with, nothing I didn't do with this
I didn't do with the left, but pain appears.
Poor circulation, nerves, arthritis—

knuckles broken years ago, no thunder,
but far-off storm clouds threatening rain.
Spread wide, the fingers tremble as if numb,
relax back into a fist, lifeline the same

after all these years, the M in my palm
still mine, already past the age foretold
decades ago—that girl in college who calmly
licked her thumb and rubbed it slowly over

my palm and stopped at the crease of my wrist.
I think of her that way, as if she hasn't aged:
her skin like vellum on my tongue insists
she's young as she was, excitingly the same

as memory, although I've heard she died.
My own hide's rough and puckered as a bull's,
my wife's exciting face wrinkled like mine,
more like each other's, now. Her beautiful

graceful fingers and my own fist hard
with clumsy knuckles are matched like hope
and hardwood joints in rockers carved
and glued and creaking, fitted years ago.

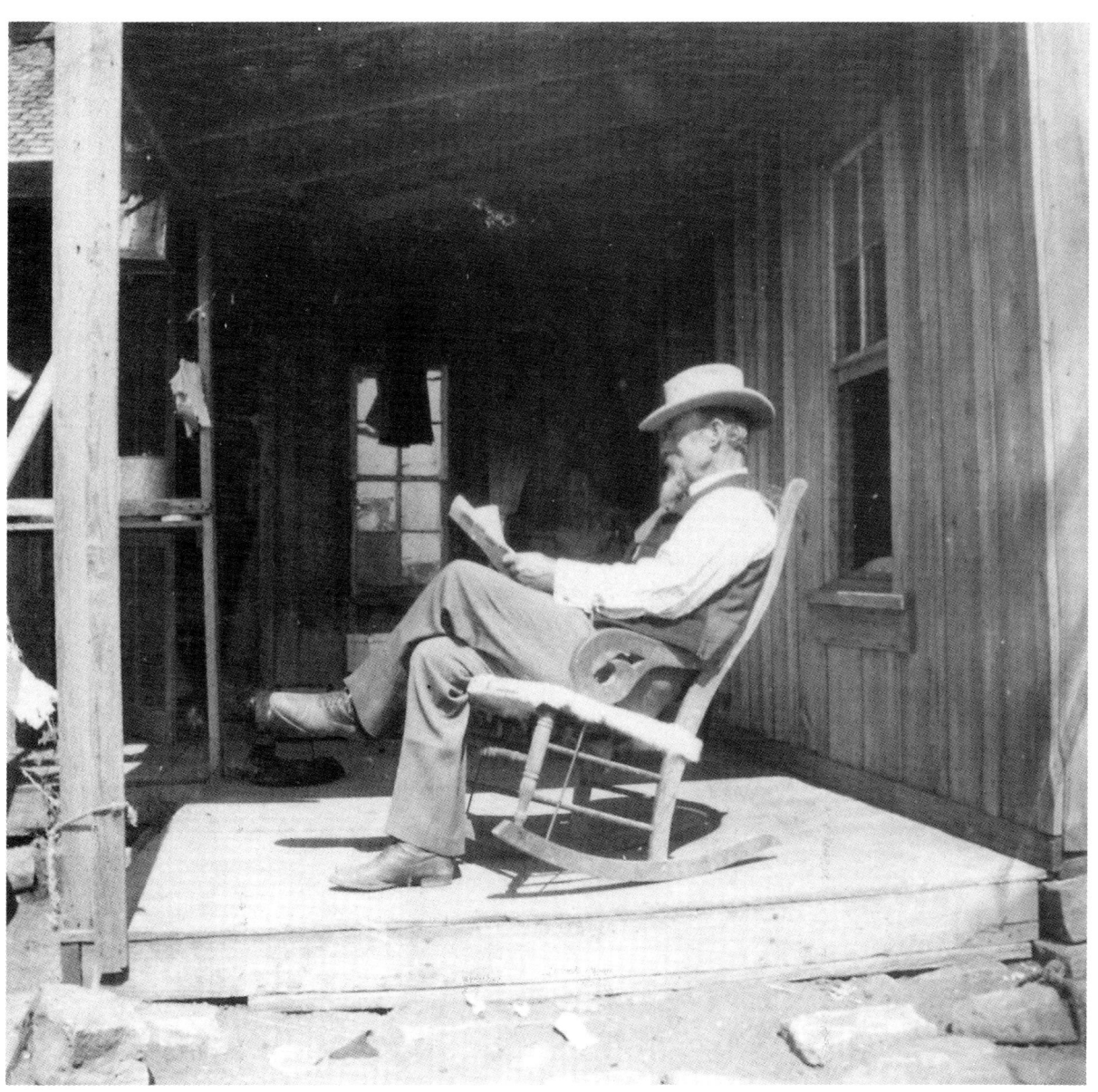

First Solo

I see her thumbs-up sign
go down to take the throttle.
She turns away, chin up
and urgent, flesh I have held
in these two hands. Until now,
I could have saved her.

Rolling, the Cessna gathers
faster down the runway, leans back nose-up
and lifts. Light shimmers between her
and the earth. The wings bounce
through bumpy air. I feel my spine like hers
slam down into the seat.

Was it enough, what I gave her,
the dual hours, the time in bed
rehearsing with our hands,
the emergency steps we drilled together?
If something should happen to me,
I said, be able to land,

then worry about a doctor.
And she was willing,
bouncing her first dual landing,
ballooning to fifty feet and stalling
before she eased it down.
She banks, now, gear down,

falling in a turn
toward final. Nothing I can do
on this hot day but beg the pheasants
nesting in fields north of the runway
to stay clear of traffic.
Bring the nose down, down,

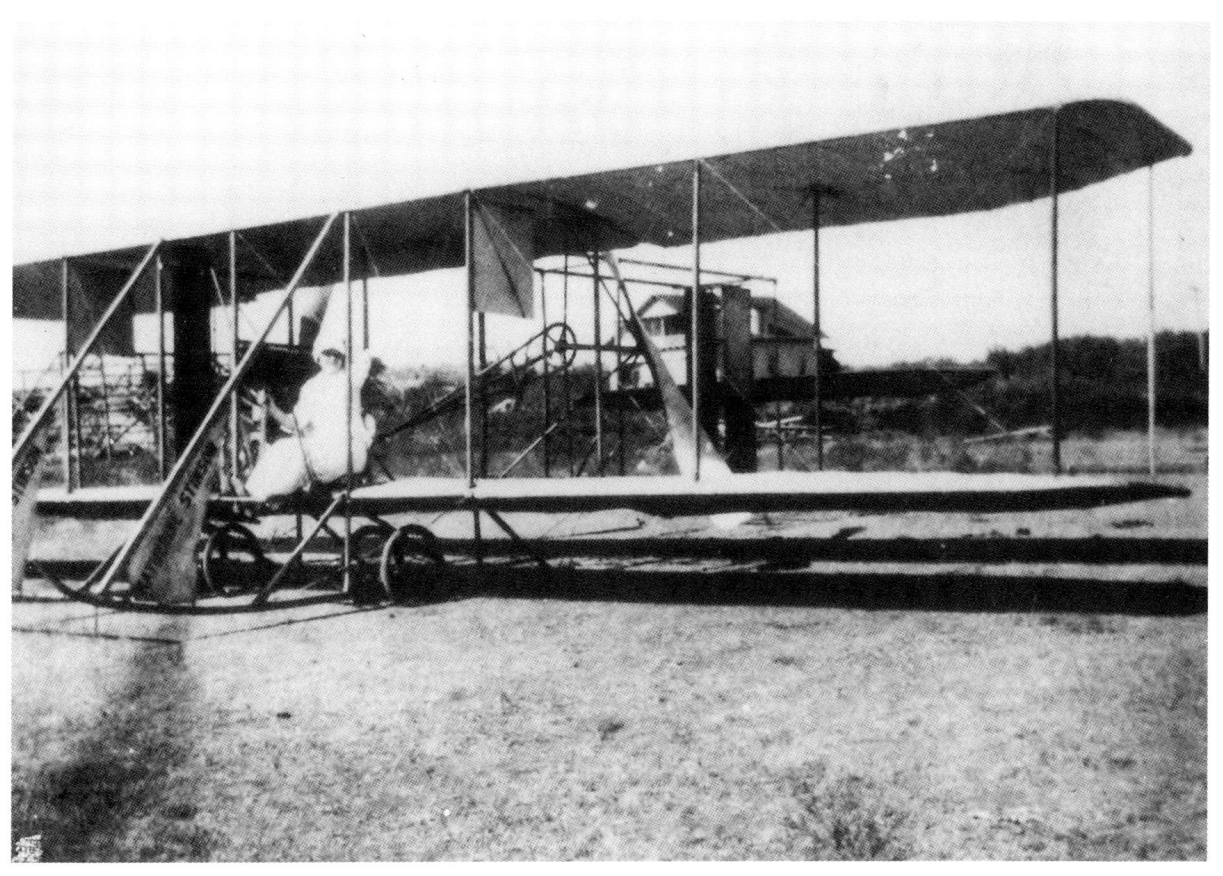

don't reach, believe the glide
will hold you, the nose
rise in the flare—There!
her wheels touch, lovely,
and faster and faster, she's off again
into the sun, the wild blue.

What's Up?

Landing at night in pilot training,
one buddy rolled inverted, then panicked
when the instructor called *Pull up!*
pulled hard straight down into the ground.
That fireball posed the puzzle for us all.

I've dangled from cross bars, flown inverted
ten feet off the ground, cocked back my head
and stared at good earth flashing by.
Whenever I look up, it's there.
I've asked the question on my knees,

in bars and bunkers far from home.
I've tumbled on the floor with grandsons
who tugged my beard and squealed.
I can't explain the simplest riddles
even the toddlers ask—where a duck goes

when it snows, if they'll grow old
like me, if they'll go fight a war.
They look me in the eye as if I'm wise,
a kind old man never out of candy,
always good for flipping books

and giving horsey rides at bedtime,
an old softy, a block of salt
they kiss goodnight and leave
to his business, time for parents
to tuck them in, those nimble,

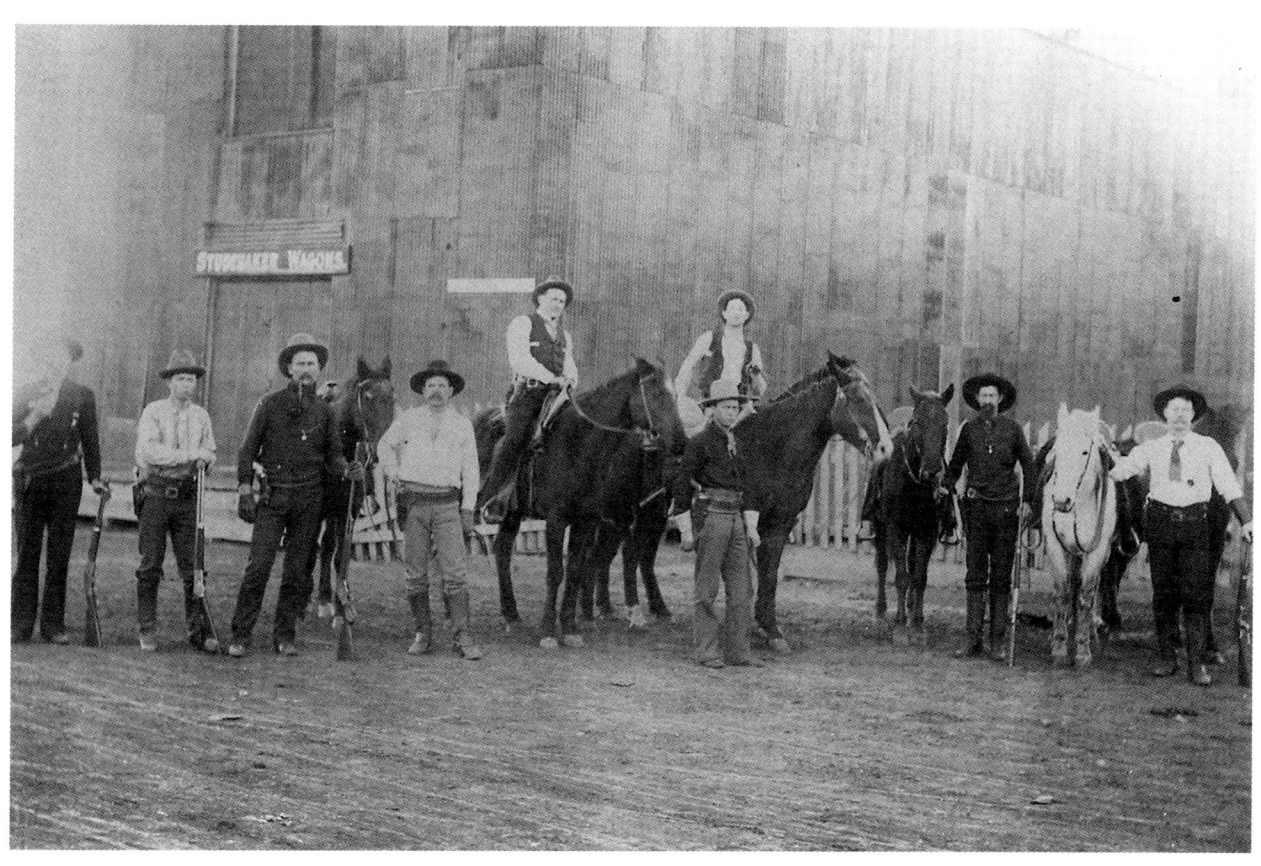

stronger people who hold them tight
after nightmares, who show them
ghosts on the ceiling are merely shadows
from the night light—cartoon dogs
and angels, winged horses flying high.

First View of the Enemy

Uncle Homer slapped us with his eyes,
a tap in the barn like bear cubs.
Butt first, we gave the pistols back,
not Cain and Abel. We only wanted
to copy his slow, bow-legged walk
and hold his cold pearl handles.
We asked how many men he killed.
Our daddy bragged about his brother's
badge, his limp, his hollow points.
Quietly, Uncle Homer led us outside
and spiked a round, green melon head
on a post. I punched my brother's ribs.
I saw the flick of my uncle's arm, blinked
at the single shot he squeezed off,
a sharp, flat flash. I flinched
when I saw the pink mush burst.

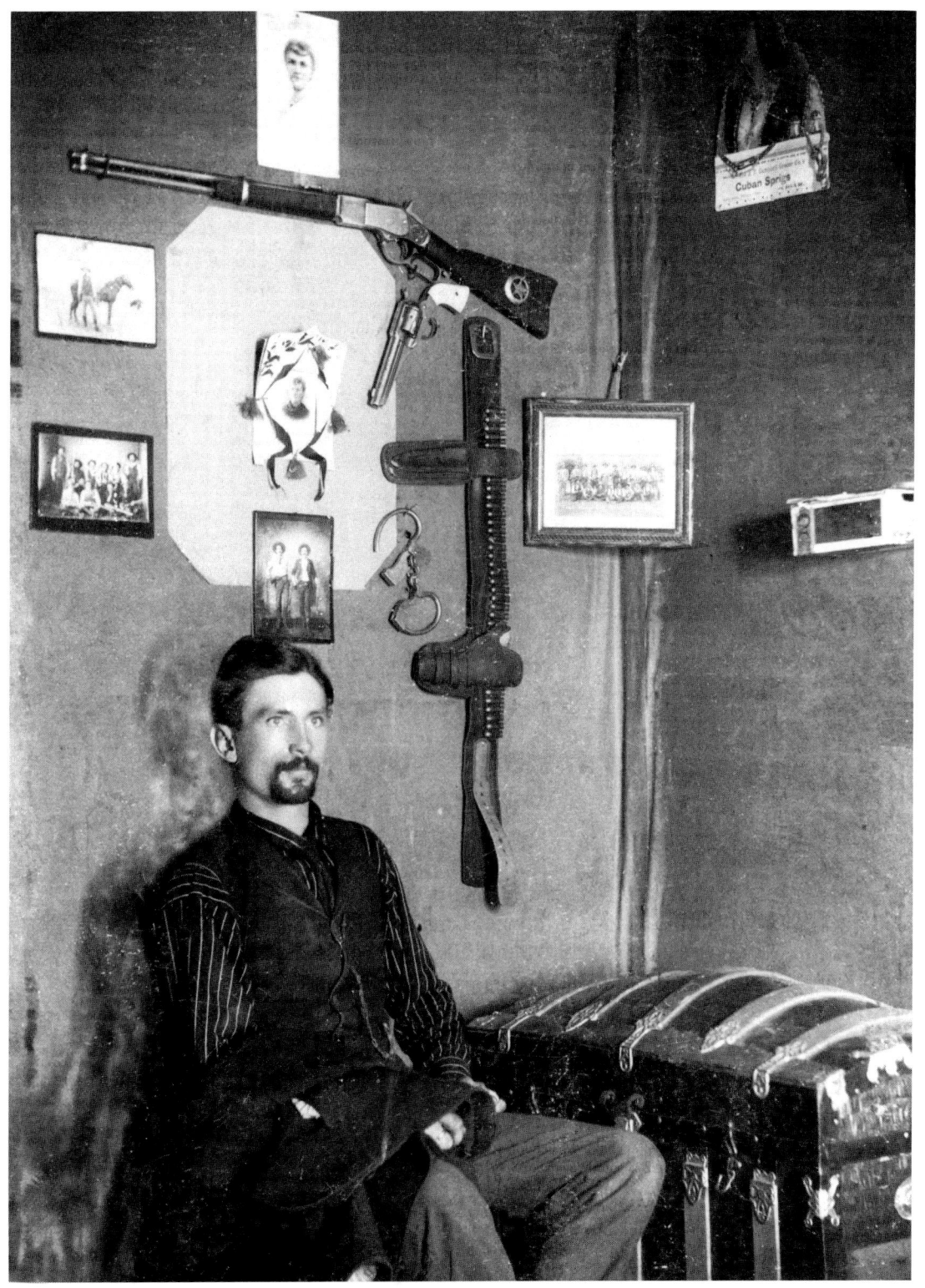

Never in My Life

had I heard my father mention love.
By twelve I felt something missing—
a girlfriend, or millions of rabbits
I needed to slaughter. By twenty I knew,
but told myself it did not matter.
I had never told him,

either. By thirty, after years
of emergencies and two children,
I admitted to myself it did.
By forty, after a war and another child,
I resolved before we died
we would say it.
I returned from Southeast Asia

to hold my wife, each child,
to bless or to be blessed by Father.
We shook hands. Months passed
the same. One night they rushed him
to the hospital. Drugged, for days
he lived by shots and tubes.
The night his hands moved

I lingered in the room,
a nurse waiting with crossed arms
while I studied this man
who fought in Flanders.
Bending down
louder than I meant
I called his name.

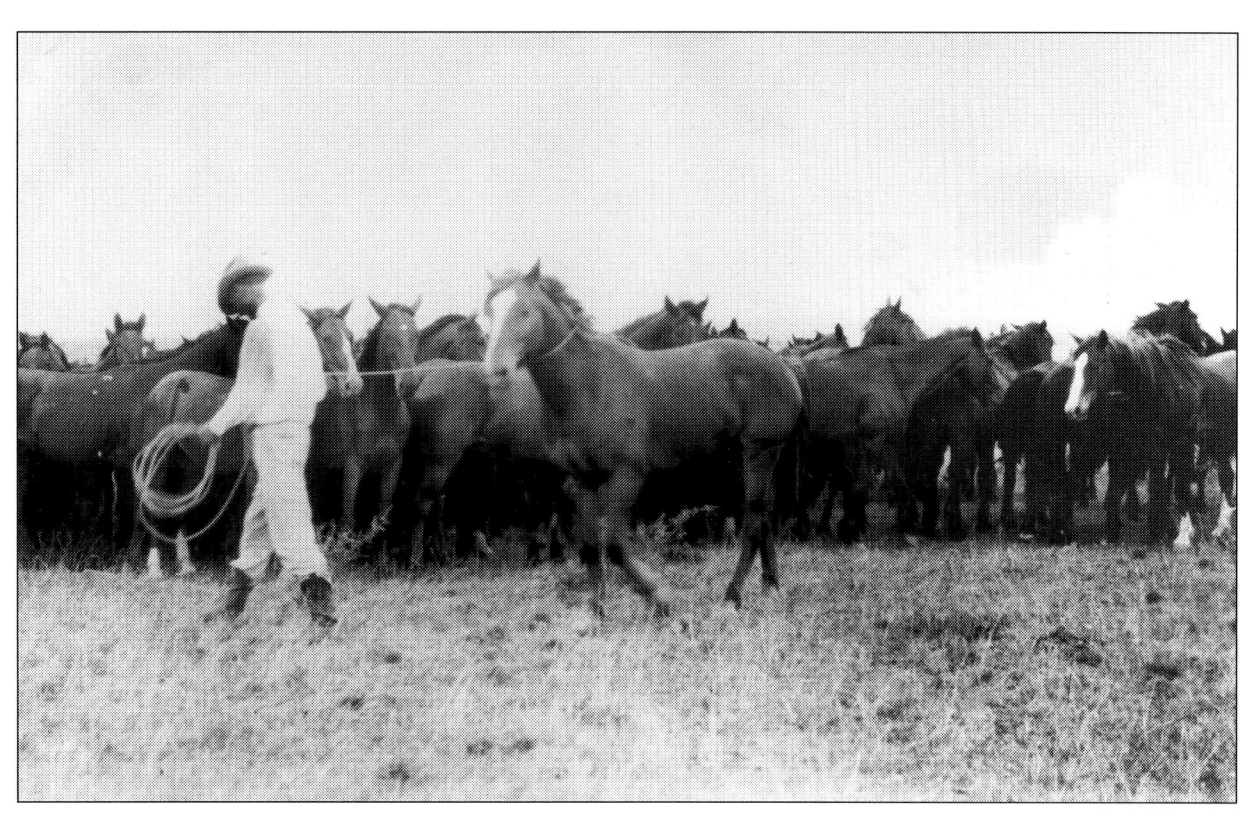

The dim eyes opened,
tried focusing
without glasses.
Up past the failing heart,
he mumbled *Humm?*
I touched the blue vein
of our blood that throbbed

beneath his head's pale skin, slowly,
slowly pulsing. I brushed his sparse
white wisps of hair back into place,
held my hand on his cool skull
and spoke the words.
His breathing stopped.
I thought *I've killed him.*

At last his dry lips closed.
He breathed again. Somewhere
far back of the blur in his eyes
I imagined electrons flashing,
decoding this dim disturbing news
for his numbed brain.
Squinting, his eyes sank far away,

away from me and from the ceiling,
down maybe to his childhood
and his own dead father's doors.
The empty eyes jerked back
and focused on my face.
Fiercely I focused too
and kept the contact tight.

Then the drugs drowned him again
in sleep. It was enough,
was all I could receive or ever give
to him. Even in that glaze
that stared toward death,
I had seen him take me in,
been blessed by what I needed all my life.

Consider the Lilies

I lie beside my wife and try to sleep.
The furnace clicks on again, a record cold.
Someone in our hometown tonight will freeze.

Today we searched the parks, the alleys, streets,
found most without fires against the cold.
I lie beside my wife and try to sleep.

The call goes out each fall for volunteers.
We roam the town in cars with heaters on,
resolved that no one we can find will freeze.

Clutching his cardboard home, one wouldn't leave.
He talked, but not to us, fiercely alone.
I lie beside my wife and try to sleep.

We offered blankets and a place to sleep.
He dragged the cardboard shack back to the cold.
Somewhere in town tonight someone will freeze.

I hear the rafters crack, this blizzard fierce.
Unless we locked him up, he wouldn't go.
I lie beside my wife and try to sleep.
Someone in my hometown tonight will freeze.

The Food Pickers of Saigon

Rubbish like compost heaps burned every hour
of my days and nights at Tan Son Nhut.
Rag pickers scoured the edges of our junk,
risking the flames, bent over,
searching for food. A ton of tin cans

piled up each month, sharp-edged,
unlabeled. Those people, ragged and golden,
could stick their hands inside and claw out
whatever remained, scooping it into jars,
into their mouths. At a distance,

the dump was like a coal mine fire
burning out of control, or Moses' holy bush
which was not consumed. Watching them labor
in the field north of my barracks, trying
to think of something good to write my wife,

I often thought of bears in Yellowstone
our first good summer in a tent. I wrote
about those bears, helping us both focus
on how they waddled to the road and begged,
and came some nights into the campground

so long ago and took all food they found.
We sat helplessly naïve outside our tent
and watched them, and one night rolled
inside laughing when one great bear
turned and shoulder-swayed his way toward us.

Through the zipped mosquito netting
we watched him watching us. Slack-jawed,
he seemed to grin, to thank us for all
he was about to receive from our table.
We thought how lovely, how much fun

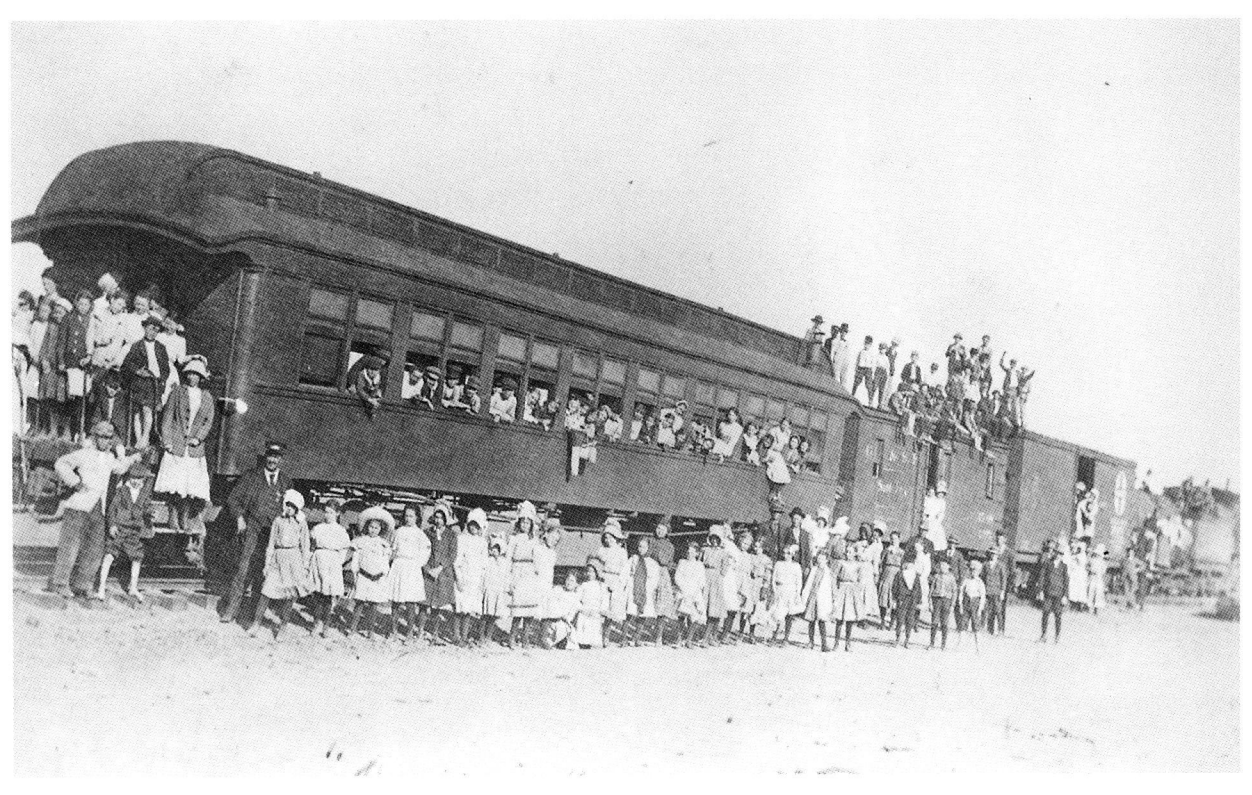

to be this close to danger. No campers
had died in that Disneyland national park
for years. Now, when my children
eat their meat and bread and leave
good broccoli or green beans

on their plates, I call them back
and growl, I can't help it. It's like hearing
my father's voice again. I never tell them
why they have to eat it. I never say
they're like two beautiful children

I found staring at me one night
through the screen of my window,
at Tan Son Nhut, bone-faced. Or that
when I crawled out of my stifling monsoon
dream to feed them, they were gone.

Leaving Sixty

Now the cycle starts, reviving trees
before the last late killing freeze.
Grandfather fought this battle for gold
in the garden. He'd fold his fists
and *flick-of-the-wrist* snatch carrots
for us to nibble, each gritty bite,

and strawberries he picked and rinsed.
My sister moaned, munching the pulp,
juice sticky on our chins.
Our pears have budded early again,
peaches and purple plums in bloom,
chill in the garden as we mulch,

clutching sweaters in the breeze.
It may not freeze again this month.
This may not be the cruelest season.
There may be time enough to spray,
to save the plums, to teach grandchildren
games, to kiss them many times.

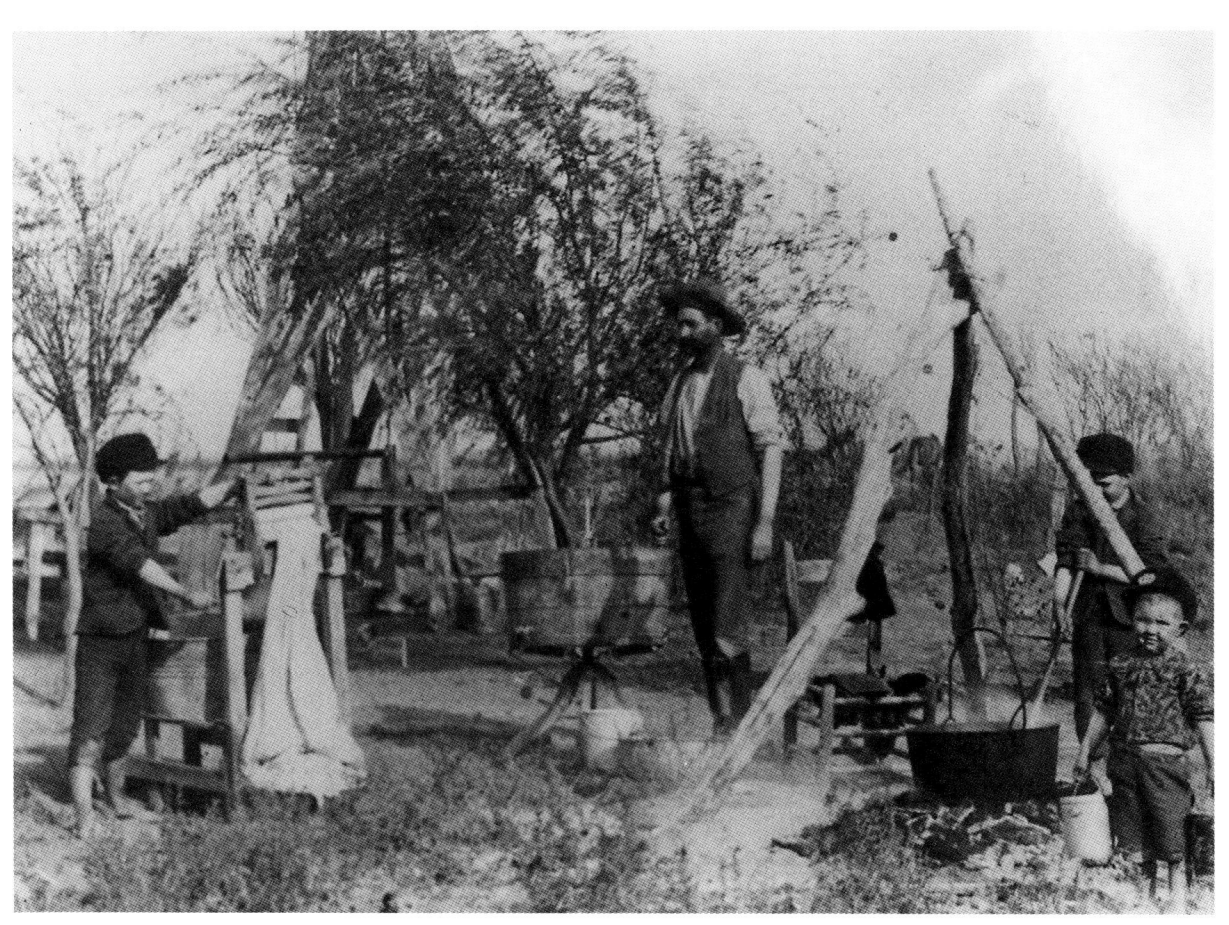

Faith Is a Radical Master

God bats on the side of the scrubs.
With a clean-up hitter like that, who needs
to worry about stealing home, a double squeeze,
cleat-pounding triples? If nothing else works,

take a walk, lean into the wicked pitch
careening inside at ninety miles an hour.
At bat, just get on base and pray the next nerd
doesn't pop up. When someone's already on, the coach

never calls me Mr. October, seldom signals Hit away.
If Johnson with the wicked curve owns the strike zone
or the ump, I'll bunt. No crack of the bat,
no wildly cheered Bambino everyone loves.

Lay it down the line like the weakest kid in school,
disciple of the sacrifice. Some hour my time will come,
late in the game, and I'm on third, wheezing from the run
from first after a wild pitch, and Crazy Elmore

waving like a windmill by the third-base line.
Hands on my knees, I'll watch the pitcher
lick two fingers, wipe them on his fancy pin stripes
and try to stare me dead. I'll be almost dead,

gasping, wondering how I'll wobble home if someone bunts
or dribbles a slow roller and the coach yells
Go! But there, there in the box is God,
who doesn't pound home plate like an earthquake

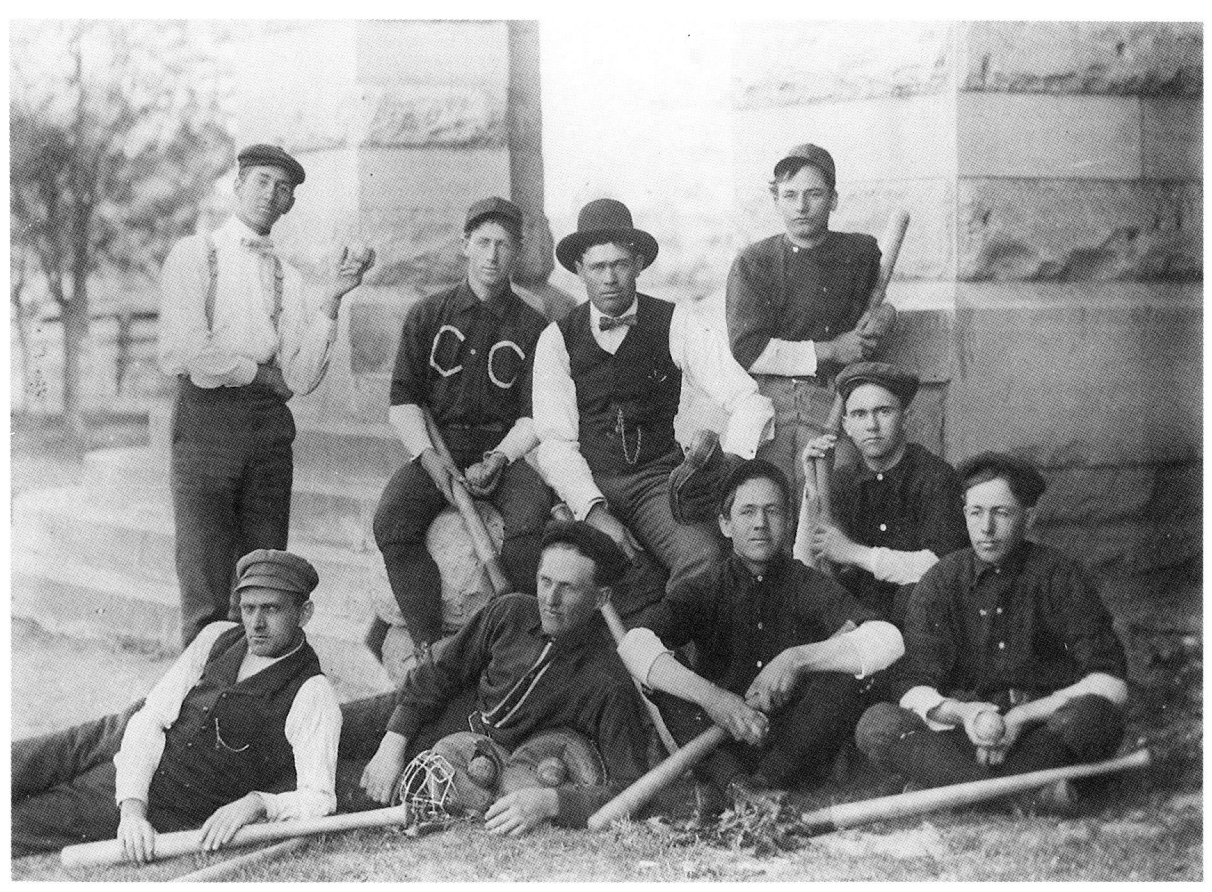

but slowly points the bat like the Babe toward center field,
and all my family in the clouds go wild, all friends
I've loved and lost, even the four-eyed scrubs
in the dugout slugging each other and laughing,

tossing their gloves like wild hosannas, and why not—
it's bottom of the ninth, two outs, a run behind
and a hall-of-fame fast-baller on the mound,
but I'm on third and leaning home, and look who's up.

Photo Credits

Page

3 Bob Criswell and Magnus "Swede" Swenson on the SMS Ranch, near Stamford, Texas, c.1914, Frank Reeves Photograph Collection, FR 265.

5 Woman shoeing horse, donated by Delia Wilkinson, Museum Photograph File no. 43-3-82.

7 Herd of buffalo, donor unknown, SWCPC File no. 454.

9 Texas Triassic, southeast of Post, Texas, undated, slide donated by Grover Murray, SWCPC File no. 197, envelope 1.

11 Unidentified family, Hereford, Texas, undated, SWCPC File no. 38.

13 Comanche campsite, c. 1872, Smithsonian Institution and Ernest Wallace, SWCPC File no. 442, envelope 6.

15 Old-timer with the Double U Company, Post, Texas, undated, SWCPC File no. 344, envelope 2.

17 Breaking sod near Muleshoe, Texas, c. 1913, donated by Edward K. Warren, SWCPC File no. 460, envelope 4.

19 Headquarters of Half-Circle-S Ranch, Crosby County, Texas, c. 1905, donated by Hudson Powell, SWCPC File no. 291, envelope 5.

21 Road difficulties, Spur Ranch, near Spur, Texas, 1909, Museum Photograph File no. 55-130-19.

23 Slaughter Ranch Headquarters, Cochran County, Texas, c. 1908, loaned for copying by Kate Boyd Keathley, SWCPC File no. 465.

27 Families came, undated, Museum Photograph File no. 55-140-60.

29 Farm house, Taylor County, Texas, circa 1905. Loaned for copying by Mrs. Era Richardson, SWCPC File no. 9(B), envelope 7.

31 Boys weighing their cotton on D. C. Moore farm, east of Lueders, Texas, undated, donated by West Texas Chamber of Commerce, SWCPC File no. 104 (C).

33 Cowboys in bedrolls, Matador Ranch, near Matador, Texas, undated, Museum Photograph File no. 1971-105-13.

35 Hi-D-Ho Drive-In, Lubbock, Texas, 1949, donated by Jim Dallas Studio, SWCPC File no. 435 (B), envelope 1.

37 Farm scene near Lubbock, Texas, undated, Museum Photograph File no. 57-38-11.

39 Two-Buckle Ranch House, Crosby County, Texas, circa 1912, loaned for copying by Rosemary English, SWCPC File no. 291, envelope 3.

41 Drace family at Turtle Hole Camp, Matador Ranch, undated, Museum Photograph File no. 1955-88-10.

43 Unidentified cowboy, undated, donated by West Texas Chamber of Commerce, SWCPC File no. 195.

45 Cowboys on the Renderbrook Ranch near Colorado City, Texas, 1904, donated by Floyd Beall, Museum Photograph File no. 56-64-37.

47 Newman and Will Boles on a Hereford bull, undated, donated by Buscher and Harris, SWCPC File no. 441, envelope 1.

49 Views of the Concho Country, San Angelo, Texas, undated, Ragsdale photographer, Museum Photograph file no. 1980-120-7.

51 Avis Fowler on Roy R, a race horse, Silverton, Texas, 1923, donated by Mrs. Cass Fowler, SWCPC File no. 14, envelope 1.

53 Long funnel in action, near Tahoka, Texas, undated, loaned for copying by Frank Hill, SWCPC File no. 273, envelope 3.

57 Cowboy dance on the Spur Ranch, near Spur, Texas, 1918, Frank Reeves Photograph Collection, FR 265.

59 Learning to use Dad's rope, undated, donated by Judge Stovall, SWCPC File no. 49(B).

61 Unidentified singer, donated by Bidal Aguero, SWCPC File no. 449, envelope 1.

63 Cowboy funeral, 1910, loaned for copying by Anna Scott, SWCPC File no. 334, envelope 1.

65 Isaac and Ida Jackson, Abilene, Texas, circa 1912, donated by Mrs. Erle D. Sellers, SWCPC File no. 3.

67 The last bale, Christmas, 1923, loaned for copying by Mosslyn Gammill, SWCPC File no. 322, envelope 1.

69 Panhandle dust storm, April 14, 1935, donated by Museum of the Plains, Perryton, Texas, SWCPC File no. 198, envelope 3.

71 LIT wagon, 1894, loaned for copying by Don Ray, SWCPC File no. 382, envelope 6.

73 A young girl with her dog, 1906, loaned for copying by H. L. Ledrick, SWCPC File no. 2, envelope 2.

75 At the Salt Well Section northeast of Tahoka, Texas, undated, loaned for copying by Mrs. C. E. Sanders, SWCPC File no. 191(A).

77 A. J. Zappe Saloon, Ballinger, Texas, circa 1905, donor unknown, SWCPC File no. 15, envelope 1.

79 Longhorns on the Ira G. Yates Ranch, Brewster County, Texas, undated, Archives of the Big Bend, Sul Ross State University, Alpine, Texas and SWCPC File no. 41.

81 Baby Kate Boyd, Hiley Boyd, Jr., and Daddy, Lubbock, Texas, 1912, loaned for copying by Kate Boyd Keathley, SWCPC File no. 465.

83 Winkler County, Texas, undated, donor unknown, SWCPC File no. 110, envelope 1.

85 Jim Perry, XIT cowboy, on the XIT Ranch, northwest Texas, circa 1910, donor unknown, SWCPC File no. 117, envelope 2.

87 Hereford canteen girls and WWI soldiers, undated, donor unknown, SWCPC File no. 38(B).

91 Untitled, donor unknown, Museum Photograph File no. 1980-120-18.

93 A baptizing in Lubbock County, Texas, 1895, donated by Lubbock County Historical Commission, SWCPC File no. 417, number 801.

95 A classroom in Lubbock's first public school, c. 1915, SWCPC File no. 454.

97 Jackson Parker riding Chance Wolf at Tucson, Arizona, circa 1965, donor unknown, SWCPC File no. 46.

99 Hank Smith family, Blanco Canyon, undated, donor unknown, Museum Photograph File no. 55-103-16.

101 SMS Ranch, near Stamford, Texas, spring roundup at Bull Creek tank, undated, loaned for copying by Swenson Land and Cattle Company, SWCPC File no. 123, envelope 1.

103 Unidentified, undated, loaned for copying by Mosslyn Gammil, SWCPC File no. 322, envelope 1.

105 Farming with a six-mule team, undated, loaned for copying by Anna Scott and National Farm Loan Association, SWCPC File no. 334, envelope 1.

107 W. A. Vest, pioneer rancher in Winkler County, Texas, undated, donated by Earl Vest, SWCPC File no. 110, envelope 1.

109 James Ranch, New Mexico, 1917, donated by John Kay, SWCPC File no. 112.

113 Unidentified group from Lubbock, Texas, undated, donor unknown, SWCPC File no. 57(M), envelope 1.

115 C. R. Michael family on the farm that originally belonged to Paris Cox, Estacado, Texas, 1900, Museum Photograph File no. 56-1-1.

117 A beauty spot in the Chisos, donated by Clifford B. Casey, SWCPC File no. 41, envelope 1.

121 Palo Duro Canyon, circa 1885, loaned for copying by Don Ray, SWCPC File no. 382, envelope 1.

123 C. C. Slaughter and Hiley Boyd at the Lazy S Ranch headquarters, Cochran County, Texas, 1889, SWCPC File no. 154, envelope 5.

125 Good Roads Day barbecue, Fort Stockton, Texas, 1914, loaned for copying by M. R. Gonzalez, SWCPC File no. 79(B), envelope 2.

127 Barksdale Ranch, undated, donated by Judge Stovall, SWCPC File no. 49.

129 Tumbleweeds, Colorado City, Texas, undated, donated by Maniss Photo, SWCPC File no. 39(A), envelope 6.

131 Cowboy on YL Ranch, Muleshoe, Texas, undated, donated by E. K. Warren and Charles Hoffman, SWCPC File no. 460, envelope 3.

133 Unidentified, undated, loaned for copying by Mrs. H. E. Jungman, SWCPC File no. 283.

135 Hilary B. Bedford with some of the animals and birds he trapped and mounted, donated by Kathleen Melton, SWCPC File no. 70.

137 Croquet game, Canyon, Texas, 1890, Museum Photograph File no. 55-130-43.

139 Gertrude Dyches, Add-Ran College, Thorp Springs, Texas, 1899, donated by May Dyches, SWCPC File no. 44.

141 Cowboys on Alamositas Creek at Picsal-Corrals, XIT Ranch, 1899, File no. 117, envelope 8.

143 Ingram dugout in Collingsworth County, Texas, 1890, loaned for copying by R. L. Templeton, SWCPC File no. 260.

145 First Lubbock mail route, 1901, Museum Photograph File no. 57-43.

147 Unidentified, Museum Photograph File no. 1971-105-9.

149 Doris Kayser sitting in front of an adobe wall at the T-Bar Ranch headquarters, Winkler County, Texas, 1907, SWCPC File no. 110, envelope 1.

153 Wedding photograph of Mr. and Mrs. I. L. Hunt, Lubbock, Texas, 1896, Museum Photograph File no. 55-84-10.

155 Hereford's first residence, home of Troy Womble, 1898, SWCPC File no. 38.

157 Cowboy with calf, Pitchfork Ranch, near Guthrie, Texas, undated, SWCPC File no. 284.

159 The perils of life, unidentified, undated, SWCPC File no. 344, envelope 2.

161 First murder trial in Hale County, 1898, Museum Photograph File no. 55-130-22.

163 S. W. Wilkinson, Silverton, Texas, donated by Delia Wilkinson, undated, Museum Photograph File no. 43-3-82.

165 Katherine Stinson, Brownwood, Texas, 1912, loaned for copying by Chester Sullivan, SWCPC File no. 22, envelope 3.

167 Captain John R. Sullivan and Company B of the Texas Rangers, circa 1900, loaned for copying by Don Ray, SWCPC File no. 382, envelope 10.

169 C. B. Fullerton, Texas Ranger, 1895, loaned for copying by Don Ray, SWCPC File no. 382, envelope 10.

171 Wagon boss on the JA Ranch, Texas Panhandle, undated, loaned for copying by Don Ray, SWCPC File no. 382, envelope 2.

175 Ice storm, Lubbock, Texas, 1942, donated by C. W. Ratliff, SWCPC File no. 57 (D).

177 An orphan train, Museum Photograph File no. 55-130-33.

179 Petersburg, Texas pioneer, A. S. G. Martin and sons doing the family wash, undated, donated by Herb Hilburn, Museum Photograph File no. 55-130-15.

181 After the game, Clarendon College, Clarendon, Texas, 1903, donated by Mrs. M. E. S. Barnard, SWCPC File no. 294, envelope 3.

About the Authors

Janet Neugebauer is an associate archivist for the Southwest Collection at Texas Tech University, where the photographs in *Whatever the Wind Delivers* are housed.

Walt McDonald, the author of seventeen collections of poems, is Paul Whitfield Horn Professor of English and Poet in Residence at Texas Tech University.

Of Related Interest

All That Matters
The Texas Plains in Photographs and Poems
Walt McDonald and Janet Neugebauer
Winner Western Heritage Award for Poetry and the
San Antonio Conservation Society Publication Award
New and selected poems of the West Texas plains are paired with photographs of the Southwest Collection.

166 pages, 7 × 8	Poetry/Texana
(cloth) $22.50	ISBN: 0-89672-291-0
68 photos	

The Digs in Escondido Canyon
Walter McDonald
Winner Western Heritage Award for Poetry
"His poems have a gritty reality along with a sensitive choice of words and phrases that make you feel as well as see the difficult world he paints."—*Books of the Southwest*

60 pages, 6 × 9	Poetry/Texana
(cloth) $16.50	ISBN: 0-89672-258-9

Alkali Trails
Social and Economic Movements of the Texas Frontier, 1846-1900
William Curry Holden
Long out of print, the newly released paperback edition of *Alkali Trails* provides an essential and accessible examination of the social and economic evolution of the West Texas plains.

256 pages, 6 × 9	Texas History
(paper) $15.95	ISBN: 0-89672-394-1
Illustrations, maps, notes, index	